Visual Literacy
Writing about Art

Visual Literacy
Writing about Art

by Amy Tucker
Queens College, City University of New York

Boston Burr Ridge, IL Dubuque, IA Madison, WI New York
San Francisco St. Louis Bangkok Bogotá Caracas Kuala Lumpur
Lisbon London Madrid Mexico City Milan Montreal New Delhi
Santiago Seoul Singapore Sydney Taipei Toronto

McGraw-Hill Higher Education 🖉

A Division of The **McGraw-Hill** *Companies*

VISUAL LITERACY: WRITING ABOUT ART
Published by McGraw-Hill, an imprint of The McGraw-Hill Companies, Inc. 1221 Avenue of the
Americas, New York, NY, 10020. Copyright © 2002, by The McGraw-Hill Companies, Inc. All
rights reserved. No part of this publication may be reproduced or distributed in any form or by
any means, or stored in a data base or retrieval system, without the prior written consent of The
McGraw-Hill Companies, Inc., including, but not limited to, in any network or other electronic
storage or transmission, or broadcast for distance learning.
Some ancillaries, including electronic and print components, may not be available to customers
outside the United States.

This book is printed on acid-free paper.

4 5 6 7 8 9 0 DOC/DOC 0 9 8 7 6 5 4 3 2

ISBN 0072302224

Publisher: *Phillip A. Butcher*
Sponsoring editor: *Joe Hanson*
Developmental editor: *Cynthia Ward*
Marketing manager: *David Patterson*
Project manager: *Anna M. Chan*
Production supervisor: *Carol A. Bielski*
Designer: *Mary Kazak*
Cover and interior detail image: *Erich Lessing/Art Resource, NY*
Eugène Delacroix, Women of Algiers in Their Apartment, 1834. Musée du Louvre, Paris.
Photo research coordinator: *David A. Tietz*
Photo researcher: *Photosearch Inc.*
New media: *Shannon Rider*
Compositor: *ElectraGraphics, Inc.*
Typeface: *10/12 Palatino*
Printer: *R. R. Donnelley & Sons Company*

Library of Congress Cataloging-in-Publication Data

Tucker, Amy.
 Visual literacy : writing about art / by Amy Tucker.
 p. cm.
 Includes bibliographical references and index.
 ISBN 0-07-230222-4 (alk. paper)
 1. Art criticism—Study and teaching—United States. 2. Art appreciation—Study and
teaching—United States. I. Title.

N7476.T83 2002
701'.18—dc21

 2001044257

www.mhhe.com

For Steve

Contents

Chapter 3
On Site:
Art and Architecture in Social Contexts 59

Chapter 4
The Museum as Context:
Display and Representation 91

Chapter 8
Editing an Essay:
Grammar, Punctuation, Usage 169

PART THREE
RESEARCH AND CRITICAL METHODS

Chapter 9
Researching and Documenting an Essay 188

Chapter 10
Critical Perspectives:
On *Women of Algiers in Their Apartment*
 by Eugène Delacroix 210

Preface

Visual Literacy: Writing About Art is a fully illustrated guide to understanding and writing about the visual arts. The book coaches students through a wide variety of writing assignments and introduces the principal issues that shape the discipline of art history today. *Visual Literacy* is up-to-the-minute in terms of critical debates and methods, but is above all student-centered in its approach to thinking and writing about art. While the book is compact and inviting enough to be read in several sittings, it is also a reference work students will return to for help with specific assignments throughout the semester.

The premise of *Visual Literacy: Writing About Art* is simple: the practice of writing expands our powers of observation and analysis. Writing is used as a method for discovering meaning. As students work through the chapters of the book, they see how an acquaintance with the fundamentals of art history opens up the intricacies and pleasures of visual art. With experience, writers learn to attend closely and to respond imaginatively to what they see, and as a result, each re-engagement with an image or object yields further meanings.

Visual Literacy: Writing About Art provides students with the necessary tools and methods for seeing, interpreting and writing about visual culture—whether the subject is a painting in a museum, a new building on campus, or one of the countless images broadcast daily from TV screens, magazine covers, billboards, and computer monitors. The chapters guide readers through a sequence of discussions, case studies, and writing activities, beginning with journal writing and proceeding to detailed descriptions and formal analyses, comparative and contextual analyses, and researched essays, with

guidelines on using library resources and documenting research in footnotes and bibliographies.

Key Features of the Text

- **Engaging Format**—The book teaches the skills of careful observation and critical thinking by actively involving students in the debates that shape the study of art history. In the text as well as in the commentary highlighted in the margins of each chapter, examples are drawn from students' writing; essays by art historians; critical reviews of recent exhibitions; and interviews with artists, scholars, museum curators and designers.
- **Wide Range of Illustrations**—*Visual Literacy: Writing About Art* is about "looking" as well as writing, and so it is amply illustrated with over 70 color and black-and-white reproductions representing a wide range of eras and artistic materials. In addition to canonical examples of painting, sculpture, and architecture, illustrations include photographs, video installations, ceramic and fiber art, advertisements, and cyberart.
- **Multicultural Perspective**—The book's discussions and illustrations emphasize the diversity of creative and interpretive modes by drawing on a broad spectrum of cultural and artistic traditions.
- **Case Studies Approach**—In-depth case studies are used to define and illustrate key terms, issues, and critical methods in art history. In addition, case studies follow individual writers as they work through the stages of composing various kinds of essays for their art history courses. The final chapter of the book provides an extensive casebook on critical theory by examining the reception history of a single painting in the art history canon.
- **Process Guide to Writing**—*Visual Literacy* provides intensive instruction and practice in research and writing in general, and specifically on writing about art, using a process-oriented approach to drafting, rethinking, and revising. Each chapter of the book is built around a "Writing Assignment" section;

students are guided through reflective journal entries, collaborative field reports, formal and comparative analyses, position papers on current debates in the art world, and longer researched essays.

The Organization of the Book

In *Part I: Elements of Visual Analysis,* students see how writing is called into play from their earliest encounters with a work of art. Chapter 1 introduces the principal concepts on which later chapters build: the influence of the viewing context on perception; the methods of close observation; the techniques of comparative analysis; the distinctive characteristics of various art media; the conventions of genre; and the uses of research and connoisseurship. Chapter 2, on perception, description, and formal analysis, provides students with the specialized vocabulary for writing detailed and precise accounts of the visual features of objects and images. Chapter 3 uses case studies of four works of art and architecture to demonstrate how art historians investigate the cultural contexts in which art is produced. Chapter 4 takes readers behind the scenes on a museum tour to examine the ways in which various exhibition methods shape our perceptions of the objects on display.

Part II: Essay Writing Strategies (Chapters 5 through 8) presents case studies of individual writers as they plan, develop, structure, revise, and edit a range of essays. *Part III: Research and Critical Methods* focuses on scholarly research, documentation of sources, and critical theory. Chapter 9 outlines research techniques as well as the standard formats for citing scholarship in footnotes and bibliography. Chapter 10 provides an overview of the critical methods of art history by tracing the reception of a single painting, Eugène Delacroix's *Women of Algiers in Their Apartment.* A casebook on the painting guides students through a survey of art history writing from mid-nineteenth-century reviews to the most recent postcolonial critiques.

The Table of Contents on pages vi–xi shows in greater detail how each of these chapters works.

Acknowledgments

Working with the team at McGraw-Hill has been a pleasure from start to finish. I brought this project to McGraw-Hill because it provided me with another opportunity to pair up with Cynthia Ward, an extraordinary editor of Zen-like equanimity; working with her is, as ever, a joy and a privilege. I'm extremely grateful to Joe Hanson for his staunch support, enthusiasm and good counsel through every stage of the book's production; to editorial assistant Ashaki Charles; to Anna Chan, who supervised the project; and to Mary Kazak, the design editor. It is a measure of the team's professionalism that eleventh-hour substitutions and frequent authorial intrusions were met with grace and good cheer. The same must be said of the team at Photosearch, Inc.—Deborah Bull, Joanne Polster, and the amazing Jennifer Sanfilippo. Thanks to all for making this a collaborative project.

A number of readers kept the book on course with their extensive comments and suggestions: Phylis Floyd, Michigan State University; Mark Miller Graham, Auburn University; Nancy Locke, Wayne State University; Patricia Mathews, Oberlin College; Lily Mazurek, Nova S.E. University; Lynn Metcalf, St. Cloud State University; Johanna Movassat, San Jose State University; Deanne Pytlinski, Colorado State University; Leah Rutchick; Jean Owens Schaefer, University of Wyoming; Diana Gregory Scott, City College of San Francisco; Sonia Sorrell, Pepperdine University; and Claudia Swan, Northwestern University.

On a more personal note, I'd like to express my appreciation to colleagues at Queens College who have offered help and encouragement. Steve Kruger's annotations of the manuscript were a model of intelligence and tact. John Weir taught me a great deal about art, writing, and friendship. Eileen Krest was a wonderful muse as the project took shape, and Donald Stone's connoisseurship provided further inspiration. I'm indebted, as well, to these friends and associates: Barbara Bowen, June Bobb, Phyllis Cannon-Pitts, Nancy Comley, Rosemary Deen, Kate Haake, Tony O'Brien, Charles Molesworth, Carol Molesworth, and Betsy Roistacher.

My students provided some of the most incisive commentary in the book. Warm thanks and best wishes go to all the burgeoning writers quoted in these chapters, to the seminar group who created the exhibition catalog described in Chapter 7, and especially to Mahwash Shoaib and Baz Dreisinger, whose research and writing methods are the heart of Chapter 5 and Chapter 6.

One of the delights of this project was making the acquaintance of a number of museum professionals who proved uncommonly generous with their time and expertise. Heartfelt thanks to David Mayo of UCLA Fowler Museum of Cultural History, and, especially, to Pamela McClusky of Seattle Art Museum, who shares her insights and her research unstintingly. I'm grateful to Geneviève Pierrat Bonnefois of the Louvre, and to Robert and Isabelle Vifian, for making Paris possible.

Working on pieces of the Delacroix puzzle in Chapter 10 gave me the chance to commission essays from two colleagues who ultimately became friends: Joan DelPlato and Véronique Chagnon-Burke. Professor Chagnon-Burke was of immeasurable assistance in researching Chapters 2 and 3, as well as in sharing with me the fruits of her teaching; her insights and her sleuthing made this a better book. For the smart and funny commentary in Chapter 2 I am especially indebted to Bronwyn Bell and to my dear friend, Marji Hooper.

My families, the Tuckers and the Tanzers, have my gratitude and love for their unfailing kindness and support. Gil, Lucy, Jeff, and Miriam have been cheering me on for as long as I can remember; this project wouldn't have got off the ground without them.

Finally, I can never sufficiently convey my admiration and thanks to Steve Tanzer for all the pages edited, doldrums routed, dinners cooked, and ideas and encouragements tendered over the past few decades. As always, the book is dedicated to him.

Visual Literacy
Writing about Art

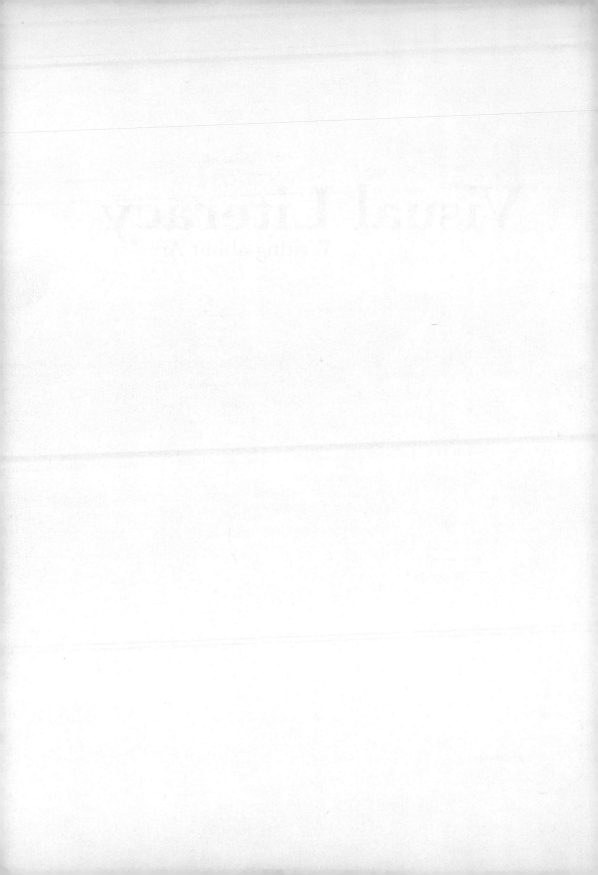

Elements of Visual Analysis

PART ONE

1 — Responding to Art

Visual Literacy and the Practice of Writing

E xactly why one work of art speaks to us more compellingly than another is something of a mystery, but we do know that matters of perception and preference are influenced in part by the viewer's knowledge and experience. Familiarity with the idioms, codes, and conventions of a visual language—what we call *visual literacy*—allows you to develop fuller and more pleasurable responses to works of art, as well as to write about visual images with clarity and fluency. You've undoubtedly noticed how you react differently on revisiting a book you've read or a film or painting you've seen before; on second and third viewing you *see* more. So it is with any text, literary or visual. This chapter introduces you to the purposes and methods for developing visual literacy through your written responses to art.

Throughout this book you'll be invited to respond in writing to various questions, exercises, and assignments posed in the text. Why the emphasis on *writing* your responses, as opposed to thinking through the problem, or discussing the topic with a classmate? The reason is that writing works as a heuristic—a method for discovering meaning—precisely because of the ways it differs from

speaking. Writing produces a visible record of your re-
sponses that allows you to reread and develop your
thoughts. You watch ideas evolve and take shape on the
page. Writing, in short, is another way of seeing.

Subsequent chapters of this book will take up the
kinds of written work commonly assigned in courses in
art history and art appreciation: detailed descriptions,
comparative analyses, researched critical essays, and so
on. In this chapter, our focus is on the exploratory process
of recording your observations in an ongoing writer's
journal. One of the best ways to begin thinking and writ-
ing about art is to consider what draws you to a particu-
lar piece. The questions posed in the following journal as-
signment will help you frame your initial responses.

Writing Assignment
Journal Responses to a Work of Art

*Select an artwork that appeals to you, an image or object in-
triguing enough to sustain your curiosity. In your journal,
record the artist and title (along with the dimensions of the
piece, if available). Jot down your observations, responses, and
questions about the work, taking note of the following elements:*

- *What subject is depicted, and which visual details
 immediately catch your eye? For instance, what are the
 predominant colors and shapes? Where are areas of light
 and dark placed in the overall design? Which spaces are
 crowded or empty?*
- *Does the object resemble any other artworks you've seen,
 and if so, in what ways?*
- *What medium is used (for example, a drawing made with
 charcoal on paper, an oil painting on a wood panel or
 canvas, a color photograph on glossy paper, a piece of
 sculpture carved from a block of wood or marble)? How does
 the artist manipulate the medium, and with what effects?*
- *How do these elements work together to project visual
 meaning?*
- *What more would you like to learn about this work?*

Most writers keep a journal, a place for asking ques-
tions, sketching fragments, and noting ideas that may be
developed in subsequent essays. Consider one student's

journal response to the Mughal manuscript illustration of *Bahram Gur Watching Dilaram Charm the Wild Animals with Her Music* (c. 1595; ink and opaque watercolor on paper, $9^5/_8 \times 6$ in.), pictured in Color Plate 1 in the color gallery of this book. In the following page from her journal, Mahwash Shoaib reflects on what attracted her to this particular painting, which she chose as her subject for a researched essay assignment. (You'll find the final version of her essay, along with a detailed discussion of the steps she took to get there, in Chapter 5 of this book.) Ms. Shoaib lived in Pakistan before moving to the United States, so she has the special perspective of an observer who has participated in two distinct cultural traditions. Notice how her background allows her to situate the painting within a cultural and historical frame, as well as to formulate questions she'd like to research further:

> My reasons for choosing *Bahram Gur Watching Dilaram Charm the Wild Animals with Her Music* were highly personal. What initially attracted me was that the manuscript from which the painting was taken was commissioned by Akbar (not my favorite Mughal emperor, but clearly the most glorious of his dynasty) in Lahore, my native city. Even though the painting makes no visual reference to Lahore, looking at it evoked a curious blend of nostalgia and homesickness for my beloved city.
>
> On the purely aesthetic level, I am fond of the muted color-palettes in Indo-Persian miniatures. The painting struck me as serene and hypnotic. I was interested in the relationship between art and literature in this work: the painting illustrates a section of the *Khamsa* (Quintet) of the poet Amir Khusraw. Since the painting was apparently based on a legend or myth, looking into the painting's background ensured a peeling away of memories of fairy tales and stories read in childhood; yet the echoes were also faint enough for me to be intrigued by the characters of the narrative, e.g., why were Bahram Gur and the animals charmed by Dilaram? What gifts did she possess?

Shoaib is clearly a canny observer. But it would be reductive indeed to say that the only valid observations about a work of art come from spectators reared in the culture that produced it. Besides, not all native speakers

are equally adept at reading a text from their own culture, least of all when the text comes from an earlier era in history. What we can say is that Shoaib's experience and background prompt her to ask more interesting and productive questions about this work of art. Acquaintance with the artistic traditions of her native and adoptive cultures leads her to notice and appreciate more in the painting than a novice would. How so?

Visual Memory and Visual Literacy

When encountering an unfamiliar image, members of the same interpretive community are able to draw on a common fund of images and references to make sense of what they see. This visual background makes viewers more receptive to patterns and nuances they might not otherwise grasp. Expanding your *visual memory*—that is, your storehouse of familiar images—is the first step toward developing visual literacy, which is the ability to "read" and understand that visual information.

Obviously, we can appreciate the expressive qualities of an artwork whose traditions are unfamiliar to us. Face-to-face encounters with works of art are far more complex and absorbing than a matter of decoding a specialized language: art is experienced as a physical process, to be seen and felt as much as comprehended. Why else revisit that painting or film or statue again and again? The sensual pull of the artwork solicits our gaze and our curiosity. In time, though, practiced observers learn to attend more carefully and to respond imaginatively to what they see, and as a result, each reengagement with an image or object yields further meanings and pleasures. This book is designed to develop your participation in the processes of perceiving and interpreting.

The remainder of the present chapter will take you step by step through each of the questions posed in the foregoing journal assignment, showing you how to use the basic tools and methods of art history to expand your observations. For the purposes of our discussion, we'll be looking at *Untitled #205* ($53^1/2 \times 40^1/4$ in.; plus large gold-toned frame), a photograph made by the American artist Cindy Sherman in 1989. Turn now to the

photograph, pictured in Color Plate 2, and take a few moments to record your initial reactions to the work in your journal. Please continue to refer to the color reproduction and to write down your responses as our discussion progresses.

Observations and Questions

Jot down your initial observations, responses, and questions about the piece. What subject is depicted, and which visual details immediately catch your eye? For instance, what are the predominant colors and shapes? Where are areas of light and dark placed in the overall design? Which spaces are crowded or empty?

I recently asked a group of students the same questions we'll be considering in the next few pages; excerpts from their written responses appear in the margins of the chapter. As you'll see, their reactions are perplexed, appreciative, cranky, changeable. In other words, there are no wrong responses. The fundamental principle of the study of art is simply careful and sustained observation and inquiry of the evidence before us.

You've been looking at a photograph from Cindy Sherman's series of *History Portraits.* Like most of this artist's pictures, the photograph is numbered rather than titled. But the series title and certain features of the picture seem to refer to some earlier image. What is Sherman "quoting"? And would our recognition of the source make a difference in our reception of the work?

The Art History Context

Does the object recall any other artworks you've seen?

Sherman's *History Portraits* take "old master" paintings of the Western tradition as their inspiration. We should note that Sherman is posing as her own model in this "portrait," and that much of Sherman's work is based on photographs of herself in various male and female guises.

The source for this particular image is *La Fornarina* (fig. 1.1), a painting generally attributed to Raphael Sanzio

What are your initial observations and questions about the piece?

I observe a picture of a woman, almost nude, lush and well endowed. Her gaze seems to say, "I am here to be watched."

She has a stern look, as if she has not had a good laugh for quite a while. Her hands seem rough and worn, evidence of her hard work.

She looks as if she's about to go into labor. Proud but guarded.

Her eyes stare directly at the viewer.

She is silhouetted against a dark background.

I think this is a picture of a male actor, wearing makeup and a fake chest and stomach. Somehow the photographer wants us to know that this person is not really pregnant.

A woman posing nude for a painting makes me an uncomfortable observer. OK, the human body is a beautiful thing, but I wouldn't want to see it naked in public.

Is she famous? The mother of someone famous? A fictional character? Is the "baby" significant?

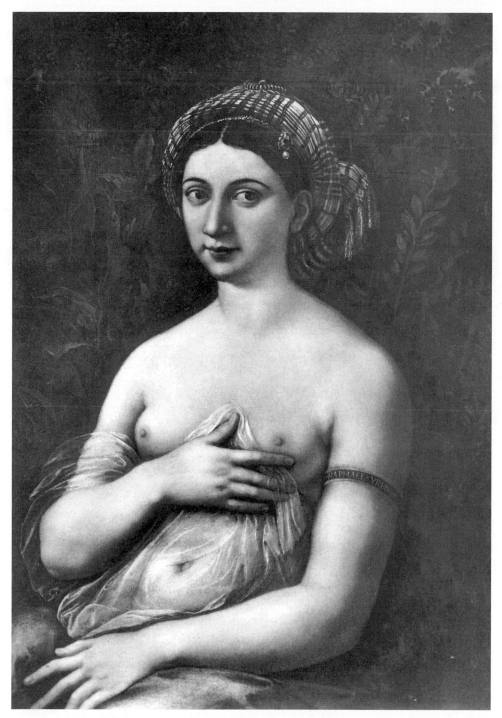

1.1 Raphael, *Portrait of a Young Woman (La Fornarina)*, 1520. Oil on panel, 85 × 60 cm. (33^1/$_2$ × 23^5/$_8$ in.). Galleria Nazionale, Palazzo Barberini, Rome.

What questions do you have concerning the second image?

Who is this girl? Who is her father?

Did she do this for money—a model's salary? Or did she do it for herself?

What's the significance of the armband?

Why are her eyes averted? Why is she smiling? Why is she attempting to cover up while deliberately showing her body?

of Urbino, one of the most revered artists in the history of Western art.

What questions do you have concerning this second image?

La Fornarina, "the baker's daughter," has come to be identified over the years as a portrait of Raphael's lover, though the subject's name and the nature of her relationship to Raphael have never been established definitively. This is a matter we'll return to later on.

Knowing the source of an image brings its own satisfactions. Informed viewers pick up hidden connections among visual references, in the same way that listeners nod appreciatively when a jazz musician slips a phrase from an old tune into a new melody or when a hip-hop group "samples" an earlier recording. But visual literacy is more than a game of "Name This!" or a test of your ability to identify famous paintings on a slide examination. Critics who attended the opening exhibition of Sherman's "History Portraits" were reportedly unable to identify with precision the sources for many of Sherman's reinterpretations or paraphrases of famous works. What they brought to the work was an ability to see the new image within the context of art history. The study of art history provides not only a shared glossary of images but, more important, an appreciation of how those images are made, how they are related, and how they gather meaning.

Intertextuality

A familiar image stands out and signifies in unexpected ways when it appears in a different context. In its new surroundings, the image trails along its own set of associations and acquires different shades of meaning. This embedding of texts and sign systems we call *intertextuality.* As you expand your repertoire of visual references, you also extend the web of intertextual threads you are able to weave around an artwork.

To underscore this point, we'll briefly consider another painting that incorporates the image of Raphael's Fornarina. Figure 1.2 shows *Raphael and the Fornarina,* painted by the French artist Jean-Auguste-Dominique Ingres in 1814.

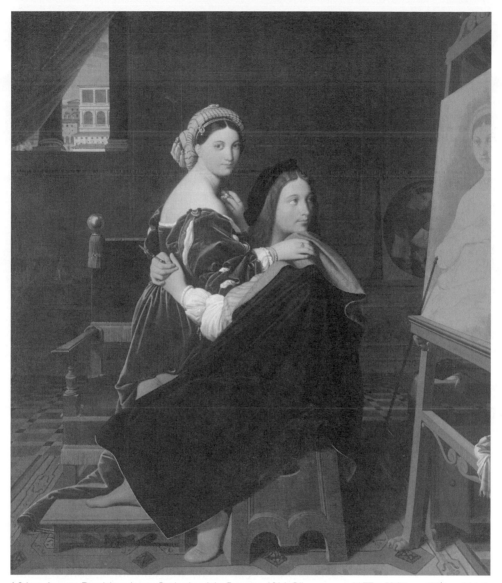

1.2 Jean-Auguste-Dominique Ingres, *Raphael and the Fornarina*, 1814. Oil on canvas, 64.77 × 53.34 cm. (25¹/₂ × 21 in.). Courtesy of the Fogg Art Museum, Harvard University Art Museums, Boston, bequest of Grenville L. Winthrop.

In this imagined scene, Raphael embraces his seated lover while gazing at his incomplete sketch of her on the easel behind him. Red chalk in hand, Raphael seems to be captured in the act of composing the painting that we now know as *La Fornarina*. If you recognized the female figure or the sketched outlines of La Fornarina on the easel, your visual memory is at work.

But how does *La Fornarina* signify in this context? Ingres was so taken with the subject that he would paint three more versions of it during his career. Perhaps he saw in Raphael's legendary affair a parallel to his own ill-starred betrothal. More important, Ingres saw himself as working in the classical tradition—a tradition that prized line, balanced composition, and invisible brush strokes (as opposed to the expressive color, dynamic composition, and free brushwork championed by Ingres's younger colleagues in the Romantic movement). In this painting, Ingres pays homage to an artist whose work he regarded as the highest expression of Renaissance classicism. He positions himself as Raphael's disciple.

At the opposite end of the spectrum from this tribute, Sherman's Fornarina is comic, grotesque, even disturbing—more unsettling, at any rate, than a parody. Sherman's "portrait" both acknowledges and subverts Raphael's *La Fornarina*. As the critical theorist Julia Kristeva points out, intertextual influences flow back and forth among images: the phenomenon of intertextuality describes not only what happens when an artist borrows an earlier motif, as when Ingres and Sherman borrow from Raphael, but also the way the *later* works of art affect our reception of the *earlier* image.

In other words, once we've seen Sherman's image, we can't help recalling it when we look back again at the Raphael. Our perceptions of Raphael's painting have been expanded, altered in some way. This does not mean that we admire Raphael's artistry any less; merely that Sherman's work takes apart, de-constructs, some of the implicit assumptions of Western art from the Renaissance onward. As we continue our comparison of the images by Sherman and Raphael, below, we'll examine these assumptions more closely.

The Comparative Method

In what ways are the objects alike or dissimilar?

Comparative analysis has been the foundation of art history virtually from the beginnings of the discipline in the nineteenth century. Heinrich Wölfflin's archival

method for comparing art objects continues in the slide presentations of the present day. Art historians compare similarities and contrast differences between artworks by considering, for example, an artist's handling of form, medium, genre, and iconography—all matters we'll take up in the course of this writing exercise.

Comparing related images or objects allows us to see the distinctive features of each more clearly. Notice how the students quoted in the margin here are able to produce further observations about Sherman's photograph now that they have seen Raphael's painting. In comparing the second image with the first, they've begun to make connections, draw distinctions and inferences, and articulate preferences.

The similarities between the two images are obvious enough. Sherman has reproduced the pose of Raphael's partially nude sitter; props such as the turban, veil, and armband; and the unspecified light source that emanates from the left side of the picture and silhouettes the figure against the dark background.

After a moment's inspection, though, our attention begins to fasten on differences, or contrasts, between the two portraits. Take facial expression: Sherman's Fornarina is dour and severe, unlike the faintly smiling subject of Raphael's painting. Her gaze is not averted but aimed directly at the viewer. Her right hand closes protectively above the exaggeratedly swollen belly rather than opening to cup her breast. Particularly evident are the devices by which Sherman reconstructs the earlier work: the theatrical makeup, the prosthetic breasts buckled onto her shoulders, the tacky curtain substituted for a diaphanous shawl. Before we proceed to interpret these observations, however, we'll develop the comparison by considering several other features of the two works.

Medium

What medium has the artist used, how is it handled, and with what effects?

To appreciate what is distinctive in an artist's treatment of subject matter, we must know something about the *medium* in which the object or image was executed: in this case, painting versus photography.

In what ways are the objects alike or dissimilar?

The second picture (by Raphael) is of someone younger, not apparently pregnant. If the first picture is based on the second, is the artist showing a progression from youthful beauty to maternal beauty?

I definitely prefer the second portrait. The model in the first picture focuses on the audience rather than glancing to the side, and her stomach is more obvious: she seems to want to challenge the softer impression of the "original" portrait.

I think the first portrait, in comparison, is gross.

The armband in the copy is missing the words "Raphael Urbinus."

The first picture seems to exaggerate, even satirize the original.

A reproduction, eh? I guess with every revision *something* is enhanced.

There seems to be some sort of strap there. Why the prosthesis?

Sherman may have wanted people to know she was modeling for the picture. She wanted people to question why this looks fake.

Under the title of "History Portrait," this piece may be telling a story about how this woman, or perhaps women in general, felt about their bodies at one point in time.

What medium has the artist used, how, and to what effect?

I was right—her body is not her own! And yet, the first picture seems more lifelike, more realistic, than the second.

Cindy Sherman's photograph has an astoundingly picturesque look. By that I mean that it looks like a painting—but not exactly Raphael's. I believe she staged it differently to say something to us. . . . I'm just not sure what that something is.

Even though paintings are made up, photographs are of real people. And yet although this is a real person, there can be a fakeness to the photograph as well.

She looks tense in the photograph; this is apparent in her staring eyes and the way her hands are stiffly positioned. The woman in the original painting seems calmer, and wears a smile/smirk. Her body appears softer and more idealized.

Let's first consider the properties of various painting materials. The Mughal manuscript illustration shown in Color Plate 1 is painted on paper in *gouache*, which is made from adding opaque white to watercolors. Gouache dries quickly, making it difficult for the artist to blend brush strokes, shadows, and hues. As a result, gouaches lend themselves to crisp, sharply delineated shapes and colors, flattened forms, and overall patterning in a composition.

In Europe around the time Raphael was working, oil was beginning to be used as a binder for pigment. Oil paint dries slowly, allowing the artist to blend colors and to apply paint in layers. By layering the paint in thin glazes, artists like Raphael were able to achieve subtle shading and luminous color, a suggestion of three-dimensionality, and an effacement of brush strokes.

The medium of oil paint allows the painter to render objects more naturalistically, giving an illusion of depth on the flat plane of a panel or canvas. Three-dimensionality or *volume* can be conveyed by the way light plays over form. With fine brush strokes the artist suggests textures peculiar to a variety of surfaces: the transparent gauze of the veil is markedly different from the rough texture of the linen turban and the glowing flesh of the sitter's upper torso, which seems to pick up warmth from the light source.

The medium of photography, in contrast, is generally assumed to reproduce an objective visual record rather than to be an imaginative rendering of objects or scenes. Photojournalists consciously strive for an impression of neutral documentary evidence. The fact is, though, that photographers make the same kinds of choices as painters. They consider the composition, lighting, and framing of a picture; the vantage point from which the subject is shot and the relative distance between camera and subject; the degree of contrast in brightness and shadow, color and tone; the soft or sharp focus of the lens; the glossy or matte finish of the print materials; and so on.

Sherman's self-conscious handling of the medium of photography points up the way photographers manipulate images. The Kodak-C print is unusually large in scale, nearly twice as large as the Raphael painting. The theatrical lighting of the *History Portrait* exaggerates the

chiaroscuro, or dramatic contrasts of light and shadow, favored by Raphael and other painters of his time. The shaded form of the sitter's left arm, whose outline is barely visible, throws into relief the rough, lined knuckles of her right hand. Harsh light also accentuates the model's hardened scowl and congealed makeup. Sherman thus emphasizes the unflattering imperfections we normally expect to be brushed out in formal portraits, whether photographs or paintings.

Genre

Having noted, above, what we "normally expect" of a portrait, we have already begun to recognize genre, or subject type. A *genre* is a customary category of subject matter in art, such as landscapes, sacred images, mythological and historical scenes, portraits, and the arrangements of inanimate objects known as still lifes. (Somewhat confusingly, the term *genre* was also adopted in the eighteenth century to describe paintings that take domestic scenes of everyday life as their subject.)

Each of these subject types is associated with a characteristic set of visual symbols, conventions, and techniques for representation. Members of a given society tend to take such categories and representations for granted. For instance, largely as a result of the conventions of portraiture established by Raphael and other artists of his time, Western viewers have come to regard a portrait as a reasonable physical likeness of the sitter, and, moreover, to read these physical attributes as indicators of the individual's character and personality.

Actually, favored subjects and conventions for portrayal are neither natural nor universal but culturally constructed. Take, for instance, the assumption that a portrait is a likeness. The Roman ancestor bust from the first century B.C.E. shown in fig. 1.3, with its lined mouth and sagging jowls, appears to be modeled on the specific features of an individual. The style is called "verist" for its true-to-life appearance, or verisimilitude.

But numerous Roman portrait busts have been found with these same particularities, suggesting that the sculptures were not meant to be specific likenesses so much as representations of admirable types—in this case, the type

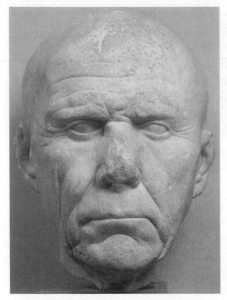

1.3 *Head of a man from Scoppito*, first century
B.C.E. Marble, height 28 cm. (11 in.). Museo
Nazionale, Chieti.

of the trustworthy elder statesman. Many official portraits (such as the pictures of historical figures on stamps and currency) combine individual and conventional features to emphasize ideal character or personality traits. In the statue of the Egyptian functionary named Montuemhet, carved in the mid-seventh century B.C.E. (fig. 1.4), the subject's face shows individuality in the heavy brows, the pouches under the eyes, and the prominent nose; yet the broad-shouldered torso, purposeful stride, and clenched fists of the statue are strictly traditional means for portraying male figures during this period.

Conventions for depicting the human figure express cultural assumptions about gender in other ways we might not recognize. To cite just one example: portraits of wellborn women such as those painted in sixteenth-century Italy were prohibited for the Muslim women of Akbar's court in Lahore.

Through the same process of acculturation, Western viewers have become accustomed to conventions for depicting nude female figures, which from the seventeenth century forward have constituted a genre of their own in Western art. Raphael could look to precedents in several Hellenistic statues that had become known through Roman copies. The gestures of the sitter's hands are very likely an allusion to the so-called Venus Pudica, or Venus of Modesty, the ideal beauty of Greek mythology. The transparent veil draped about the female nude was used in classical sculpture to suggest modesty while in fact hiding little.

To gauge how our perceptions of Raphael's painting have been conditioned by long-established social roles and artistic practices, try reversing the genders of artist and model. You would doubtless be disconcerted to see a painting *by* La Fornarina of her lover Raphael, seated, naked but for a hat and a veil, demurely shielding his genitals and smiling provocatively at the viewer.

Sherman's "portrait" achieves something like this reversal of viewpoint. The various devices we have noted

in Sherman's photograph serve as reminders of how tradition normalizes certain subjects and poses. Casting herself in the role of the artist's naked mistress, with amusingly theatrical exaggerations, Sherman brings to the surface some of the social and artistic conventions that Western audiences take for granted.

Iconography

In pointing out Raphael's allusions to classical sculpture, we've entered into a discussion of *iconography,* the system of visual signs frequently associated with a given genre in art. Studies in iconography (from the Greek words for "image" and "writing") interpret clusters of visual images by tracing their symbolic meanings back to sources in mythological, religious, and social texts and conventions of representation. If we go a bit farther in our investigation of the iconography of Raphael's painting, we begin to perceive a whole network of classical and contemporary Renaissance allusions to idealized beauty, modesty, and fidelity. Together, these signs function as a counterpoint to the frank realism of Raphael's depiction of the nude figure.

Some of the iconographic signs in *La Fornarina* are still part of the modern viewer's visual lexicon—for instance, the gesture of hand on heart that signifies a betrothed or faithful lover. Other references will be less apparent to modern-day viewers who are unacquainted with traditional imagery in the history of Western art. The laurel, quince, and myrtle branches faintly visible in the background of Raphael's painting would have had bridal connotations for contemporary viewers in Italy; quince and myrtle were both associated with Aphrodite, or Venus, the goddess of love and marriage, and myrtle wreaths were customarily worn by Jewish brides. The pearl (seen on the turban) came to signify, in its lustrous and unbroken spherical form, female chastity and devotion. Barely visible in our reproduction, a ring is worn high on the second finger of the model's left hand;

1.4 *Statue of Montuemhet,* Karnak, Temple of Amun-Re. Late 25th to early 26th dynasty (mid-seventh century B.C.E.). Gray granite, height 137 cm. (60 in.). Egyptian Museum, Cairo.

according to Renaissance belief, the vein of this finger led directly to the heart. With her other hand the model points to an armband bearing Raphael's name.

The comments reprinted in the margins suggest that many of these allusions are lost to modern viewers. Iconographic connotations are not fixed for all time but subject to adaptation from one generation or culture to the next. Without specific information about the background of a work of art, our responses will certainly be less textured and nuanced, and so we owe it to ourselves and to the artwork to learn as much as we can about the context in which it was created. But does this mean that our first responses are therefore wrong or inappropriate?

True, informed viewers of a given era approach a contemporary artwork with certain shared expectations or a preunderstanding of the genres, forms, and subjects of already familiar works. But viewers of succeeding eras will naturally come to the same work with different expectations and questions about form and content, and this is one of the many ways that art of the past speaks to viewers of the present. Several of the viewers quoted in this chapter, for example, are taken aback by the realism of the nude portrait, considering it invasive. Some of Raphael's contemporaries—and, centuries later, many mid-Victorian viewers—would have agreed. In other words, within the space of a single painting or photograph, several systems of meaning and valuation may intersect and even conflict.

Ultimately, no artist can predict the wealth of associations each viewer will bring to the artwork. Strange to say, seventeenth-century inventories tell us that at one time Raphael's picture had attached shutters that could be closed over the painting, so the image was probably once reserved for private viewing. Who could have foreseen the widespread circulation of this intimate portrait through reproductions in books and classrooms, much less its reinterpretation in a late-twentieth-century work of art?

Interestingly, along with the other differences we've been noting between Raphael's and Sherman's pictures, we find that Sherman has eliminated from her photograph the entire network of iconographic signs discussed in the previous pages: the flora in the background, the

pearl, the ring, the gesture indicating the name on the armband. What can we make of such omissions and differences?

Moving from Observation to Interpretation

How do all the elements you have noted work together to project visual meanings?

We have begun to see how Sherman's work prods us to examine our own expectations and preferences in art, as demonstrated in the comments of the students quoted in these pages. Their responses have become more developed and reflective in the course of this exercise.

For example, as one student observes, Sherman's *History Portrait* shows that a photograph is not necessarily a likeness, any more than a painting need be. Indeed, by transforming her face and body so utterly in this picture and throughout her work, Sherman seems to challenge the very notion of stable identity on which Western portraiture is founded from the Renaissance onward.

It is as though an actor were holding back the curtain during a performance to reveal the backstage mechanisms and creaking scenery normally hidden from the audience. The overt phoniness of Sherman's costume reminds us that the model who at first glance seems to be exposed is, in fact, hidden. Her actual nakedness is obscured by a false front, just as, were we to push aside the veil, her protruding stomach would be revealed as illusion. The "child" she bears, like the picture she produces, is her own creation. In the act of reimagining works of the old masters in her *History Portraits,* Sherman manages to suggest both continuity and rupture with the past.

We've also seen that the process of looking at works of art is cumulative, a series of visual impressions and insights we bring to the work. With the acquisition of new information, we return to earlier images with fresh perception. As it turns out, Sherman's late-twentieth-century "reproduction" (of which six photographic prints were made) teases out another set of intriguing questions about the "original" *La Fornarina.* For answers to some of

How do all the elements work together to project visual meanings?

I wonder if she is mocking the posing and painting of slender models. This also makes me think about how society shapes our opinion of what is beautiful. Today, overwhelmingly, we blame the media for perpetuating these images; perhaps in the fifteenth and sixteenth centuries it was done through forms such as Raphael's painting. Sherman's in-your-face photo seems to set out to shock the viewer.

She's showing that she's a fake and wants to make it rather obvious—like some cheap imitation of the original. She's mixing the old with the new. The effect is humorous, like a parody.

Raphael's subject projects a more innocent vulnerability but Sherman has a more "wise to the world" look. She's challenging the ideals of womanhood expressed in the original picture. Of course, net-like cloth takes the place of the soft drape in the original, signifying her view of the woman being bound in stereotypes.

It is a feminist's point of view because of how she prepared for the pose: the observer senses that she doesn't like this passive role. The body is fake because she is not into selling herself.

The Sherman photograph strips away most of the beauty of the original.

I think Cindy Sherman is trying to show what old models really looked like. She may be showing that women in paintings centuries ago appeared just as she does, not with the soft and perfectly contoured bodies we see in paintings like Raphael's: she shows how artists transformed models through their imaginations.

Since Sherman herself is an artist, I infer that her exaggerated body, her stern look, her differences in appearance were done to convey the artist's point of view on Raphael and the "typical" female model Raphael painted.

Why is the baker's daughter being depicted nude?

I enjoy the viewpoint of the Sherman photo but I still like the original more.

The original by Raphael now appears to be more crude. I would never consent to pose nude, and the Sherman photo brought this fact to my attention. Did that young girl really want to be Raphael's mistress? Did she want to be naked for all time?

these queries, we may want to consult other sources in the literature of art history.

Research and Connoisseurship

What more would you like to learn about the artwork?

In tracing Sherman's work back to Raphael's, we discover that questions about the identity of both the sitter *and* the artist of the earlier work have been matters of ongoing debate. To examine these issues we require the help of more specialized interpreters. What can their scholarship add to our understanding of *La Fornarina?*

The detective work of attributing an unsigned painting or piece of sculpture to a given artist is a fascinating puzzle. The study of individual artists' distinctive styles, subjects, and techniques, for the purposes of evaluating, dating, challenging, or attributing authorship to unsigned or questionable works, is called *connoisseurship.*

We might think of connoisseurship as a more specialized and nuanced form of comparative analysis. This area of expertise draws on research and minute observation of concrete physical data. Even when bolstered by scientific tests like infrared and chemical analysis, connoisseurship relies on informed subjective judgment. To participate in the debate over *La Fornarina*, we would have to examine firsthand the painting that now hangs in the Palazzo Barberini in Rome. We would also need to place the work in the larger context of Raphael's career and have a working knowledge of the painting techniques of his contemporaries.

We can, however, examine some key evidence in the case. Reproductions in books and slides are pallid substitutes for actual encounters with the objects themselves, but they do enable us to study and establish links among artworks we may not have had the opportunity to see at close range. Scholars have traditionally assigned the painting of *La Fornarina* to Raphael for several reasons. You've already picked up one clue: the name Raphael Urbinas (Raphael of Urbino, the artist's birthplace), inscribed on the woman's arm bracelet, has been taken by some observers as evidence of Raphael's authorship.

Further clues linking the portrait to Raphael are found when we consult other paintings in this artist's *oeuvre*, or body of work. For example, the traditional attribution of *La Fornarina* to Raphael owes something to the sitter's resemblance to several madonnas painted by the artist. In addition, the woman's features and pose echo another, earlier portrait known to have been painted by Raphael, the *Donna Velata* (c. 1513? 1516?), or "veiled woman," shown on the following page (fig. 1.5).

From what you observe in these (admittedly poor) reproductions of the Raphael portraits (figs. 1.1 and 1.5), do you think the same woman posed for both pictures? And do you think the same hand painted both pictures?

In their monograph on Raphael (a monograph is a study of a single artist or subject), Roger Jones and Nicholas Penny (1983) attribute both the *Velata* and the *Fornarina* to Raphael. They infer from evidence such as the virtuoso handling of the gossamer tissue in the nude portrait and the opulent silken costume in the earlier portrait that both pictures are by the same hand, but they conclude from comparing the facial characteristics of the sitters that two different women are depicted.

On the other side of the debate, several art historians have concluded that *La Fornarina* is *not* by Raphael. These observers argue that the nude portrait seems rather hard-edged and steely-eyed in comparison with Raphael's other work. Some assign the painting to Raphael's pupil Giulio Romano. Giulio was Raphael's apprentice, and, after Raphael's death, his literal heir, completing the master's works and getting paid his commissions. Another art historian, Frederick Hartt, attributes the painting to a pupil of Giulio's, arguing that the picture has "the occasional brilliance of surface overlying an unpleasant lack of structure which is characteristic of the hand I believe to be Raffaellino dal Colle [i.e., Giulio Romano's own apprentice and heir]."

In a more recent monograph on Raphael (1999), Konrad Oberhuber perhaps helps us reconcile the opposing sides of the debate. He argues that the two portraits are indeed of different women, the *Velata* being more oval

What more would you like to learn about the artwork?

Is this a portrait for personal use?

If this is a historical figure, who is she and where is she from?

What makes this a famous painting?

How long did you have to stay in that position? Did you feel uncomfortable showing your body like this or honored that someone like Raphael chose to paint you?

Are the Raphael portraits of the same woman? By the same artist?

The ears are different.

Not the same woman.

The style of the baker's daughter is much harsher/harder than that of the Donna Velata.

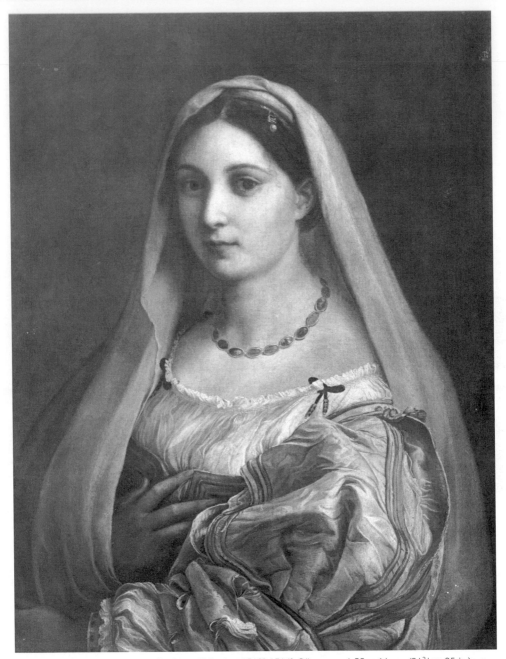

1.5 Raphael, *Portrait of a Woman (La Donna Velata)*, c. 1513? 1516? Oil on panel, 55 × 64 cm. (21³/4 × 25 in.). Galleria Palatina, Florence.

and delicate of feature. He notes the iconographic signif-
icance of the head covering of the *Donna Velata,* which in
sixteenth-century Rome was customarily worn by ma-
trons (that is, married women who had borne children),
and thus he reasons that this woman cannot be the mis-
tress of the later work. Oberhuber attributes the subtle,
light-infused treatment of the flesh of the neck, hands,
and torso to Raphael. But he suggests that the face, which
shows the harsher realism characteristic of Raphael's late
style, may in fact have been left unfinished at the artist's
death and subsequently completed by his apprentice
Giulio Romano.

 Even this brief discussion of *La Fornarina* suggests how
our interpretations of originals and copies, of genres and
iconographic signs, and of the criteria used to construct
the *canon*—the core list of "official" masterworks—are
subject to mutation over the years. For the purposes of
this last part of our discussion, I have wanted to empha-
size one of the reasons scholars have difficulty assigning
attributions, namely the common practice throughout
history of producing art in workshops or collectives.

 Mughal paintings like the one shown in Color Plate 1
were typically produced by artists working collabora-
tively in the royal studio. In the West, it was not uncom-
mon for artists such as Raphael, Rubens, and Ingres,
whose work was much in demand, to have apprentices
execute various parts of a painting, a tapestry, or a sculp-
ture. Sometimes, to satisfy the demands of their patrons,
workshops produced multiple copies of the same paint-
ings, with or without the participation of the master.
When pupils in a workshop execute portions of a paint-
ing or sculpture, or produce copies in the manner of the
master, who is the author of the work? Must a master-
piece be the exclusive work of a master?

 These questions have been prompted by Cindy Sher-
man's re-creation of *La Fornarina* for her series of *History
Portraits.* Sherman is one of numerous contemporary
artists, many of them women, who use photography and
the appropriation of famous images in the history of art
as a means of questioning traditional notions about male
authorship and the exclusivity of the art object. Sherman
has said that she favors photography as a medium whose

In his book *Mughal Minia-
tures* (1993), J. M. Rogers
writes:
"There are many paint-
ings of the periods of
Akbar and Jahāngīr that
exist in several copies
which are so close that
in order to determine
which is the originial and
which the copy we must
resort to circumstantial
evidence."

Here is Jean-Auguste-
Dominique Ingres, writing
in his journal about
Raphael:
"Today [August 1854], I
understand—if the divine
intelligence of Raphael
can be understood—how
Raphael could produce
so many works in paint-
ing, and I have reached
my idea through what I
have produced myself
here of late, with the
help of my two pupils,
who paint—so to speak
—as I do, executing the
material beauty of my
works under my continu-
ing direction while I, for
my part, do the finishing."

"images can be reproduced and seen anytime, anywhere, by anyone," and that her goal is an accessible art, "not one that you felt you had to read a book about" to understand.

On this last point, viewers of her work might disagree. True, Sherman's lush color photograph, with its saturated shadows and disturbing ambiguities, is, to my way of thinking (though not necessarily to my students'), a beautiful and provocative object in its own right. We don't need to "get" the allusion to Raphael to appreciate Sherman's witty confusion of nature and artifice. But consider how much more complex our responses to her work have become once we've seen the image in an art historical context.

In this chapter, you've employed the vocabulary and syntax of visual literacy, as well as some of the more specialized analytic methods of art history. Art history considers what an object looks like and why it moves us, when and how it was produced, where it is displayed, who is perceiving it, and how it is interpreted in the discourses of mass media, museum catalogs, classrooms, and scholarly journals.

Each of these questions will be taken up in the chapters to come. Chapter 2 provides you with a specialized vocabulary for describing and analyzing the visual elements that make up works of art. Chapter 3 examines the social and historical settings in which various works of art are produced; Chapter 4 analyzes the museum contexts in which these cultural artifacts are most commonly encountered in the West. In addition, each of these chapters focuses on a different writing assignment, from detailed descriptions to comparisons, contextual analyses, and position papers. Chapters 5 through 9 use a series of case studies of individual writers to show you how to develop these writing assignments into organized and persuasive essays, as well as how to locate and document outside sources for researched essays. Finally, Chapter 10 provides you with a casebook on critical methodology in art history by surveying the range of critical perspectives from which a single artwork can be interpreted.

As you've seen, the book addresses the connections between perception and analysis by using writing exercises as a mode of learning. You're encouraged to use your journal for class notes, essay ideas, sketches, and reactions to what you see and read. Chapter 2 invites you to take your journal along on your next museum visit.

WORKS CITED AND SUGGESTED READING

Asian Art: Patronage by Women in Islamic Art. New York: Oxford University Press and the Arthur M. Sackler Gallery, Smithsonian Institution: VI, no. 2 (Spring 1993).

Bal, Mieke. *Reading Rembrandt: Beyond the Word-Image Opposition.* Cambridge: Cambridge University Press, 1991.

Cohn, Marjorie B., and Susan L. Siegfried. *Works by J.-A.-D. Ingres in the Collection of the Fogg Art Museum.* Cambridge, Mass.: Harvard University Press, 1980.

D'Ambra, Eve. *Roman Art.* Cambridge: Cambridge University Press, 1998.

Danto, Arthur C. *Cindy Sherman: History Portraits.* New York: Rizzoli, 1991.

Hartt, Frederick. *Giulio Romano.* New Haven: Yale University Press, 1958.

Herder Symbol Dictionary: Symbols from Art, Archeology, Mythology, Literature and Religion. Trans. Boris Matthews. Wilmette: Chiron Publications, 1986.

Jones, Roger, and Nicholas Penny. *Raphael.* New Haven and London: Yale University Press, 1983.

Kimmelman, Michael. *Portraits: Talking with Artists at the Met, the Modern, the Louvre and Elsewhere.* New York: Random House, 1998.

Krauss, Rosalind, with an essay by Norman Bryson. *Cindy Sherman 1975–1993.* New York: Rizzoli, 1993.

Kristeva, Julia. *Desire in Language: A Semiotic Approach to Literature and Art.* Ed. Leon S. Roudiez. New York: Columbia University Press, 1980.

Oberhuber, Konrad. *Raphael: The Paintings.* Munich, London, and New York: Prestel Verlag, 1999.

Pach, Walter. *Ingres.* New York and London: Harper & Brothers, 1939.

Pope-Hennessy, John. *Raphael*. New York: New York
 University Press, 1970.
Rogers, J. M. *Mughal Miniatures*. New York: Thames and
 Hudson, 1993.
Rosenblum, Robert. *Jean-Auguste-Dominique Ingres*. New
 York: Harry N. Abrams, 1968.

"Intelligent Seeing"

Description and Analysis of Form

2

"Nothing that is seen is seen at once in its entirety."
—*from "The Optics of Euclid," trans. H. E. Burton*

"The picture is a series of blotches which are joined together and finally form the object, the finished piece, over which the eye may wander completely unhindered."
—*Pierre Bonnard, notebooks*

"It is the spectators who make the pictures."
—*from an interview with Marcel Duchamp*

"The only thing that is different from one time to another is what is seen and what is seen depends upon how everybody is doing everything."
—*Gertrude Stein,* Composition as Explanation

S eeing is a mental as well as a physical operation. Consider your impressions of *Dining Room Overlooking the Garden* by Pierre Bonnard (Color Plate 3). After examining the color reproduction for a moment, look away from it and try this experiment: make a rough sketch of the general outlines of the painting, to the best of your recollection. Now return to the reproduction: What patterns do you notice at second glance that you didn't see at first? What objects can you make out on further inspection?

Throughout his career, Bonnard experimented with this hide-and-seek interplay of perception and memory, of startling colors and hidden forms at the periphery of vision. It is the gradual process of perception—the way our eyes receive visual stimuli, which our brains then integrate into a meaningful whole—that allows the submerged figures and designs in Bonnard's painting to swim to the surface of the canvas and into the viewer's consciousness.

Because of the way our eyes are constructed, we can take in only a narrow range of visual data at one time; objects become fuzzier at the edges of the visual field.

Scientists tracking the eye movements of viewers have discovered that an observer's gaze roams constantly over an image, scanning and pausing at prominent features. The way we perceive a work of art depends not only on the physical facts of sight but on the artist's methods for directing the path and duration of our gaze.

Although vision is inevitably selective, we can learn how to attend more carefully to the visual information transmitted to us. Bonnard himself distinguished between *vision brute,* or crude vision, and the more sophisticated and rewarding viewership he termed *vision intelligente.* This chapter is designed to develop your skills of "intelligent seeing" by providing you with a glossary of terms for describing and analyzing the elements and design principles that go into the making of visual art. You'll discover that when you attempt to capture an image in a verbal description (or even to sketch the image, as in the foregoing exercise), you become a more receptive viewer because you have begun to appreciate the kinds of creative choices artists make. We'll be returning to Bonnard's *Dining Room Overlooking the Garden,* to consider what an understanding of form and composition contributes to our perceptions of the painting.

Naturally, there will be variations in what each viewer notices, infers, or emphasizes. What allows spectators and writers to explain their different points of view is a shared vocabulary of descriptors. Having learned to perceive and describe the visual elements, you are able, in a *formal analysis,* to analyze how the elements work together to achieve their effects. This is not to say that the appeal of a work of art is entirely attributable to matters of form and color: in Chapters 3 and 4 we'll examine contextual elements, as well, that contribute to the object's meaning and expressive power. But all essays on art require writers to provide a verifiable and coherent account of the object at hand.

Writing Assignment
Formal Analysis of a Work of Art

Select an artwork that appeals to you; as with any formal analysis, you should spend a good deal of time in front of the

work you choose. Describe the key visual characteristics of the object: the subject, forms, colors, and textures as well as their physical and psychological effects on you. (Remember that the surface of the artwork not only excites our tactile sense but records the artist's physical activity in making the object.) How are all these expressive components arranged into a composition? Do you see a balanced harmony of lines and shapes or an unstable arrangement of conflicting forces? The artist combines formal elements to record a particular perception of the world: What sensations and moods does he or she convey by these methods?

The objective of the following discussion is to define the elements and design principles of visual art by concentrating on how a single artist reworks these basic components over the course of a career. As it happened, a major retrospective of paintings by Pierre Bonnard (1867–1947), shown at the Tate Gallery in London and then at the Museum of Modern Art in New York, was attracting a good deal of attention in the media as I was putting this chapter together. Owing to its "blockbuster" appeal and its controversial claims for Bonnard as a revolutionary figure in modern art, the show generated passionate debate among the viewing public and in the press. The retrospective thus furnished numerous illustrations of the terms in which critics, artists, and other informed viewers describe, analyze, and argue over what they see.

In the following pages, each visual element will first be explained and then illustrated with examples from various commentaries on the Bonnard retrospective. By way of an experiment, I tape-recorded the conversation of three knowledgeable friends—a writer and two professional artists—as they toured the show in New York; portions of their transcribed conversation are quoted below. In the margins alongside the speakers' comments, I've reprinted excerpts from reviews of the exhibition by British and American art critics.

Under the time constraints of academic coursework, we sometimes lose sight of art as a living subject that provokes physical and emotional reactions as well as intellectual inquiry. The comments cited below are striking for

the obvious pleasure each observer derives from looking at and thinking about paintings. You'll note that the three speakers address (sometimes earnestly, sometimes comically) the same interpretive questions being debated by the critics quoted in the margins. Together, these interwoven strands of dialogue enact the dynamic process by which the borders of art history—indeed, of any scholarly field—are continually being surveyed and redrawn.

Below, the speakers (we'll call them A, B, and C) and reviewers discuss Bonnard's choice of subjects, his handling of *line, shape, color, value, texture, space, time, and movement*, and his methods of *composition*. Although the discussion focuses on painting, I've provided additional examples of works of sculpture and architecture to demonstrate how similar formal considerations apply regardless of medium. The questions that introduce each section are meant to serve as general guidelines for your written descriptions and formal analyses.

The Visual Elements

Line, Shape, Mass, and Volume

How does the artist use line to define shape and volume?

In two-dimensional or graphic art such as drawings, paintings, and prints, *lines* are the marks produced as the artist moves an implement—pencil, brush, engraving tool—across the picture surface. Lines inscribe the boundaries of two-dimensional *shapes*. Broken or faint *implied lines* suggest visual paths or connections between points in the composition. In three-dimensional works of sculpture and architecture, lines define the contours of actual forms in space. In describing the design of the rock garden at Ryoan-ji Temple (pictured in Color Plate 4), for instance, we would note how the jagged contours of the rocks emerge in relief against the straight horizontal lines of ground, wall, and viewing pavilion.

Various devices may be used in two-dimensional works of art to create the illusion of objects occupying three-dimensional space. Artists depict solid *form* or *mass*

(the two words are often used interchangeably to refer to three-dimensional physical bulk) and *volume* (*volume* is the space enclosed by mass) by means of overlapping lines, shading, and hatching or crosshatching (that is, areas darkened with clustered lines drawn in different directions). Shadows and half-shadows suggest an object's solid form by approximating the way light would hit its surface in actual space; the object's cast shadow, falling on the surface beneath or behind the object, reinforces the impression of volume.

Lines and shadows aren't simply illusionistic devices: they create drama and tension in works of art. If we extend our discussion of these visual elements a bit further, we can understand the viewers' reactions (on page 30) to the painting shown below in fig. 2.1.

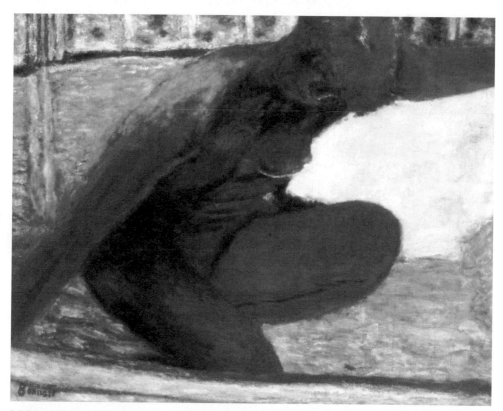

2.1 Pierre Bonnard, *Nude Crouching in the Bath*, 1940. Oil on canvas, 67 × 85 cm. (26³/8 × 33¹/2 in.). Private Collection.

A: (Pointing to several nudes, including the one pictured in fig. 2.1) Look at all these amputations!

C: I don't see it that way; I see only shapes and colors and textures on a canvas.

Linda Nochlin, *Art in America*, July 1998: "It is significant that Bonnard's work is at its most provocative best when he kills off or mutilates his subject: Marthe dismembered or floating in deathlike passivity is the heroine of his most exciting canvases."

A: Wait a minute! You see patterns of lines and shapes in the pictures, so why can't I see other patterns? What I see here is a repetition of certain kinds of motifs, like blurred faces and chopped-off arms and legs, that happen to involve naked women.

C: I just had this conversation with my niece last week, and I don't want to go into it again.

A: I'm not trying to be polemical; I'm just saying there's room for lots of interpretations here, and your particular interpretation revolves around pure shapes and colors. But these are representational paintings, not pure abstraction. The objects he depicts bear some resemblance to objects in the outside world, so I have to ask, "in what ways does he repeat, change, distort some of these forms?"

C: The way he crops the picture makes it dynamic. He's creating an implied pyramid shape: if you start at the left corner of the picture and follow the line of her arm right up to the chopped-off top of her head, that's one side of the pyramid. But there's a corresponding implied line that runs back down at the same angle from the top of her head, through the tip of her knee, to the lower right corner of the painting. That implied pyramid holds her in; if she weren't hooked on to the corners and the top of the composition, she'd tip over from the weight of that big unattached oval shape formed by her left leg.

 The effect is monumental, frozen, static movement—it's stopped movement, literally and pictorially speaking. See how those two dark horizontal lines of the tub, near the top and bottom of the canvas, squeeze her like a pair of barbecue tongs? She's good and wedged in, with all these pointy triangular shapes of negative space around her. There's this tension between containment and dynamism.

The observers are struck by—in art critic Peter Schjeldahl's word, "elated" by—the disjointed forms in the painting, however much they disagree on interpretation

of those elements. How does the artist achieve these provocative effects?

Let's start with the cropping or "amputation" effect. As Rudolph Arnheim explains in *Art and Visual Perception*, in order for a painter to create the spatial illusion of a nearer object partly blocking another object, the blocked unit should not only look incomplete but also evoke the viewer's sense of how that object would look if the whole were visible. Even in nonrepresentational art, viewers should be able to imagine that a form continues behind the overlapping form.

But when these forms don't seem to occupy different planes, or when the overlapping form cuts across a model's limbs at the joints, a sense of visual amputation rather than overlapping is the result. This is because the truncated shape looks complete in itself. In fig. 2.1, note how the line of the tub cuts off the right leg of the model at the knee. The left leg, bent under itself, melds calf and thigh into a large ovoid shape.

Yet Bonnard's truncated figure is somehow dynamic: even though the arms and legs are abruptly cut off, the forms are explosive. Why? And what keeps the disjointed parts coherent and unified? Bonnard's figure is an example of an *open form* in two-dimensional space. The jutting diagonals of the figure's arms seem to project outward into space and continue in either direction off the canvas. At the same time, the body is bent in on itself and contained by the thick horizontal lines of the tub, seen at the top left and bottom right of the composition. The impression is one of compressed energy and power, as the body torques to escape the confines of the tub and the edges of the picture.

By way of contrast, we can point to the *closed form* of the prone bather stretched out in the tub in fig. 2.6 (see page 39). Bonnard painted numerous versions of his wife Marthe using this compositional motif. Figure 2.2 shows two sketches Speaker C drew in her notebook as she was looking at Bonnard's series of "bather" paintings (artists call such quick sketches *croquis*). Her drawings emphasize the way Bonnard's floating figures are enveloped by the undulating outlines of the tub.

Peter Schjeldahl, review of MoMA show, *The Village Voice*, July 1998: "[Bonnard] could really handle pigment, but he didn't quite paint with it. . . . His pictures are incredibly devoid of compositional tension and tonal snap. . . . "One landscape in the show, *The Garden* (1936), and one naked Marthe, *Nude Crouching in the Bath* (1940) [fig. 2.1, on page 29], elated me. Each is daringly awkward, with disjointed parts that compete for attention and interpretation. These pictures challenge me to perceive the secrets of their coherence, because they do hang together somehow in my experience. I try and keep failing, but I don't get frustrated. Bonnard fights back! I feel that I am dealing with a passionately complicated person."

2.2 Marji Hooper, pencil sketches after Bonnard, 1998.

Closed forms in two- and three-dimensional artworks do not seem to interact with the space around them but rather appear self-contained, like the compact little Mayan figurine shown at left in fig. 2.3. Whereas the open form of the crouching nude in fig. 2.1 is pushed against and beyond the picture plane, the closed forms of the bathers in fig. 2.2 and fig. 2.6 seem remote and isolated.

In the foregoing examples, we've seen how Bonnard manipulates line and form for pictorial and expressive effects. Obviously, then, it would be simpleminded to conclude that when an artist takes liberties with line, form, and perspective, he or she does so out of ignorance or incompetence. In their discussion of a painting from very early in Bonnard's career (*Man and Woman*, fig. 2. 4), however, the speakers question the effectiveness of the artist's draftsmanship—that is, his use of drawn or painted line to depict form.

2.3 Dwarf Figurine Whistle with Bird Headdress, Mayan Lowlands, c. 600–900 C.E. Ceramic with red and white pigment, height 9.7 cm. (3⁷/8 in.). Los Angeles County Museum of Art, Gift of Constance McCormick Fearing.

B: An awful lot of artists would *not* like to have their earlier work shown—it doesn't matter whether they're musicians, or dancers. . . . Look at this painting (fig. 2.4). He's more a colorist than a draftsman. Her figure with the kittens works as a separate panel; but I think what he does with the male figure is just terrible draftsmanship. His drawing here is pinched; that's the best way I can describe it.

2.4 Pierre Bonnard, *Man and Woman*, 1900. Oil on canvas 115 × 72.5 cm. (45^1/4 × 28^1/2 in.).
Musée d'Orsay, Paris.

James Gardner, review of MoMA show, *National Review*, September 1998: "If one thing comes across at the Modern's retrospective, it is that Bonnard painted too much. . . . Seen together [the work] looks impressive and engaging, but it lacks that final and overwhelming sense of excellence that would be immediately evident if one were to reduce these hundred-odd images to two dozen."

Toward the end of his life Bonnard told a fellow painter, "There was a time when, under pressure from my dealers, I let them have canvases that I ought to have kept, either to do more work on, or to forget about and return to later. This is why a number of them—at least half—may need further work, or should even be destroyed."

A: What do you mean?

C: Here, I'll tell you what she means. [Pointing to male figure in *Man and Woman*]: His left leg has the same rippling line as that towel or sheet he's holding. Looks like he's holding both his leg *and* that sheet.

A: But what do you say to viewers who object, when looking at some abstract or distorted form in a work of art, "Oh, the artist didn't know how to draw"? Whereas everyone who defends the artist says, "Of course he means to do that; he's manipulating that form."

C: You have to ask, "To what purpose?" If he were really manipulating form in this painting, you'd say, he's using that rippling line for a reason. Like, for instance, in the "bathtub" pictures, he stretches and distorts the line of the tub to create a kind of envelope for the bather's body. But here it's just a wavy line.

In other words, as Bonnard himself suggests in the comment quoted at left, not all works in a retrospective are equally successful; each must be taken on its individual merits. Whatever opinions you formulate, you must back up your assertions with concrete evidence from the work before you—as when Speaker C answers A's question—"What do you mean?"—by pointing to specific details in the painting.

Color and Value

What colors are used, how are they juxtaposed, and where are areas of light and dark placed in the composition?

Even for modern-day viewers, Bonnard's unprecedented juxtapositions of color still deliver a powerful jolt. As our speakers and writers will be commenting on Bonnard's experiments with color in several canvases discussed below, we'll pause to examine the means by which colorists achieve their effects.

First, some basic terminology. If you have seen the rainbow cast by sun shining through a prism, you know that white light can be broken down into a spectrum of constituent pure colors or *hues*. From Isaac Newton onward, theorists have conceived of this spectrum as if it

were arranged around an imaginary wheel: the *primary colors* (red, yellow, and blue) are equally spaced around the circumference, and between them are the *secondary colors* (orange, green, and violet—each made by combining two primary colors: yellow + red = orange, yellow + blue = green, and blue + red = violet). *Intermediate colors* are made by mixing a primary and its neighboring secondary color (e.g., blue-violet). Neighbors on the wheel seem harmonious and are called *analogous* colors. Colors that lie opposite each other on the wheel are called *complementary* pairs (i.e., orange/blue, yellow/violet, red/green); these colors contrast dramatically when juxtaposed.

Now, if you've ever tried to match a blue sweater from memory, or found that the pale gray paint you loved in the store looks like bilious green on the walls of your bedroom, you understand that color perception is relative, not absolute or predictable as the traditional color wheel suggests. In his famous course (1963) on the interaction of colors, Josef Albers demonstrated that color is the most context-sensitive of the visual elements. By the same quirk of perception, two applications of the same color may appear quite different, and two different colors may appear alike, depending on how they are positioned relative to one another.

Value refers to light and dark in the context of visual art. When we speak of the values of a particular color, we refer to its lighter tints and darker shades, created when white or black is added to the hue. Again, value obviously depends on context: an area of color is lighter or darker relative to neighboring shades.

Artists experimented with color interaction throughout the nineteenth century. To take one notable example: Eugène Delacroix's painting of the *Women of Algiers* (1834), shown in Color Plate 8, demonstrates the way the complementaries of red and green balance and intensify one another (an observation that would be the central principle of M. E. Chevreul's theory of "simultaneous contrasts," published in France in 1839). Painters became increasingly preoccupied with rendering *perceptual color,* the optical sensations of color as they are perceived by viewers under a particular set of conditions, as opposed

to *local color*—that is, the color we expect an object to be in naturalistic representations.

In the latter half of the nineteenth century, artists began to free color from its representational function. Several technical innovations fostered this move toward abstraction of color and form. The manufacture of a wider range of synthetic pigments and the availability of premixed paint in tubes liberated artists from the studio, providing Impressionist painters with the means to work outdoors, to observe the fleeting atmospheric changes of sunlight and shadow.

Influenced, as well, by new "scientific" theories of color perception, Impressionists like Monet and Renoir recorded the way shadows are tinged with the reflected colors of adjacent highlights. During the 1880s, Georges Seurat and other post-Impressionists experimented with "divisionist" applications of separate dabs of pure color in attempts to achieve the optical illusion of blending. In the final decade of the century, a group of artists calling themselves the Nabis took their inspiration from the paintings of Paul Gauguin and from Japanese prints that had made their way to Paris. The Nabis, Bonnard chief among them, used sinuous lines and patterns of color to emphasize the flat, decorative surfaces of their pictures.

In his canvases from about 1912 on, Bonnard's colors become more daring in juxtaposition and intensity. (*Intensity*, or *saturation*, refers to the purity and brightness of the hue.) Bonnard characteristically contrasts vibrant complementaries of violet/yellow and blue/orange, often giving equal weight to each of the colors on his canvas. Nonnaturalistic or *arbitrary color* (sometimes called *subjective color*) frequently replaces perceptual and local color treatment as a vehicle for expressing mood.

In the following pages, our speakers and writers discuss the chromatic effects in several of Bonnard's paintings. They point to Bonnard's methods for distributing color around the composition, the saturation of his pigments, his optical effects, and his use of subjective color to create mood or movement in the painting. In addition, the two speakers who are artists ruefully note that a painter's use of pigment tells us something about the economics of artistic production.

A: What's your favorite in this room?

B: This one (fig. 2.5, on page 38), I think, because I like the drama in the construction of the painting. I like the angle of the leg. That one bright green slipper is wonderful. Usually Bonnard's color is distributed in dabs all over the canvas, but here he isolates his color in blocks, so your eye moves around the canvas with the color and with the diagonal of her leg. For me the composition has integrity. If I could just take that dog [a shapeless brown form at bottom left] out of there: it blocks the movement of the painting.

A: Boy, that blue just radiates, doesn't it? Saturated. It comes across as more violet in the reproduction from the catalogue.

B: That's got to be real lapis. You can't find it anymore unless you want to pay $155 a tube.

A: Lapis—ultramarine—that was the most expensive color for rich patrons in Italy during the Renaissance to order when they commissioned a painting: "Give me three things in lapis color." Bonnard must have been fairly comfortable at this point financially.

B: I sure can't afford it. Earth colors are cheap—but the cadmiums—I have one Missoni cadmium yellow, $33.95. I mete it out in tiny dabs.

(They proceed to a room hung with four paintings depicting Marthe, Bonnard's wife, immersed in her tub. One of these paintings is shown in fig. 2.6.)

A: I've only seen these in reproduction. Now that I see them grouped together, in person, I have to say they're fabulous. But I used to wonder: Why is he always looming over her in the bath?

C: Well, he didn't make her stay pickled in the tub the whole damn time! I read where he painted these decades later, from memory, when Marthe was in her fifties.
 The fascinating thing about painting clear water is the way it contains all the colors. I remember being knocked out years ago when I saw these pictures in art school because I'd seen nothing else like them—the flesh catching all the distortions and pastels from the water. That was what was so much fun about painting water, like a bunch of flowers in a clear glass vase. You could catch the color.

Two historical notes on color:
From David Bomford, *Pocket Guides Conservation of Paintings* (1997): "Pigments have been derived from a wide variety of sources—naturally occurring minerals (such as cinnabar, lapis lazuli, azurite, and malachite), organic plant and animal products (madders, carmines, Indian yellow) or synthetic manufacture by chemical processes (lead white, lead-tin yellow, prussian blue, and chrome or cadmium colours)."

From Michael Baxandall, *Painting and Experience in Fifteenth-Century Italy* (2nd ed. 1988): "After gold and silver, ultramarine [made from powdered lapis lazuli] was the most expensive and difficult colour the painter used. . . . The [fifteenth-century] painters and their public were alert to all this and the exotic and dangerous character of ultramarine was a means of accent that we, for whom dark blue is probably no more striking than scarlet or vermilion, are liable to miss."

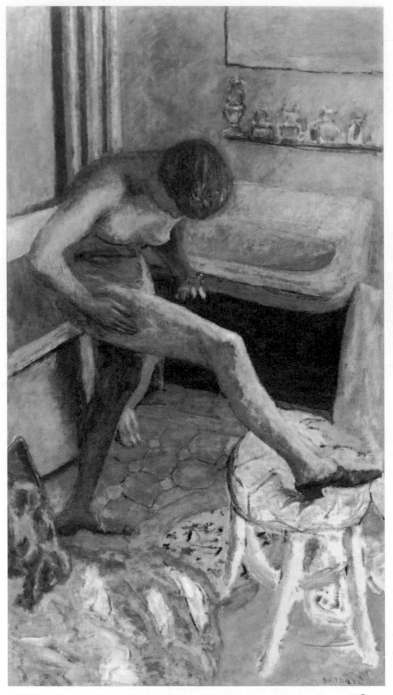

2.5 Pierre Bonnard, *Nude with Green Slipper*, 1927. Oil on canvas, 142 × 81 cm. (55⁷/₈ × 31⁷/₈ in.). Private collection.

2.6 Pierre Bonnard, *Nude in the Bath and Small Dog,* 1941–1946. Oil on canvas, 121.9 × 151.1 cm. (48 × 59¹/2 in.). The Carnegie Museum of Art, Pittsburgh. Acquired through the generosity of the Sarah Mellon Scaife family, 70.50.

B: Take your glasses off. Every once in a while it's useful to look at the work that way—just as blocks and juxtapositions of paint. Because we're talking brilliant colorist here. Nothing gets muddy, no matter how much pigment he spreads around a canvas.

Texture

How does the object appeal to the tactile as well as visual sense?

We're forbidden to touch the objects on display in museums; what makes us *want* to do so is the texture of the work. Artists manipulate the plastic properties of a given medium to imply the different textures of represented objects and to enliven the actual surface of an artwork. An architect uses, say, polished marble or porous limestone for the façade of a building; a sculptor scores the surface

Charles Molesworth, review of MoMA show, *Salmagundi,* Winter-Spring 1999): "Then there are the four late bathers, all paintings of Marthe lying in a tub. The psychobiographical temptation reasserts itself here—what can he be acting out about his three-decades-long relationship? Critics have spoken of the tub as a tomb, but also as a memorial or shrine. The lack of modeling in the limbs and torso does create a sense of mortality or spirituality. Much has been made of the fact

that Marthe died even as Bonnard was working on the last of the four paintings. But the colors are especially compelling: the patterned tiles on the bathroom floor in *Nude in the Bath and Small Dog* (1941–1946) go from pink-and-blue to yellow-and-blue as if there weren't nearly enough colors in the world to satisfy him. . . . The wife's body is treated as much like a landscape as it is a classical nude, all because its color scheme is so dangerously, yet effectively integrated into everything else."

Jed Perl, review of MoMA show, *The New Republic*, September 1998:
"Something in the directness of Bonnard's drawing allows us to see the woman in the tub not so much as a figure with weight and mass but as a shimmering imagination that wafts up and dematerializes into the glittering, Byzantine mosaic-rich array of the surrounding room. Marthe is of this world and out of this world, too. And Bonnard's ultra-personal paint handling—his dabs and smears and scumblings of pigment—tell us that he is right there with her, alive to every dip and turn of her mind."

of a mask with a chisel or leaves a thumbprint in wet terra-cotta. A painter applies pigment to a stuccoed wall, silk scroll, wood panel, or stretched canvas by means of various tools, motions, and consistencies of paint. When we consider the medium in which a painting or piece of sculpture is made, we note how the material's texture and color, as well as the marks of *facture* (the way the medium has been worked with tools) appeal to our tactile as well as visual sense.

Bonnard's paintings are noticeably textured, revealing the actions of the painter's brush, palette knife, and cloth dragged along the surface of the canvas. Bonnard builds up layers of paint, typically beginning with a turpentine-diluted overall wash of color and gradually adding pigment in heavy daubs or tentative brush strokes to arrive at the thick texture called *impasto*. He may also add depth and texture by *scumbling* the surface (a technique in which an opaque color is applied irregularly so that an underlayer of color is visible), or by allowing the unpainted supporting canvas to peep through.

The critic Jed Perl, quoted in the margin at left, underscores the significance of texture in Bonnard's painting of his wife Marthe in the *Nude in the Bath and Small Dog* (fig. 2.6). Even in our black-and-white reproduction, several layers of color are visible in each block of colored tile behind the tub (in this example, yellow is applied in thick horizontal brush strokes over violet, violet over red). Between the tinier squares of floor tile and the bathmat on which the dachshund sits, Bonnard has allowed bits of canvas to show. Besides adding depth and texture to the painting, these devices, as the reviewer notes, are traces or reminders of the physical presence of the painter.

Spatial Depth, Perspective, and Scale

How is spatial depth suggested (or negated)? How are figures and objects placed relative to one another in pictorial space?

Earlier in this chapter, our discussion of line and shape touched on artists' techniques for suggesting actual forms in space. At this point we need to examine the

broader assumptions behind systems of *perspective*, the formulas for depicting spatial depth in two-dimensional art. In Chapter 1 we observed how artistic conventions such as genres and iconographic programs are shaped by different cultural traditions. Nowhere are these differences more evident than in the solutions artists have found for the problem of depicting three-dimensional space.

In classical Chinese hanging scrolls, for example, a landscape may be viewed from *shifting perspectives*, or what an art theorist of the Sung dynasty called "the principle of viewing the part from the angle of totality." In *Through the Autumn Mountains with a Lute in Hand* (fig. 2.7), the artist, T'ang Yin, shows vistas within the same pictorial space that could be seen only if the viewer were to walk around the landscape. Moreover, the written verses, commentaries, and seals of successive generations of viewers have gradually become part of the depicted scene, seemingly suspended in the painted sky. Like these calligraphic notations, the hanging scroll is "read" from top to bottom.

In contrast, narrative handscrolls (in Japanese, *emaki*) are meant to be unfurled slowly from right to left so that the reader can follow the story line through alternating written texts and illustrations.

Notice the steep tilt of the ground plane in the twelfth-century illustration from *The Tale of Genji emaki* shown in fig. 2.8. The scene is viewed from above, as though we had removed the roof of the dwelling, and at an oblique angle. In *isometric perspective*, items are arranged

2.7 T'ang Yin (1440–1524), *Through the Autumn Mountains with a Lute in Hand*. Vertical silk scroll painting, 88.2 × 30 cm. (34³/₄ × 11⁴/₅ in.). Musée des Arts Asiatiques-Guimet, Paris.

2.8 "Bamboo River," from *Genji Monogatari Emaki*. Handscroll, Heian period (12th century). Ink and opaque pigments on paper. Tokugawa Art Museum, Nagoya.

along diagonal parallel lines that do not converge; distant objects are indicated not by diminishing size but by their placement higher up in the picture. In handscrolls like this one, the format, text, and perspectival system work together to suggest a ribbon of space moving past the viewer as the narrative unfurls.

In Western art from the fifteenth century onward, pictorial space tends to be oriented toward a single vantage point, that of an individual viewer occupying a fixed position at a given moment in time. The system of linear perspective is particularly suited to framed easel paintings, which became a favored and prestigious format in Western art during the fifteenth century, as wealthy private patrons began collecting paintings for their own homes. Framed pictures were conceived as individual works of art that could exist independently, apart from the larger decorative programs of religious and civic architecture.

According to conventions of *linear perspective* (codified as mathematical rules by the Florentine architect Leon Battista Alberti in 1435), parallel lines of vision recede at right or oblique angles to the picture plane and converge in a distant *vanishing point* (or several vanishing points) on the horizon line. Leonardo's perspective study (fig.

2.9 Leonardo da Vinci, Perspective study for *Adoration of the Magi*, c. 1481. Pen and ink on paper. Galleria degli Uffizi, Florence.

2.9) for his *Adoration of the Magi* shows how the artist draws guidelines leading from the corners of the picture to a central vanishing point on the horizon. Objects are then situated within this deep space by means of their comparative size, or *scale* (larger objects being read as nearer the viewer, with diminishing size indicating distance); and by *foreshortening,* the optical distortion of forms as they recede from the viewer.

In keeping with the other developments we've noted in European painting toward the end of the nineteenth century, Western artists began to break away from the conventions of illusionism and linear perspective. To take an example discussed earlier in this chapter, in Bonnard's painting of Marthe in her bath (fig. 2.6), the figure, wall, tub, and water are all made to reflect one another. Mosaics of iridescent color merge background and foreground. Space, color, and texture are imagined as subjective elements in an intensely private and self-contained world.

Similarly, the overall patterning of the composition of *Dining Room Overlooking the Garden* urges viewers to read across the picture plane as well as through it. Landscape is flattened, figures are abstracted and at times indeci-

pherable, and the table in the foreground tilts precariously, as though seen from above. Figure 2.10, below, shows what happens to the pictorial space when, a few years later, Bonnard sections off a corner of that table in the foreground.

2. 10 Pierre Bonnard, *Corner of a Table*, c. 1935. Oil on canvas, 67 × 63.5 cm. (26³/₈ × 25 in.). Musée National d'Art Moderne, Centre Georges Pompidou, Paris.

As you can see, in *Corner of a Table*, the artist has moved still farther from naturalistic spatial depth as a visual motif and closer to the abstraction of these forms as an arrangement of shapes, colors, and textures. Shapes are divorced from their representational functions as "chair" or "bowl" or "tablecloth." Cast shadows detach themselves from their objects, further loosening the objects' ties with three-dimensional space. Naturalistic scale and proportion are contradicted in the size of the table items relative to the tiny partial figure of the chair.

It does not take much imagination to make the connection between this painting's semiabstract forms and the pure abstractions of *nonobjective* art, where shapes, colors, and textures constitute the principal subject matter. This is the case in the richly patterned textiles pic-

tured in Color Plate 7 at the front of this book, as well as in paintings like the one Sonia Delaunay created to accompany a text written by Blaise Cendrars for a limited-edition book called *La Prose du Transsibérien et de la Petite Jehanne de France* (fig. 2.11). Delaunay's unfolding "simultaneous book" is based in part on the theory of "simultaneous contrasts" of complementary colors.

In Delaunay's painting there is no central focal point; rather, the design forms an allover pattern that seems to extend past the edges of the painting. The desire to overcome the limitations of the picture frame—and a fixed time frame—would give impetus to many art movements of the twentieth century, from abstract expressionism to conceptual art.

Time and Motion

How does the artist invoke the "fourth dimension" of time and motion?

Like the Chinese and Japanese scrolls we've looked at, Delaunay's book is meant, quite literally, to unfold in time. The elements of tempo and duration are essential components of our experience of visual art—most obviously, in forms such as cyberart, which the viewer scrolls on the computer screen—performance art, and video installations like Shirin Neshat's multimedia *Rapture* (see figs. 10.10 and 10.11), discussed at the end of Chapter 10.

Time and motion figure, too, in our experience of stationary three-dimensional art forms: consider the time it takes to walk the length of the viewing pavilion of Ryoan-ji or to circle a freestanding sculpture. In analyzing works of architecture, which are made to be functional as well as visually appealing, we take into account the way these structures organize social space and interaction. How do people move through the site? How are transitions effected from the façade to the interior of the building and from one room to another?

In more subtle ways, time is also a component of two-dimensional art. In a bas-relief from Lorenzo Ghiberti's doors for the Baptistery in Florence (fig. 2.12), the sculptor portrays several scenes from the biblical story of Isaac, all within a single frame. Ghiberti's treatment of

2.11 Sonia Delaunay, *La Prose du Transsibérien et de la Petite Jehanne de France*, c. 1913. Watercolor and printed text, 198 × 36 cm. (77 × 14 in.). Musée National d'Art Moderne, Centre Georges Pompidou, Paris.

2.12 Lorenzo Ghiberti, *Story of Isaac*, panel from the east doors of the Gates of Paradise, Baptistery of San Giovanni, Florence, 1425–52. Gilt bronze, 79.4 × 79.4 cm. (31 1/4 × 31 1/4 in.). Museo del'Opera del Duomo, Florence.

space illustrates Albertian linear perspective, which, as we know, is calculated from a stationary viewpoint; and yet different scenes, all involving the same characters, are represented in the same space. The pictorial space makes sense only when "read" as a continuous narrative connecting several moments in time.

In modernist art, we see something like this coexistence, within a single work, of different ways of reading time and space. Our further examination of *Dining Room Overlooking the Garden* will show how Bonnard creates competing "narrative" sequences of space and time with multifocal points of emphasis. To understand these methods, though, we need to grasp the basic principles of compositional design.

Principles of Design

As you've gathered from the preceding definitions, it's virtually impossible to speak of any one formal element in a work of art without thinking about the role it plays in conjunction with other elements within the overall design. *Composition,* whether in music, literature, or visual art, refers to the way the separate parts work together to form an ensemble.

Unity and Variety

What are the unifying features in the composition, and what variations do you perceive among repeated elements?

Repetitions or correspondences among families of shape and color give coherence to a composition. An artist organizes disparate formal elements with an eye toward the effect of the totality, but it is the variations each artist works on a unifying theme that create visual excitement.

Design can be seen as an orchestration of *positive* and *negative elements,* both of which are necessary to the over-all composition. The dominant shapes in a composition are referred to as the positive elements; spaces that are not occupied by positive elements are perceived as nega-tive space, or ground. In the composition of the garden at Ryoan-ji, for example, the bare expanses of the back wall and the pebbled ground surrounding the rocks are as cru-cial to the unity of the total design as the rocks themselves.

Two-dimensional art forms rely on the same play of negative and positive elements. Take the example of Bon-nard's *Corner of a Table* (fig. 2.10), in which the artist uses the unoccupied areas of the table to balance the positive elements of the items in the still life. If you look at the pic-ture as a combination of shapes and values rather than a representation of objects (and this is even easier to do with our black-and-white reproduction), you can see how negative areas with distinct boundaries function as balancing shapes in the design of the artwork.

Balance

How does the artist balance the visual elements within the composition?

We speak of compositions as being symmetrically or asymmetrically balanced, but even symmetry allows room for variation. As a rule, *symmetrically balanced* com-positions such as the carved Mende mask shown in Color Plate 6 function like bilateral symmetry in human ap-pearance: the two sides of any face or figure in general terms look virtually the same, but on closer inspection re-veal subtle differences.

Similarly, the interior scene of the *Last Judgment* in the Beaune altarpiece (Color Plate 5) comes close to symme-try without being identical on both sides of the composi-tion. The scene is divided vertically by the two large fig-ures aligned along its central axis. The groups of figures on either side of this visual fulcrum correspond closely, but do not exactly repeat one another, in arrangement, pose, clothing, and color scheme. The geometric stability of the composition (observe, for example, the implied

pyramid formed by the red-robed saints on either side of the painting and Christ at the apex and *focal point* of the design), and the harmony of its shapes and colors, reinforce the spiritual message of the Last Judgment, in which souls are weighed in the balance held by St. Michael. The minor variations or *elaborations* of the theme, as in a piece of liturgical music, heighten and sustain our attention.

In *asymmetrical balance*, the two halves of an image or object are obviously dissimilar but equal to each other in *visual weight* or importance. If we were to take a photograph of the frontal view of Ryoan-ji garden and fold it in half vertically, superimposing one half upon the other, we'd see that the shapes of the rocks on the two sides do not at all overlap. They are asymmetrically arranged, but balanced, because the halves manage to make equal claims on our visual interest.

An artist balances dissimilar elements by weighing the variables of size, complexity, and placement of forms. A few observations, stated simply, illustrate the general point: a larger form has more "weight" than a smaller form; a smaller but more complex form balances a large simple form; a small form near the edge of a frame balances a larger form at the center of the composition.

Scale and Proportion

How are represented objects proportioned relative to one another in pictorial space?

Let's go back for a moment to Bonnard's *Man and Woman* (fig. 2.4) for a rather crowded example of asymmetrical balance and manipulated scale. A dark vertical line (which seems to represent a folded screen) blatantly bisects the painting, emphasizing the problem of balancing panels of equal size.

The nearer, standing figure at right is disproportionately large and prominent relative to the figure seated on the bed at left. Yet the two sides of the painting have been made to equal each other in visual weight. In effect, Bonnard balances the distortion in scale by adding visual ballast to the left panel: he adds a large dark rectangle in the

top third of the panel and a complex vignette of kittens on the plaid blanket in the bottom third of the panel.

Rhythm, Movement, and Tension

How does the artist direct the viewer's gaze through the composition?

The movement of our gaze among pictorial elements in a stationary composition can be managed with any of the visual elements. Lines, for instance, may slash or undulate across a surface. Diagonal lines imply action as they slice through the calmer horizontal axis of a composition: hence the "drama" of the extended leg in the composition of *Nude with Green Slipper* (fig. 2.5). As we've noted, the diagonal sweep of the arms of the crouching bather in fig. 2.1 is similarly dynamic. Tension in the painting is created formally by the conflicting forces of the diagonal lines of the bather's body and the horizontal lines of the tub and water line that restrict the bather's movement.

Repeated shapes—circles, embedded squares, grids of shadow—create visual rhythms in works of art and architecture. In an early photograph of the Metropolitan Museum of Art on page 76 (fig. 3.8), for instance, you can see how the massive vertical accents of the paired columns punctuate the arches of the façade at regular intervals. The resulting alternation of light and shadow enlivens the symmetrical rigor of the architectural form.

Colors create movement, sometimes quite literally, through their placement and intensity. The "simultaneous contrast" of complementaries, for instance, produces the physical effect of faint afterimages that vibrate and follow the viewer's eye path. The afterimage of a given hue appears as its complementary color: if you stare at a patch of bright red for a few minutes and then turn your gaze to a white surface, a patch of green (actually, blue-green) will appear. Bonnard's vivid contrasts create an impression of movement that charges the surface of his paintings.

In the following discussion, the speakers consider at length how all these formal elements and design

principles come together in Bonnard's *Dining Room Over-looking the Garden*. You'll notice that a good deal of conversation is devoted to sorting out the rather confusing visual "facts" of the painting. This was Bonnard's visual game, the effect of which is to make viewers self-conscious about their own processes of perception.

The more important point is that we wouldn't take the trouble to play the perceptual or intellectual game if the painting didn't exert a sensuous pull that draws our gaze back and forth from the center to the periphery of the canvas. This is, after all, a static composition, based on a series of rectangles that suggest a receding series of shallow spatial planes: tabletop, wall and window, terrace, garden. The composition has no single focal point to attract our attention; how then does the artist pace the "narrative" of our exploration of the picture? Below, our viewers discuss the ways in which the spectator's vision is directed around the painting. As you read, note how the speakers call into play most of the concepts defined in this chapter.

C: That skinny figure on the left gets stuck to the pattern of the wallpaper, but that's interesting. She stays stuck, flattened, in the weird, shallow space he creates between the table and the wall. The compressed space works here. The still life on the table looks as though he organized it very carefully; he's usually not as manipulative as Matisse was with his tabletops. Here he moves you around the table beautifully.

A: How do you mean?

C: Do you see the fish, or whatever, in the basket on the right side of the table? He's carried out the little triangle and semicircle design in the basket and in the plate of rolls (or is it a plate of meat?) to the left. It's like a piece of music: you move along in rhythms—only it's light-hearted rhythm here, because the eye moves in circular patterns—because there are these small oval shapes all over the table. You move from the red beet shape to the glass on the orange plate, down to the blue circle at the top of the creamer, then to the orange circle in the middle. The rhythm keeps your eye on that table a long time, and that's nice. He uses the empty space at the lower right to balance the green block shape at the upper left of the table.

Everything has its own space on that table, and because of the shadow each object casts, the objects don't quite sit flat: they sit softly, cushioned by the shadows. He tips that table so far forward—see how those stripes of the cloth go straight down?—but the plate of rolls holds the tablecloth up, and that wonderful half cup he's painted on the bottom of the picture keeps the tablecloth from sliding right off the table. Put your finger over the cup, and you'll see how everything would slip off without it.

B: What my eye goes to right away is the balustrade separating the porch from the garden beyond it. The picture is divided structurally by the window frame, but also by the colors inside and outside the room. My eye moves from the warm oranges of the interior to the blues and greens of the garden. So there are a lot of avenues for moving through the painting.

C: So what *is* that thing on the right? At first I thought it was a puffy sleeve and an elbow, but it doesn't work as that: it's too big in relation to the other figure. The only other thing I can think of—that puffy thing could be a head of hair—a profile, with the nose—Oh, I know what it is: it's somebody carrying something toward the table.

A: I think it's a face. I think the blond figure is a ghostlike Renée [Bonnard's lover], and Marthe's way up in the foreground, hulking over the table, nudged out of the picture.

C: If that's her face, where is she sitting? On the floor? The scale doesn't make sense. Let's forget about what it is; let's think about what it *does* as form and color in the painting. You tell me.

A: The face comes as a surprise, like the hidden figure on the left. Compositionally, he makes the two women serve as bookends: both figures run up the sides, and the pointy nose of the face on the right balances the point of the chair on the left. Naturally, I read the two woman as marginalized in Bonnard's life and work! They're both flat, blurry afterthoughts. But if you take that face away, the painting needs something for balance.

C: Maybe, but it's awkward.

B: It's that distinctive hide-and-seek aspect of Bonnard's work. These women couldn't have been together often in

From Sara Whitfield's catalog essay for the show (1998): "The gap that exists between seeing an object and recognizing it comes across very strongly in the way certain objects in a Bonnard painting remain utterly mysterious. . . . One can only guess at the identity of the shape protruding into the picture from the right in *Dining Room Overlooking the Garden* . . . [while] the merging patches of brown and yellows in *Nude with Green Slipper* become coherent only after long and careful study."

Bonnard, late in life, on painting from memory: "I have all my subjects to hand. I go to see them. I take notes. Then I go home. And before painting, I reflect, I dream."

their lifetime. [The painting] shows how he imaginatively reconfigures visual memory. Something is unfolding, but it's in his head.

At the end of their tour, Speaker B concludes, "A lot of artists are waiting for their retrospectives. There are plenty of lesser-known artists to explore. This one's just been canonized. But you don't have to accept everything an artist produces—the healthiest thing we can do is look critically." Exactly so. The comments quoted in this chapter show how seeing and remembering—whether you're painting a picture or viewing it or writing about it—are essentially creative acts. The meaning of a text is never inscribed on its surface, no matter if the text is a novel, a painting, or a friend's casual remark. Meaning arises from your own informed encounter with the visual or verbal material before you. The most rewarding interactions are conversations rather than monologues. The more you are able to ask of an object, the more it discloses.

Using Description to Support a Thesis

How do the participants in the foregoing conversation go about making their points? Each viewer begins by noting something she finds interesting about the painting: this can be a comment about the artist's subject or technique, a supposition or inference about the work, or simply a statement of preference or dislike. Each then seeks to "prove" that judgment, inference or opinion—to convince her two companions of its validity—by citing relevant concrete observations about the painting. In other words, the speaker backs up an arguable assertion with the evidence of specific details. In doing so, the speaker progresses from *description* of the visual elements of the painting to *formal analysis*—that is, to a consideration of how these formal elements work together (or don't work together) as a whole.

Writing Formal Analyses

In written analysis, similarly, you marshal evidence to support your point of view. The strength of an interpre-

tation depends on the specificity and coherence of details cited in corroboration of the author's main idea. Just as artists organize a coherent composition from the disparate elements of form, color, and so on, writers unify the verbal composition through a controlling idea, or *thesis*. Your thesis is an arguable assertion, the main point you want to prove with evidence from your observations of the artwork.

The art-historical literature on Bonnard provides numerous analyses of *Dining Room Overlooking the Garden*. In each case, the author organizes description of various formal elements in the painting in defense of a thesis. The following three excerpts will suffice to demonstrate how art historians use the terms of formal analysis discussed in this chapter to support their views.

In his monograph on Bonnard (1994), Nicholas Watkins analyzes the painting as part of a group of three similar canvases Bonnard painted in the 1930s. For Watkins, Bonnard's primary concern is with a set of formal issues, worked out with the same elements from painting to painting. The thesis of the following passage is that in this series of pictures, Bonnard sought—and achieved—a *balance* of colors, forms, and themes: "[the] state of equilibrium or harmony which remained his ultimate goal":

> Bonnard moved on to the extraordinarily ambitious problem of balancing two themes, the laden table and the window view, a combination which achieved glorious fulfilment in three major paintings. . . . Although each began in the experience of a particular place, Bonnard pursued a set of pictorial issues from painting to painting: there is a definite feeling of development towards the abstract and the poetic. Marthe remains in all three as a moody presence merging with the background. In *La Salle à manger sur le jardin* [*Dining Room Overlooking the Garden*] she stares out with unseeing eyes, cup in hand; in *Salle à manger à la campagne* [*Dining Room in the Country*] (1934–5) she has been moved to the right of the window, leaving a phantomic form above the chair on the left; in *La Table devant la fenêtre* [*Table in Front of the Window*] (1934–5) she exists as a partial silhouette etched into the colour of the wall.

> *La Salle à manger sur le jardin* is the busiest and if any-
> thing the most realistic. The rigorous architectural divi-
> sion between the competing areas of the pale blue-and-
> white striped tablecloth in the interior and the view,
> flattened like a tapestry of yellow and green foliage in the
> window, is softened by the play of shadows dissolving
> form. A glowing orange takes over from deep red as the
> colour of interior warmth, establishing in the process the
> play between red and orange that runs as a chromatic
> theme through all three compositions . . . (176).

Commenting on the same painting in their catalog notes for a 1984 exhibition ("Bonnard: The Late Paintings"), Laure de Buzon-Vallet and Claude Laugier focus on the artist's radical flattening of form and perspective:

> Here, as in many of his interior compositions, Bonnard
> exploits the geometric solidity provided by the lines of
> the window frame, the railed balcony and the rectangular
> table. The tabletop slopes at a precipitous angle, a com-
> mon perspectival trick in Bonnard's work. "Bonnard
> turned compositions vertically . . . tilted tables toward the
> viewer," Fermigier wrote. Thus, the objects seem closer to
> the viewer, funneling him immediately into the room.
> As in his other interiors, the vanishing point is found
> beyond the edge of the painting. The outdoor setting [,]
> bathed in a warm autumn light, is greatly flattened be-
> cause of the sparseness of the scenery. "The view of the
> distance," said Bonnard, "is a flat view."
> In a corner of the painting, the barely perceptible out-
> line of a woman can be seen against a latticed back-
> ground. The vagueness of her presence is necessary, as
> Bonnard noted in one of his sketchbooks, because: "A fig-
> ure should be a part of the background against which it is
> placed." The peaceful, silent atmosphere of domestic life
> pervades the canvas (198).

In her catalog essay for the 1998 retrospective, co-curator Sarah Whitfield interprets the visual data of the painting against the background of Bonnard's biography, quoting a letter Bonnard wrote as evidence of the artist's psychological isolation at the time he was working on this canvas. ("For some time now," he wrote to his friend

George Besson, "I have been living a very secluded life as Marthe has become completely antisocial and I am obliged to avoid all contact with other people.") Reading the painting as a representation of Bonnard's isolation, Whitfield focuses on the window as the primary "subject" of the painting. Again, we have the same formal elements of the description—composition, color, line, and so on—this time configured by the author to emphasize what she sees as the psychological import of Bonnard's separation of interior and exterior views:

> *Dining Room Overlooking the Garden,* one of the masterpieces of the early 1930s, shows the interior of the Villa Castellamare, and the garden in front of the house which looks onto a large public park (the house and park are still there). In the light of Bonnard's letter to Besson, and his self-imposed isolation, it is perhaps worth taking a harder look at the main subject of this painting, which is the window. The viewpoint is that of someone standing in front of the table, gazing out into the garden, and once it is understood that it is the painter who has taken up that position, who is looking through the window and out across the green of the trees and the grass, the more the window appears as a glass barrier closing off the world outside, making secure everything that is inside. The idea of the window as an impenetrable opening is reinforced here by the solid wooden slats dividing the panes like bars, and the stone balustrade blocking the other side of the glass. The garden, tantalisingly out of reach, now seems as unattainable as ever, and its thunderous luminosity (very reminiscent of the light in Fragonard's landscapes) is heavy with suggestion, so much so that the painting seems as close as Bonnard gets to painting "not the thing itself," as Mallarmé said, "but the effect it produces." It does not take much imagination to see this work as a profound distillation of his recent isolation, as closely bound up with the painter's private life as *Man and Woman* had been thirty years earlier (27).

One could cite numerous other critical perspectives on the painting. For example, one writer uses research in the science of optics to interpret the work as Bonnard's exploration of the intricate processes of perception itself. Another art historian observes how the female figures

seem to fade into the background in many of Bonnard's paintings.

You'll find some interpretations more convincing or useful than others. In Chapter 10, we'll consider in detail the range of critical perspectives from which a work of art can be analyzed. For the purposes of the present discussion, I have simply wanted to show how works of art live in the perceptions of their viewers. W. H. Auden once observed that "a poem does not come to life until a reader makes his response to the words written by the poet." Bonnard wrote to his friend Matisse in the summer of 1940, "But as for vision, I see things differently every day, the sky, objects, everything changes continually, you can drown in it. But that's what brings life."

Taken together, the spoken and written comments in this chapter invite you to consider other observations and interpretations that might be offered. We know that formal matters of color and design account for only part of an artwork's power to move its viewers. In Chapter 3 we'll revisit four examples cited briefly in the course of this discussion—the garden at Ryoan-ji, the Beaune altarpiece, the Metropolitan Museum façade, and the Mende mask—to examine how each artwork functions in the social, spiritual, and economic life of a community.

As a preface to the following chapter, then, we might consider how Bonnard's framed paintings—portable objects meant for display—function as icons of social status and commodities of exchange. The question is prompted by the newspaper column quoted at left, which appeared around the time of the Bonnard retrospective at the Tate in London. After all, the "blockbuster" exhibition, a fairly recent phenomenon of museum culture, serves many purposes: it draws crowds and stimulates popular interest in the subject; generates revenue from giftshop tie-ins and catalog sales; provides material for critics and scholars; bolsters claims for the artist's canonical status; and boosts the market value of the artist's work as it is traded in the private sector.

The variety of viewpoints quoted in this discussion attests to the open-ended nature of analysis and the contribution each participant is able to make to the public discourse surrounding a work of art. All of which is to conclude:

From an article by Jonathan Jones on the mystery writer Lord Jeffrey Archer in *The Guardian*, September 1998:

"[Archer's] art collection is his pride and joy, exhibited in his penthouse overlooking the Tate Gallery, but it's the very opposite of avant-garde. David Lee, editor of *Art Review*, was given a tour by Lord Archer and left convinced he has no real taste. 'He talks about the paintings proprietorially,' says Lee. 'He says "This is my Bonnard, it's worth £4 million." It's hardly the approach you expect from someone of discrimination.' Along with the price-tagged Bonnard, Archer owns Impressionists, a Lowry and some political cartoons—in short, nothing that could be described as other than conservative."

Reviewing and Revising Impressions

Artists continually rework their compositions. So do writers, of course, as you'll observe in the "further thoughts" of the last two reviewers quoted in the margins at right. "Intelligent seeing" means reengaging works of art over a period of time, making subtle visual and intellectual adjustments in our perceptions. The process of revising written observations will be examined in detail in Chapter 7 of this book. For now, though, our three speakers have a few final words on revision:

B: Bonnard worked with a paintbrush in one hand and a rag in the other, continually reworking the paint. He was known to go into museums to touch up his work long after it had been hung.

C: Picasso hated him for that. He said the work was painted over until it looked like melting wax.

A: I heard a similar story about a writer who had a speaking engagement at a college and was found later in the college library crossing out and adding words in one of her own books. I guess you're never finished revising.

WORKS CITED AND SUGGESTED READING

Albers, Josef. *Interaction of Color.* 1963; rev. ed. New Haven and London: Yale University Press, 1975.

Andrews, Lew. *Story and Space in Renaissance Art: The Rebirth of Continuous Narrative.* Cambridge: Cambridge University Press, 1998.

Arnheim, Rudolph. *Art and Visual Perception: A Psychology of the Creative Eye.* 1954; rev. ed. Berkeley and Los Angeles: University of California Press, 1974.

Baxendall, Michael. *Painting and Experience in Fifteenth-Century Italy,* 2nd ed. Oxford and New York: Oxford University Press, 1988.

Bomford, David. *Pocket Guides Conservation of Paintings.* London: National Gallery Publications, 1997.

Fermigier, André. *Pierre Bonnard.* New York: Harry N. Abrams, 1969.

Fong, Wen C., and James C. Y. Watt. *Possessing the Past: Treasures from the National Palace Museum, Taipei.* New York: The Metropolitan Museum of Art; Taipei: National Palace Museum, 1995.

Linda Nochlin, *Art in America,* July 1998: "*Nude in the Bath and Small Dog* is as much a work of the constructive, formally aware and emotionally expressive painterly imagination as the best of Picasso's sensually distorted, coloristically inventive images of Marie-Thérèse or Matisse's most daring Odalisques.

"But wait! These are not my last words on Bonnard's bathers, apt as they might be for an elegiac grand finale. As a woman and a feminist, I must say I find something distasteful, painful, even, about all that mushy, passive flesh. Yes, I am being naive abandoning my art-historical objectivity, but certainly contradictory intuitions have a place in one's reactions to the work of art."

Author in E-mail to Charles Molesworth, June 2000: "Re: your review in *Salmagundi* [see pages 39–40]: Can you clarify what you meant when you wrote that the color scheme of *Nude in the Bath and Small Dog* is 'so dangerously, yet effectively integrated into everything else'? Any second thoughts?"

Charles Molesworth in E-mail reply to author, June 2000: "What I remember most from the Bonnard show is how changed I had become as a viewer. When I was younger—around 17 years old or so—he was far and away my favorite painter. I thought of his work

58 Elements of Visual Analysis

(though I would not have had this language then) as 'painting itself.' From what little I had gleaned of art history, I saw that riot of color, that juxta-position of the outside vista with a door or win-dow frame, etc., as the culmination of things: color 'over' (triumphantly over) line, volume, or shape, or rather, color as line/volume/shape.... Eventually I went back to Bonnard, nowhere so happily (and haply) as at the MoMA show, and dis-covered that indeed there was a lot that I still admired, though the swoon factor had faded rather badly. So Bonnard is for me an object les-son or cautionary tale about infatuation with formal problems. Call it age, call it jadedness, call it "post"-ness, I can no longer quite put my total faith in formal problems and their resolution.... Drunk on form, I still want more, either to sober me up before the world returns, or to take me past form, to what? Wisdom? Truth? The inef-fable? ...

"Some of this *may* be behind my rather puz-zling use of the adverb in 'dangerously integrated.'"

Gombrich, E. H. *Shadows: The Depiction of Cast Shadows in Western Art.* London: National Gallery, 1995.

Kemp, Martin. *The Science of Art: Optical Themes in Western Art from Brunelleschi to Seurat.* New Haven and London: Yale University Press, 1990.

Newman, Sasha, ed. *Bonnard: The Late Paintings.* Exhibition catalog. Paris: Centre Georges Pompidou; Washington: Phillips Collection, 1984.

Okudaira, Hideo. *Arts of Japan 5: Narrative Picture Scrolls.* Trans. Elizabeth ten Grotenhuis. New York and Tokyo: Weatherhill/Shibundo, 1973.

Ocvirk, Otto G., et al. *Art Fundamentals: Theory and Practice.* Boston: McGraw-Hill, 1998.

Sullivan, Michael. *The Arts of China,* 3rd ed. Berkeley and Los Angeles: University of California Press, 1984.

Terrasse, Antoine, ed. *Bonnard/Matisse: Letters between Friends.* Trans. Richard Howard. New York: Harry N. Abrams, 1992.

Watkins, Nicholas. *Bonnard.* London: Phaidon, 1994.

Whitfield, Sarah, and John Elderfield. *Bonnard.* Exhibition catalog. London: Tate Gallery; New York: Harry N. Abrams, 1998.

On Site

Art and Architecture in Social Contexts

<div style="text-align: right">3</div>

"What conditions are necessary for the creation of works of art?"
—*Virginia Woolf,* A Room of One's Own

"The fact that our experience of the world is bound to language does not imply an exclusiveness of perspectives. If, by entering foreign language-worlds, we overcome the prejudices and limitations of our previous experience of the world, this does not mean that we leave and negate our own world. Like travelers we return home with new experiences."
—*Hans-Georg Gadamer,* Truth and Method

"The uninitiated sees nothing"
—*Mende saying*

T he twentieth-century European paintings we've just examined in Chapter 2 were made expressly for display and contemplation. This is a peculiarly Western concept of art, and a fairly recent one at that. Until the nineteenth century, when the modern museum began to evolve, most works of art were made in the service of social, religious, or political rituals rather than for aesthetic pleasure alone. In books, galleries, and auction houses, these objects have been plucked out of their social lives and set down in the Western context of art history. Yet each object has a distinct biography, comprising its origins and uses, along with its owners, viewers, or worshipers. The expressive power of an artwork is more keenly felt and understood when its formal characteristics are seen within the context of the setting in which the object was produced.

The present discussion should be read as a continuation of the preceding chapter. We'll be revisiting four works of art mentioned briefly in Chapter 2: the rock garden at Ryoan-ji in Japan, the altarpiece of the Hospices de Beaune in France, the architectural layout and entrance façade of the Metropolitan Museum of Art in New York, and the Mende mask from West Africa. Our previous discussion touched on the formal elements of these

artworks. This time, our objective is to compose a kind of cultural biography for each work, so that we can see more clearly the ways in which the object's form, setting, iconography, and function are interwoven.

⬛ Writing Assignment
Contextual Analysis of a Work of Art

Choose a work of art you'd like to write about and describe it briefly, according to the elements of form and design discussed in Chapter 2 (medium, composition, treatment of space, use of light and color, texture, and so on). Then consider the social and historical circumstances in which the work was created by asking yourself the following questions:

- *Where is the artwork meant to be seen? How does the setting affect our perceptions of the work? Has the **site** been incorporated into the composition?*
- *What **subject matter** does the work depict, and for what **purpose** was it designed?*
- *How does the work reflect the **historical era** (or eras) in which it was produced?*
- *What roles do **patrons, performers, and audience** play in the creation of the work?*

The four case studies in this chapter focus on the questions posed in the writing assignment above. In the margins, a series of specific writing topics encourages you to use the case studies as guides for your own exploration of the contexts in which works of art and architecture are made and used, starting with your observations of objects encountered in everyday life. At the end of the chapter, bibliographies for the case studies show the range of materials that can be used to investigate contextual questions. (For a detailed discussion of research methodology, please see Chapter 9 of this book.)

The point of contextual analysis is not to recover a single "essential" or "original" set of meanings and viewing patterns of another time or place. Simply put, we can't. We've already seen in the first two chapters of this book that spectators are a heterogeneous lot: the original audience for a work of art doesn't necessarily agree on mat-

ters of interpretation and evaluation. And if contemporary viewers from the same cultural background differ in how they read artworks, surely the ambiguities multiply when a modern viewer looks at art of the past, or when an outsider attempts cultural interpretation. As recent studies in anthropology remind us, we can't help seeing through the lens of our own cultural predispositions.

But distance needn't be a barrier to understanding. The theorist Hans-Georg Gadamer explains, "To think historically always involves mediating between those ideas [of the past] and one's own thinking. . . . To interpret means precisely to bring one's own preconceptions into play so that the text's meaning can really be made to speak for us." (1994:397) Understanding arises from what Gadamer calls a "fusion of horizons": we explore foreign territory and translate unfamiliar concepts while acknowledging the distinctive cultural sensibility we bring along with us in our travels. An image—whether a fifteenth-century altarpiece or a Zen garden—speaks eloquently to modern-day viewers, provided that we take the time to learn the visual vocabulary and grammar of its distinctive "foreign language-world." In studying the history of world art, we gain access to a range of visual languages as well as methods for interpreting these cultural codes.

Case Study: Questions of Context
Site as Context: The Rock Garden at Ryoan-ji

Where is the artwork meant to be seen? How is the *site* incorporated into the composition of the work?

Photographs of the rock garden at Ryoan-ji Temple in Kyoto, Japan (fig. 3.1; Color Plate 4) are routinely included in art history surveys. On the basis of a photograph alone, you might wonder how this stark architectural landscape became so celebrated. Consisting of fifteen irregularly shaped rocks arranged in five low-lying clusters on a bed of raked gravel, the garden is bound by a low earthen wall that is overhung with several rows of tile. A sort of anti-garden, this: no trees, flowers, water, grass—no living thing, apart from narrow strips of moss surrounding the base of the rocks and bits of lichen that

Writing Topic 1

We often overlook the art on display locally, all around us. Pick a piece of public art in your neighborhood or on your college campus—a freestanding sculpture or statue, a carved frieze on a municipal building, a mural, a formally landscaped section of the park, a wall decorated by local schoolkids or graffiti artists—and write an essay about it that incorporates these elements: a brief introduction that indicates why this object interests you; a detailed description of the object, with a consideration of how it fits (or doesn't fit) into its surroundings; and interviews with local residents and passersby regarding their responses to the object. How do viewers interact with the work? How does the work function in the community?

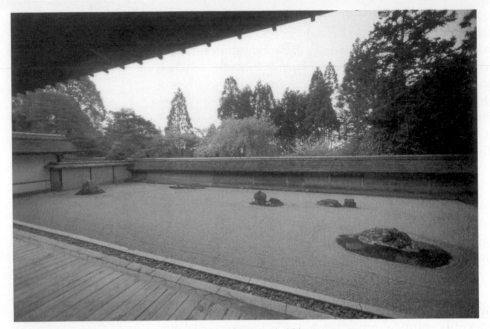

3.1 Ryoan-ji Temple and garden, Kyoto, Japan. Late 15th to early 16th century.

have attached themselves to the rough surfaces. Limited to these simple elements, the eye seeks out subtle variations in color: the ochre wall darkened in spots where oil has seeped through the clay mixture; silvery-green moss; gray tiles.

One's first impression on visiting Ryoan-ji is that the garden is surprisingly modest in scale. The rectangle measures around 30 feet by 70 feet, roughly the dimensions of a tennis court or a large exhibition space in a museum. Although an eigthteenth-century woodcut shows that guests were once permitted to stroll in the garden, present-day visitors are confined to a viewing pavilion that tracks along one side of the field, so that it is impossible to view the garden from other perspectives. The result is an oddly two-dimensional experience of a three-dimensional work. Why then do we say that this work of art, like so many sculptural pieces, needs to be experienced firsthand, on the site for which it was designed?

Put the question this way: If these rocks in their shallow gravel-bed were somehow transported to a museum setting (I'm thinking of the reconstituted Japanese tea-

house I used to visit in the Philadelphia Museum of Art when I was a child), what would be lost? Let's look again at fig. 3.1, this time attending to the frame, which is sometimes overlooked and occasionally omitted from photographs of the site. The garden is edged with several borders, like the design of a Persian rug: a stone coping and a narrow trough of loose gray pebbles, a row of brickwork, and the weathered planks of the viewing pavilion. In the background is the mottled wall, beyond which is glimpsed a partial "borrowed landscape" of treetops that leaf and flower in the spring. Completing the frame is the tiled roof of the low-eaved building giving out onto the garden. This subtemple was moved to the site to replace a temple destroyed by fire in the late eighteenth century.

What is to be gained by seeing the garden as part of a larger composition that incorporates its surroundings? To begin with, a dry rock garden enclosed by a frame but open to the elements expresses in its form a tension between stability and flux. By way of illustration, let me offer two informal snapshots of the garden. My first trip to Ryoan-ji was in late summer, in bright light, in the company of dozens of tour groups scuttling along the viewing ledge. My second visit fell on a drizzly, shadowless, colorless day in January of the following year, when only a few hushed visitors were present. Both views make up my picture of the garden. Its timeless design is set against the particularities of seasonal change and local incident.

We can also see how the rigorous right angles of the broader composition throw into relief the irregular forms of the rocks and their concentric swirls of raked gravel. That is to say, the garden's visual impact owes a good deal to the stark *Shoin* style characteristic of Japanese temple architecture during the Muromachi era (c. 1330– c. 1570). In his essay "In Praise of Shadows" (1977), the novelist Jun'ichiro Tanizaki contrasts two kinds of religious structures, the Japanese Zen temple and the Gothic cathedral:

> I understand that in the Gothic cathedral of the West, the roof is thrust up and up so as to place its pinnacle as high in the heavens as possible—and that herein is thought to lie its special beauty. In the temples of Japan, on the other hand, a roof of heavy tiles is first laid out, and in the deep,

spacious shadows created by the eaves the rest of the
structure is built. (17)

The temple's *Shoin* style, an example of the post-and-
lintel system of building, uses a series of upright posts to
support horizontal beams or lintels and a low-lying
hipped tile roof. In contrast to the vertical thrust of the
vaulted ceilings and pointed arches of the Gothic style,
the *Shoin* style emphasizes horizontal planes, straight
lines, right angles, and simplicity of materials to the point
of austerity. Interior space is divided by movable screens.
The overall effect is one of elemental order, calm, har-
mony, and pure geometry shorn of surface ornamen-
tation.

Small-scale dry landscapes called *karen-sansui* (singu-
lar: *kare-sansui*) were conceived during the Muromachi
era as attachments to the abbot's quarters, or *hojo*, of the
Zen temple complex. Translucent sliding screens defined
the exterior wall, so that the garden became an extension
of the interior space, as you can see from the ground plan
of the Ryoan-ji *hojo* (fig. 3.2).

The concept of a walled garden as a spiritual precinct
is not unique to Zen Buddhism. We see versions of it in
Christian images of the *hortus conclusus* (a sheltered gar-
den symbolic of the Virgin's Immaculate Conception) as
well as in the lush gardens of mosques, which are meant
to prefigure the gardens of paradise described in the
Qu'ran. What was unprecedented in the *kare-sansui* was
the idea of a landscape consisting simply of stones set in
a perfectly flat plot of ground, designed to be seen from
fixed vantage points. The *kare-sansui* expresses the dis-
tinctive aesthetic and spiritual aim of Zen meditation, a
form of Buddhism brought from China by Japanese
monks. Zen meditation strives for enlightenment that
comes from within oneself; the point of meditation is not
to engage in contemplation of the outer world but to di-
rect the flow of energies inward. A "landscape" stripped
to its barest essentials expresses the Zen aesthetic of sim-
plicity and emptiness: the profound beauty and signifi-
cance of empty space.

Over the centuries, various allegorical explanations
have been offered for the configuration of rocks at

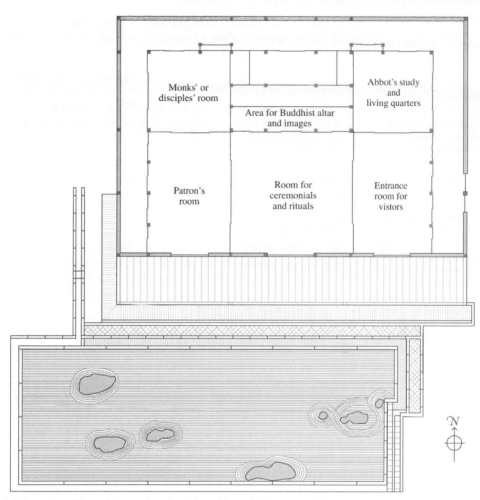

3.2 Floor plan of Ryoan-ji *hojo* and garden (adapted from Onishi, et al., 1993).

Ryoan-ji—for instance, a mother tiger protecting her cubs, or five islands floating in an inland sea. But these narratives strike one as limiting and somehow beside the point. The visual force of the garden derives from the way asymmetrical abstractions take on heft and balance when placed in this precise and mysterious relation to one another. So it's tempting to say, along with some ob-servers, that the garden is pure form emptied of worldly representation, a quality that the Zen scholar Shin'ichi Hisamatsu characterizes as "freedom from attachment," and to leave it at that.

Writing Topic 2

Sketch a rough floor plan of your house or apartment. Then interpret the floor plan by decoding the "language" of the space. What can we learn about the identities, interests, and concerns of the inhabitants? Does the space define any separation according to age or gender? How is public versus private space demarcated? How has the original plan been modified by the inhabitants to fit their changing needs? For example, has the living room become a vestigial organ—something that evolution has rendered unnecessary, like the appendix in the human body? Has the dining room been turned into another bedroom or a study?

And yet, surely it is significant that the setting of Ryoan-ji keeps the world continually before us. In subtle ways, the design of the enclosed garden communicates its relationship to the outside world, beginning with the changing landscape glimpsed above its low earthen wall. In his study of Japanese gardens (1993), Günter Nitschke reminds us that before the dense growth of trees blocked the view, visitors to the Ryoan-ji *hojo* would have seen farther into the landscape beyond the garden (90). Returning to the floor plan of the six-room *hojo*, we can see how the garden serves worldly as well as spiritual purposes. You'll notice that the Buddhist altar is tucked away in the room farthest from the garden; the three rooms that face the garden (entrance, ceremonial, and patron's rooms) are intended for the reception of visitors.

Hiroshi Onishi (1993) points out that although the garden suggests an idealized universe of spirit, the monks of Ryoan-ji never really retired from the public theater. Under the patronage of the samurai class of military leaders, the monastery received financial support and physical protection from the civil wars that raged outside the garden walls. In return, the monks supported their patrons' political authority by serving as diplomats and advisors (32–35). Thus Ryoan-ji was able to grow as a great cultural center and gathering place during the late fifteenth and sixteenth centuries, a period plagued by internal conflict in Japan.

The studied calm and timelessness of the monastery garden take on greater nuance and tension when viewed against the political turbulence and social flux of the era in which Ryoan-ji flourished. Seen within its wider physical and cultural setting, the garden represents not so much a turning away from temporal concerns as a kind of mediating space between social and spiritual spheres.

Subject Matter, Function, and Form:
The Beaune Altarpiece

What *subject matter* does the work depict, and for what *purpose* was the object designed?

Like the fifteenth-century garden at Ryoan-ji, the fifteenth-century artifact known as the Beaune altarpiece (fig. 3.3 and Color Plate 5) has become part of the art history

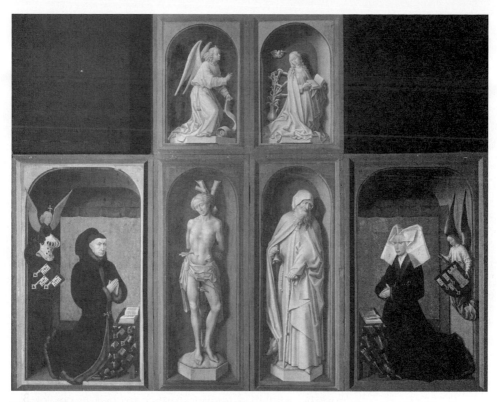

3.3 Rogier van der Weyden. Reverse panels of the altarpiece of *The Last Judgment* from the Hôtel-Dieu, Beaune, France. c. 1443–1448. This view of the exterior of the altarpiece is how the multipaneled work originally appeared in its closed state.

canon. This *polyptych,* or multipaneled work, was executed in oil paint on wood by the Belgian artist Rogier van der Weyden and members of his workshop sometime between 1443 and 1448. The painting was commissioned by Chancellor Nicolas Rolin and his wife, Guigone de Salins, to serve as an altarpiece, or retable, for the chapel of the Hôtel-Dieu, the hospital they established for the poor in the Burgundian city of Beaune.

The exterior panels of the altarpiece (fig. 3.3), painted in relatively subdued tones, show the donors, Rolin and Salins, kneeling in prayer. Between and above them are four panels painted in *grisaille,* the gray shades used by painters to mimic carved statuary. Two "statues" of saints are displayed in illusionistic painted niches. These figures represent St. Sebastian and St. Anthony, the first patron saint of the hospital. Above them the artist has depicted the Annunciation, a scene often painted on the

Writing Topic 3

Find examples of various kinds of sacred icons for religions whose art you have studied. For instance, you might choose a sculptural relief of a Greek deity, a painting of Buddha, a statue of Krishna, or a tapestry showing the Virgin Mary. Write clear descriptions for two of these examples of the "sacred body," and discuss how each embodies the major ideas of that religion.

Alternatively, analyze two objects or images, such as official portraits, that have been made to represent the idea of political or social power.

exteriors of fifteenth-century altarpieces. This is the scene in which the angel Gabriel appears to the Virgin Mary to announce that she will give birth to Christ.

If you turn now to Color Plate 5 at the front of this book, you will see the interior of Rogier van der Weyden's altarpiece. This is the *open state* of the altarpiece, or what fifteenth-century viewers would have seen when the hinged exterior panels were unfolded.

The interior painting of the *Last Judgment* shows the disposition of the dead before the resurrected Christ. Stripped of earthly possessions, the naked souls are weighed on the scales of the Archangel Michael and judged by Christ, who is enthroned on a rainbow at the apex of the composition. The blessed souls at the right hand of Christ (this is the left panel facing the viewer), clasp their hands and file through the delicate Gothic spires of the entrance to paradise. The damned, at the left hand of Christ (the right panel) writhe and claw one another in the dim caves of hell.

Unlike many religious artifacts that have been transported to museums, the Beaune altarpiece has remained on the premises for which it was commissioned. It can now be seen in a temperature-controlled annex of the Hôtel-Dieu, just a few rooms away from the chapel of the Great Hall, its original site. The present-day experience of viewing the radiant painting in the cool dark museum annex is wonderfully dramatic: a guard stationed at the doorway moves a large magnifying glass by remote control along the spotlighted panels, pausing to focus on pertinent features of the tableau.

The museum display offers certain practical advantages. The interior and exterior panels of the altarpiece, having been sawn apart by restorers in the nineteenth century, can now be seen simultaneously on adjacent walls; obviously this would not be possible if the altarpiece were in its original state, as repeated opening and closing of the shutterlike wings would place undue stress on their wooden frame.

Modern viewers, positioned behind a guardrail a few yards from the painting, can now study minute painterly effects through the magnifier that would be invisible at a greater distance—the sheen of pearls, let's say, on

St. Michael's brooch, or the stiff nap of his cut-velvet robe. At close range, written inscriptions from the New Testament emerge from the composition in the form of *banderoles,* or ribbons of sacred speech, with which medieval artists sometimes annotated their paintings to convey specific doctrinal messages. The Latin inscriptions on either side of Christ are taken from verses in the book of Matthew: Christ welcomes the blessed into the kingdom of heaven and condemns the cursed to everlasting fire.

The painting was originally meant to be placed on the high altar of the chapel at one end of the long rectangular Great Hall, so it could scarcely have been seen in the kind of detail we've just noted. Although contemporary viewers of the painting would have recognized the general iconographic program of the biblical subject, some of the painting's meanings would have had to be communicated in other ways. Modern-day viewers must keep in mind that hinged altarpieces were designed to operate sculpturally, in three dimensions (four, including the time and motion it took to unfold the panels), their shape and appearance transformed through performance. Once we are able to imagine the object as it might have appeared to its fifteenth-century viewers, we gain insight into the ways in which its iconography, function, form, and setting worked together.

The Great Hall of the Hôtel-Dieu today looks very much as it did in the fifteenth century, a vast room lined with brightly canopied four-poster beds. The vaulted ceiling, with its elaborately painted wooden beams, reaches a height of 52 feet. By the standards of any historical period, this is a remarkably airy and lavishly appointed sickroom. To the poverty-stricken inmates of the Great Hall infirmary (also called the Salon des Pauvres, or Charity Ward), even bundled two to a bed, it must have seemed a miraculous refuge.

Chancellor Rolin specified that the infirmary be spatially continuous with the chapel so that Rogier's altarpiece would be visible to all the inhabitants of the Great Hall, including those too ill to approach the altar (Hayum, 1989:28). In this setting, the altarpiece performed several functions. Closed, it provided the backdrop for the daily ceremony of the Catholic Mass,

during which, according to the Catholic doctrine of the Eucharist, the consecrated wafer and wine are transformed into the physical body and blood of Christ. The two patrons who commissioned the altarpiece played an important part in the visual program. As praying donors on the exterior of the altarpiece, Rolin and Salins served as stand-ins for the invalids who wished to participate in the sacrament of the Mass.

At the same time, the donor portraits reminded indigent patients of their indebtedness to their benefactors. Here then was a more subtle performative function of the altarpiece. Nicolas Rolin rose from bourgeois beginnings to amass great wealth and political power in the service of the dukes of Burgundy. He was said to have built his hospital for the poor to atone for his many sins—in the words of the hospital's foundation charter, "to exchange for celestial goods temporal ones" (quoted in Harbison, 1991:109). In a way, Chancellor Rolin was attempting to tip the scales in his favor in the afterlife.

The altarpiece remained closed most of the week; it was opened up only on Sundays and feast days. On these occasions the extraordinary panorama of the *Last Judgment*, brilliantly colorful and detailed, slowly unfolded. Having considered the functions of the altarpiece, we can return to Color Plate 5 to see more clearly how its form conveyed spiritual lessons to the patients in the Great Hall.

In Chapter 2, we pointed to Rogier van der Weyden's painting as an example of virtually symmetrical balance. Horizontally, the composition sharply separates the world of mortals below from the celestial zone occupied by apostles and saints. The strong vertical line down the center of the composition, formed by the figures of Christ and St. Michael, balances the alternatives of heaven on the left side of the painting and hell on the right. The *Last Judgment* laid out the opposing prospects of redemption and eternal damnation in such clear schematic terms that even those viewers at the far end of the infirmary could see how their choices in this life would determine their fate in the next. The cursed souls in the painting outnumber the elect, a graphic warning. And yet the picture is so perfectly balanced in its composition, so firmly anchored by its central axis with Christ enthroned at the

3.4 Exterior of the Hôtel-Dieu, Beaune, founded in 1443.

summit, and the whole so bathed in golden light, that the message of retribution and suffering is counterweighted by the possibility of salvation for the faithful.

The chapel's placement at one end of the infirmary underscored the fundamental connection between spiritual and bodily healing. The medieval concept of illness—one we still share, perhaps—as both a punishment and a source of salvation is reinforced, as well, by the larger architectural plan of the hospital complex. We might say that in form and function the Beaune altarpiece once mirrored the form and function of the Hôtel-Dieu. Viewed from the cobbled street (fig. 3.4), the gray stone exterior walls and

3.5 Interior courtyard of the Hôtel-Dieu, Beaune.

steeply pitched slate roof of the hospital appear quite
plain, even austere. You pass under a peaked Gothic por-
tal and walk through a long dark entranceway to gain the
interior of the hospital complex. All at once the courtyard
(fig. 3.5) opens up to you. The filigreed spires and brilliant
mosaics of the glazed tile roofs reveal themselves in a burst
of color and pattern.

Before you is a sheltered cloister, formed by slender
stone columns on which rests the timbered gallery of the
second floor. Deep dormer windows, capped by lacy
wrought-iron finials and weathervanes, punctuate the
geometric designs of the roof tiles. This is one of the most
exuberant (and best-preserved) examples of Burgundian-
Flemish architecture, and it still strikes the visitor as a
touch fantastic. The passage from the building's sober
façade into the glorious hospital courtyard, like the open-
ing up of the closed altarpiece, enacts a visual narrative

of transcendence: somber piety and suffering lead the way to healing and salvation.

By imaginatively transporting the altarpiece to its original site, we can now see how various features of the hospital scenario reinforced the transformative function of the Beaune altarpiece. The entry into the courtyard of the Hôtel-Dieu, the celebration of the Mass and the unfolding of the altarpiece, the performance of daily medicinal rituals and last rites in the infirmary: each of these ceremonial enactments would have dramatized the patient's sense of an imminent transition from one physical and spiritual state to another.

Historical Context: Main Entrance and Floor Plan, Metropolitan Museum of Art

How does the work reflect the *historical era* (or eras) in which it was produced?

It has been said that museums are the modern equivalents of spiritual retreats, places to which we repair in search of wonder. In face-to-face encounters with works

Writing Topic 4

Write an analysis of a virtual museum tour on the Web. In what ways does it resemble or differ from an actual museum visit? How does the virtual tour enhance—or detract from—your experience of the works of art on display?

3.6 The Metropolitan Museum of Art in New York City, 1995. Aerial view from the northeast shows glass-enclosed Sackler Wing at right; main entrance is seen at far left of photo. Courtesy of the Metropolitan Museum of Art.

of art, we apprehend something that cannot be conveyed in photographic reproductions: a quality Walter Benjamin (1969) termed the object's "aura," by which he meant its physical presence, its unique existence.

Museums set beautiful objects apart from everyday life, surrounding them with pools of light and space, so that viewers are encouraged to slow down and take note. The invitation to look intently is what the art historian Svetlana Alpers (1991) has called the "museum effect." Visitors tend to invest the ritual of aesthetic contemplation with hushed significance, so it's not surprising that they commonly compare museums to palaces, libraries, and houses of worship. This case study looks at how one large municipal museum came to assume this ceremonial function and at how the museum structures viewing rituals.

In *Architecture in the United States* (1998), Dell Upton writes, "Architecture is an art of social storytelling, a means for shaping American society and culture and for 'annotating' social action by creating appropriate settings for it" (11). In this section we'll consider the architectural design of the Metropolitan Museum in New York—specifically, a sequence of alterations made to its main façade on Fifth Avenue—for what it tells us about the evolution of the American museum as a cultural institution. The "social story" of the present architectural form of the Met emerges more distinctly when the building is situated in a historical context. As Morrison H. Heckscher observes in his superbly documented *The Metropolitan Museum of Art: An Architectural History* (1995), the "majestic and apparently seamless classical composition" of the Fifth Avenue façade "masks a structure of vast scale and startling complexity" (5) that has undergone major changes over the past century.

The Metropolitan Museum dates from a period of economic growth following the Civil War when museum construction boomed in urban centers throughout the United States. Galleries, concert halls, and parks were created in part to counteract the perceived threat of forces that assailed American cities in the latter half of the nineteenth century: industrial pollution, restive workers, slum conditions in tenements, and successive waves of

immigrants from all over the globe. Public museums were conceived as a means of educating and uplifting the citizenry. In 1870, the New York Legislature incorporated the Metropolitan Museum of Art with the stated mission of "encouraging and developing the study of the fine arts, and the application of the arts to manufacture, of advancing the general knowledge of kindred subjects, and to that end, of furnishing popular instruction and recreation" (quoted in Hibbard 1986:8).

In 1880, the museum moved from downtown Manhattan to its present location on the east side of the nearly completed Central Park. Its new quarters were designed by two English-born architects, Calvert Vaux and Jacob Wrey Mould, in the Victorian Gothic Revival style. Influenced by the critical essays of John Ruskin—an ardent admirer of Italian Romanesque and early French Gothic architecture—a generation of Victorian-era architects drew on the medieval vocabulary of pointed and banded arches and richly colored façades. Often these designs combined textured and hand-hewn materials like brick with industrial-age materials like cast iron for structural support. (In *The Age of Innocence* [1926], the novelist Edith Wharton recalls the deserted interior of the Metropolitan Museum in the 1880s as a "queer wilderness of cast-iron and encaustic tiles.")

Figure 3.7, below, shows the original design of the museum. The blocky structure features a compact ground plan, a façade of warm red brick, huge pointed arches with polychrome granite banding, and a sloped mansard roof. The overall effect is massive without being grand.

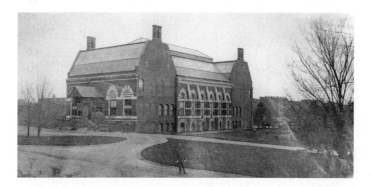

3.7 Calvert Vaux and Jacob Wrey Mould. Original structure of the Metropolitan Museum of Art, c. 1880. © Collection of the New-York Historical Society (Neg. No. 1022).

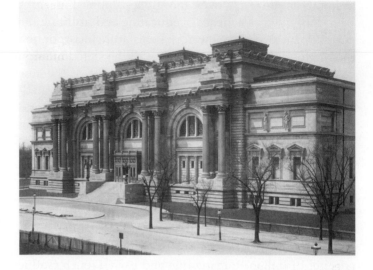

3.8 Richard Morris Hunt and Richard Howland Hunt. Eastern façade of the Metropolitan Museum of Art, 1894–1902. Courtesy of the Metropolitan Museum of Art.

Contemporary observers noted the unfinished and truncated appearance of the museum, which was clearly intended to accommodate winged additions (Heckscher 18).

By the early 1890s, after a number of interim additions to the original structure, the time (and money) had come for a major expansion of the Metropolitan Museum. Richard Morris Hunt, the first American architect to be trained at the École des Beaux-Arts in Paris, remade the structure in the imposing Beaux-Arts image (fig. 3.8).

In the course of renovation, the raw and lively original structure was sheathed in a thick limestone carapace, like a turtle in its shell. Yet in a sense, the architectural design of the museum makes visible its own history, for parts of the original red brick façade can still be glimpsed today from several vantage points inside the building. What do these layers of transformation reveal about the evolving role of the museum in the cultural life of the city?

Hunt's design (completed after his death by his son) reoriented the new, monochromatic limestone façade from west to east, facing the newly constructed limestone mansions of the wealthy residents of Fifth Avenue. The colossal scale of the entrance reflects the increased prominence of the institution. Set back from the street, the mu-

seum rises on a high rusticated base (*rustication* describes masonry of roughened texture that appears to be separated into deeply cut blocks). The elevation, or head-on view of the building, suggests a distinct and formidable precinct, removed from the everyday level of human activity.

The entrance is formal and symmetrical. Three arched portals are punctuated by four pairs of towering Corinthian columns set on plinths (see diagram, fig. 3.9). The columns support four massive broken entablatures, these in turn are surmounted by huge uncut blocks of stone. The effect is awe-inspiring, even a little intimidating.

Public buildings provide ritual space in which a community can pass on its beliefs and values. What gets foregrounded in a municipal museum is only one narrative of the national culture: the story that a society, or a segment of that society, tells about itself. In contrast to the medieval inspiration of the Victorian Gothic style, the classical-revival vocabulary of the Beaux-Arts style was drawn from ancient Greek and Roman models. The architectural program promoted civic pride not only by conveying grandeur but by tracing its mythical cultural roots back to the birthplace of Western artistic and democratic tradition. The "invented tradition" of a shared Western heritage was a means of communicating cultural solidarity to an increasingly diverse American population.

In *Civilizing Rituals: Inside Public Art Museums* (1995), Carol Duncan argues persuasively that the interiors of the Met and other large public museums constructed during this period were organized as temple-like spaces where a culturally diverse audience was guided through the narrative of a shared national heritage. The layout of these museums, patterned after the plan of the

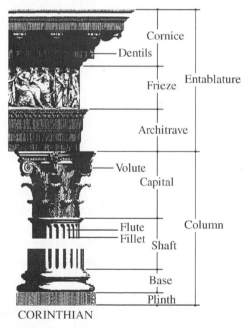

CORINTHIAN

3.9 Parts of Classical column.

Writing Topic 5

Turn your attention to a nonresidential public work of architecture in your neighborhood that intrigues you—perhaps a shopping mall, a sports stadium, or a municipal building. How are the floor plan, construction materials, and ornamentation adapted to the function of the building? What does the building reveal about past or present-day life in the community? What kind of story does this building or architectural complex tell?

For this project, students in one class took photographs of the architectural sites to illustrate their theses. For instance:

Caroline Bennett wrote about *sukkot*, the temporary tabernacles constructed by Jewish-Americans to celebrate the holiday of Succos. Bennett photographed numerous *sukkot* in a Queens neighborhood to show the variety of ways a religious group adapts sacred rituals to urban surroundings.

Christina Lee made a composite photograph of a block of Main Street in Flushing, New York (fig. 3.11), based on the artist Ed Ruscha's collage of Sunset Strip in Los Angeles. Lee used the composite to illustrate the mingling of social and linguistic communities in a commercial "contact zone."

Louvre, followed what was to become the traditional art history survey: artworks were organized according to chronology, national origin, and art historical "school," with emphasis given to acknowledged master artists. Visitors were thus led through the canon of official masterworks via a narrative that began in Egypt, moved on to classical Greece and Rome, and centered on European painting, taking the Renaissance as its high point.

Like the original façade, the original floor plan is embedded in the present structure of the Met. But as you can see from the current layout (fig. 3.10), the many-layered construction of the museum has somewhat obscured the earlier plan. Non-European art has been accommodated in various additions: the American Wing, the Sackler Wing, the Rockefeller Wing for the Arts of Africa, Oceania, and the Americas, and so on. Along with large separate bequests (like the Lehman Collection), these additions interrupt the traditional art survey narrative.

The design of the Met typifies the way museums around the world have adapted in recent years in efforts to narrow the gap many people perceive between their experience of art and their everyday lives. These changes include more amenities and commercial venues such as gift shops and restaurants, as well as new educational facilities and lecture halls. Equally important, the adaptations signal a rethinking of the museum's presentation of art outside the European canon.

Turning back to the recent photograph of the Met (fig. 3.6), we can see how the museum has morphed and expanded. In addition, the architectural design has continued to annotate social activity. In extensive renovations of the museum during the 1970s, the architectural firm of Roche, Dinkeloo created a walkway that merges with the Fifth Avenue pavement and extended Hunt's narrow front steps into an expansive three-sided cascade. The wider stairway modulates the steep base of the building and provides an outdoor theater of social interaction for museum visitors, street vendors, impromptu performers, and passersby. Increasingly, survey museums like the Metropolitan have become "contact zones" that reflect the dynamic interplay of social groups and

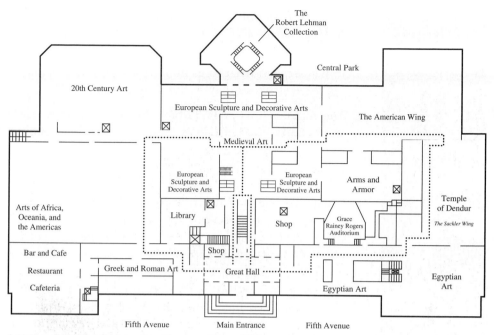

3.10 Plan of first floor, Metropolitan Museum of Art, c. 2000.

cultures in the artistic and intellectual life of the community.

The point of the foregoing discussion is that a museum tells its own version of art history by the way it houses and displays its collection. What happens when different belief systems come into conflict in the context of the survey museum? Our final case study takes up this question.

3.11 Christina Lee, photomontage of Main Street, Flushing (1999), detail.

3.12 Protective scroll,
detail showing Solomon
attended by two demons
(represented by two
eyelike shapes on either
side of his head). Ethiopia,
nineteenth century.
Paint on parchment,
22 × 7.7 cm. (8³/5 × 3 in.).
Musée des Arts d'Afrique
et d'Océanie, Paris.

Patrons, Performers, and Audience:
A Mende Helmet Mask

Who creates the object, who speaks for it, who defines it, who sees it: what roles do *patrons, performers, and audience members* play in the production of art?

The focus of this case study is the West African mask shown in Color Plate 6 in the color gallery of this book.

Like the Beaune altarpiece, many works of art are created for use in healing and spiritual rituals rather than primarily for aesthetic contemplation. Ethiopian parchment scrolls like the one shown in fig. 3.12 are commissioned by clients to be inscribed by clerics with images and prayers; the scrolls are meant to be wrapped or carried about the body of the patient and stored away when the ailment is cured. Sandpaintings are created by Navajo healers in the southwestern United States during medicine ceremonies that include poetry, dance, and song; the paintings, made with colored sand, are obliterated in the course of the ritual. Mende masks like the one shown in Color Plate 6 are also made for performance in rituals; they too are designed to be viewed by a limited audience under a specific set of conditions.

Some years ago, one of my students, Fatima Tunis, wrote about the mask in response to an art history assignment similar to the one printed at the opening of this chapter. As it happens, Ms. Tunis comes from Sierra Leone and belongs to a Mende community in which masks of this type are produced. In the following discussion of the mask, I've reprinted her commentary alongside the museum label for the mask, for several reasons.

Labels and wall panels have become prominent features of the museum landscape, so much so that visitors are said to spend as much time reading explanatory texts as they do gazing at the artworks themselves. In the case of the Mende mask, both the student and the museum professionals do a first-rate job of helping viewers to situate the sculpture within its ceremonial context. Obviously, however, no commentary, whether composed by a member of the culture or an outside expert, can tell the whole story.

 The literary critic Mikhail Bakhtin (1981) observes that
particularly rich texts are "heteroglossic," or multivoiced.
By the same principle we might say that cultural artifacts
and images are multivoiced. Depending on their setting,
some voices are muffled while others are heard more
clearly. In the museum, the institution is the official voice of
these objects, speaking in the form of exhibits, audiotapes,
labels, and catalogs. Yet in its own ceremonial setting, the
Mende helmet mask is brought to life only through the
agency of a group of interpreters, including an attendant
whose job is literally to speak for the mask and call it by its
proper name. Tunis's commentary speaks, in some meas-
ure, for this community—or at least for the community as
it existed a decade ago. Taken together, the two "labels"
printed below suggest the ways in which our definitions of
art, beauty, and viewership are shaped by social context.

Museum label

Mende Helmet Mask, wood, metal; Sierra Leone, Mende
peoples, 19th–20th century. In the sixteenth century, im-
migrants from western Sudan arrived on the Guinea
coast, merging with earlier settlers to become the Mende
people. Within Mende culture, helmet masks are commis-
sioned and performed by senior members of a female ini-
tiation society known as Sande. Using the artistic
medium of masquerade, Mende social values and aes-
thetic ideals are presented before audiences of young girls
during initiation. This idealized form represents Sowei,
who epitomizes the Mende conception of beauty through
the arrangement of her coiffure, the blackness of her com-
plexion, the serenity of her expression, and her strong
broad neck, which is subdivided into horizontal bands of
flesh. This particular mask also comments upon ideas of
power and transformation through the addition of pro-
jecting animal-horn amulets around the perimeter of her
coiffure. In the original context, Sowei is also defined
through her juxtaposition with the masquerade of
Gondei, who is a mirrorlike inverse reflection of all that is
graceless and ugly.

Commentary by Fatima Tunis

The mask is carved out of wood and is polished jet black;
it has an object on the top of the head which is

surrounded by four horns. The shape is hard to describe:
I can only describe it as the letter "U" turned upside
down; the whole thing represents the parts of the body
from the neck up. It has a ringed neck, a small face, and a
small nose, mouth and eyes.

Some of the features are typical of such a mask—the
ringed neck, the color—and some are not (instead of the
horns on the head sometimes it has braids). There is no
difference between front and back on some masks, while
some have a face on the back of the head, to which the
ringed neck extends, and designs are carved to make it as
beautiful as the front. It makes no difference, though, how
it looks; it is still the same mask serving the same pur-
pose.

It is usually big enough to be worn over the human
head—which is probably why it is called a "helmet mask"
in the Metropolitan Museum of Art. This mask plays a
significant role in the Mende woman's life—the Mende
are a tribe in Sierra Leone to which I partially belong. The
Mende have a female society called Sande: I will not go
into what goes on in the Sande society because it is
strictly confidential and off-limits to men and nonmem-
bers. This mask belongs to the Sande society and is worn
only by special people called Sowe. The Sowe is the
leader of the Sande; she performs a lot of duties, one of
which is to wear the mask—Sowe-wei (Sowe's head), as
the Mende call it—and a raffia costume to dance during
Sande ceremonies and special occasions.

Men are not allowed to see the Sowe dance during
Sande ceremonies, except on other occasions such as feast
days when the Sowe will just dance in a masquerade. The
Sowe-wei is carved by men, under the instructions of the
Sande women as to how it should look. As soon as it is
done, it is handed over to the women and then becomes
sacred and is kept away from men and nonmembers. (One
seldom finds a Mende woman who is not a member of the
Sande.)

The Sowe-wei is regarded as the most beautiful thing
in Mende tribes; features such as the ringed neck, dark
complexion, etc., are parts of the Mende definition of
beauty in women. It is so highly respected that not just
any Sande woman can wear it; even those qualified, I am
told, have to adhere to certain rules (which are part of the
secrets of the Sande) or else their heads will get stuck in it
or it will get so heavy that they will not be able to keep

their balance. If such things happen, the other Sande women will get together and release the person.

The main purpose of the Sowe-wei is to be worn during dancing ceremonies, but it is also kept as an artifact or a legacy of a family of Sowes (daughters of Sowes usually succeed their mothers). Miniatures or medium sizes are also made as decorative pieces, but since these have not been worn by the Sowe, they are mere copies and thus can be [seen] outside of the Sande society like the mask in the Metropolitan Museum of Art, which measures about $17^1/4$ inches, and is a 19th/20th century piece. The authentic pieces, kept in families or tribes, and *not* for display in museums, are much older.

The two commentaries overlap to a considerable extent. Both discuss the mask's beauty in terms of its performance. Both show how the demure expression and delicate features of the carved female face embody social as well as aesthetic ideals. The surface of the mask is smooth and oiled to an ebony gloss, like dark healthy skin. Broad bands or folds of flesh at the neck suggest strength and good health, perhaps fecundity. (Some scholars note that these concentric rings may also allude to the origins of the mask, signifying the ripples of water as the spirit emerges from the deep black pools of the forest.) The intricately plaited hairdo is evidence of a well-ordered life graced by leisure, prosperity, and the attentive care of sisters in the Sande society. The large unlined forehead, closed lips, and lowered eyes convey serene self-possession and an avoidance of idle chatter, for, according to the Mende saying, "Talk makes palaver."

At this point we need to turn our attention to what each label doesn't say, as each highlights the omissions of the other. The museum text strives for thoroughness and objectivity. Yet our student observer alerts us to the kinds of information that museum labels tend to leave out: for example, a history of how the sacred object was acquired, an indication of any alterations or repairs, and some acknowledgment of the taboo against open display of the mask (usually spelled *sowo-wui,* or "head of the Sowei," in scholarship on the Sande).

For her own part, Tunis acknowledges that she withholds information from her readers, explaining that the

Writing Topic 6

Compose two different versions of a museum label for an object of your choice. What do you see as the advantages and disadvantages of each text?

secrets of the Sande cannot be divulged to nonmembers. The point she keeps returning to is that viewing the mask is generally proscribed for Mende men and all other outsiders. Once the mask is made by a male carver under the direction of the Sande women, it becomes their property and legacy. For this writer, then, ownership, secrecy, gender, and power are essential elements in the definition of the mask. How might these elements of the social context figure in our appreciation of the object?

Let's begin by asking how different societies construct the identity of the artist and the artwork. In Tunis's account, mask making is a collaborative effort in which the carver seems to play a subordinate role. Sande women are regarded as the co-creators of the mask. They serve as leaders of an association that educates young women in ethics, deportment, medicine, and so on; as patrons who commission or purchase the carver's work; as dramatic performers who dance the masquerade; as participants and active audience members in a whole range of ceremonies; and as owners and inheritors of the sacred object.

Tunis goes so far as to maintain that the physical variations distinguishing one mask from another are incidental to its uses. In other words, the traditional emphasis that Western art history places on connoisseurship, on close comparative analysis of material objects, has relatively limited application here. Like the parchment scroll and the sandpainting, the mask is defined by its performance context.

The student's description focuses on the mask as the embodiment of arcane knowledge available only to select initiates in the community. The identity of the wearer is concealed by the mask and the raffia costume (which has not survived or simply is not displayed in the example in the Metropolitan Museum). In discussions of the object with outsiders, a member of the Mende community is still enjoined to secrecy. Here let me cite an analogous example: a friend of mine who

Writing Topic 7

Examine the influence of various participants in the production of a work of art: Research and discuss the role of a patron, performer, or collector in the creation of a specific work of art or architecture.

3.13 Navajo sand painting tapestry, 1925–1935. Handspun wool, 176 × 168 cm. (69¼ × 66⅐ in.). Southwest Museum, Los Angeles.

spent two years teaching on the Navajo tribal land at Chinle, Arizona, where he witnessed several Navajo ceremonies, refused to describe for me the sand paintings he had seen—for again, the ceremonies are generally off-limits to outsiders. "Once the ritual is finished," he explained, "there's no need to leave the artifact lying around where it might be defiled, misused, or seen by the wrong eyes."

Thus the Navajo artist who wove the tapestry pictured in fig. 3. 13 did so in defiance of the belief that she or he would be struck blind for making a permanent record of a sacred sand painting design. Tunis's essay cites a comparable story of punishment for the Sande woman who breaks the code of secrecy: the wearer of the mask becomes stuck and loses her balance—surely a severe consequence in a society that places a premium on female composure and group affiliation. Significantly, the story tells us that the wrongdoer can be released only by other Sande women acting in concert.

Secrecy, often linking specialized knowledge to gender and power, is an important aesthetic strategy in many African art forms. (For an excellent discussion of this point, see the collection of essays edited by Mary Nooter, cited in the references at the end of this chapter.) A particular design or art form might be used and understood chiefly by selected members of the community. The privilege is more commonly reserved for men than for women, but there are notable exceptions.

3.14 Mural art on the façade of Maria Sekasa's house. Murals painted by women in South Africa have used abstract designs as an instrument of secret resistance to the practices of apartheid.

A few examples should indicate how the aesthetic of secrecy, connected to gender roles, is likely to be overlooked by uninitiated observers of African art. For instance, Gary van Wyk (1998) has extensively documented how Sotho women in South Africa have expressed resistance to political repression by encoding "secret" messages in the colors and designs of the murals they paint on their houses (fig. 3.14).

Traditional Kuba cut-pile textiles from Zaire are embroidered by women using a repertoire of hundreds of gender-specific geometric designs, each with its own name and connotations. Bogolan cloths from the Bamana-speaking region of Mali (fig. 3.15), made by women using a painstaking process of mud-dyeing, encode designs and meanings relating to specific ceremonial occasions on which the cloths are worn. And some of the most powerful Bamana sculptures, according to Sarah Brett-Smith (1994), are made in secret by women artists. Because of the strict prohibitions against women as makers of ritual objects, the sculptures are officially attributed to the artists' husbands (247).

Scholars note the ways in which controlled access to the creation and performance of African art forms serves to maintain social boundaries, cooperation, and a balance of power within and between genders. One reason Tunis emphasizes the role of women in the creation of the Sande mask is that the exclusively female masquerade is an extremely uncommon practice in African societies, the exceptions being among Mende peoples in Sierra Leone and Liberia.

One more feature of the performance aesthetic should be emphasized here: the competitive context in which artistic creation takes place. Ruth B. Phillips (1995:104) points out that Mende women maskers typically dance in competition with one another; similarly, Donald Cosentino (1982:161) observes that

3.15 Bogolan cloth made by women of the Beledougou tribe in the Bamana-speaking region of Mali, nineteenth century. Mud-dyed hand woven cotton, 148 × 76 cm. (58¼ × 30 in.). Peter Adler Gallery, London.

Mende women's oral narratives are told collectively, in informal competitions among contesting storytellers. An isolated tale or helmet mask cannot fully communicate the vitality and meaning of the art form. A mask in a museum speaks to viewers more powerfully when seen as part of a larger network of beliefs—-social, political, spiritual, artistic.

"Giving to art objects a cultural significance," the anthropologist Clifford Geertz observes, "is always a local matter" (1988:97). Our two printed commentaries on the Sande mask issue from interpretive communities with different ways of structuring the identity of the artist and the work of art. Who creates the mask and what makes it authentic, who sees it and when, who owns and names it?

For Tunis, the Mende helmet mask in the Metropolitan Museum is a fragment. She tells us that a mask requires a raffia costume, a performer, an audience, and a specific performance occasion; it is never submitted to general scrutiny. She concludes that this mask is not authentic, and indeed by her definition it is not. The juxtaposition of the two "labels" reveals two very different, socially determined modes for looking at art.

In light of the violent turmoil that has disrupted life in her country during the years since Tunis wrote her commentary, the questions her work raises become all the more urgent. How do we understand and represent cultural difference in our study and exhibition of art from around the world? In Chapter 4, we'll analyze alternative strategies for displaying artworks such as the Mende helmet mask.

Writing Topic 8

After you've read through this chapter and the chapter that follows, try designing your own exhibition around a theme. (This can be an actual exhibit or a detailed projection on paper; it can be an individual or group project.) Try to include items from a range of cultures and media, and discuss how you would mount the exhibit if you had the opportunity. Consider how you would group the objects, what (if any) labels and wall texts you'd provide, what lighting you'd use, and any other multimedia techniques (such as audiotours and music) you'd like to experiment with.

WORKS CITED AND SUGGESTED READING

THE ROCK GARDEN AT RYOAN-JI

Fisher, Robert E. *Buddhist Art and Architecture.* London: Thames and Hudson, 1993.
Gadamer, Hans-Georg. *Truth and Method;* 1975, 2nd revised edition. Trans. J. Weinsheimer and D. Marshall. New York: Continuum, 1994.

Hashimoto, F. *Architecture in Shoin Style: Japanese Feudal Residences*. Tokyo: Kodansha, 1981.

Hayakawa, Masao. *The Garden Art of Japan*. New York: Weatherhill, 1973.

Hisamatsu, Shin'ichi. *Zen and the Fine Arts*. Trans. Gishin Tokiwa. Tokyo: Kodansha, 1982.

Itoh, Teiji. *Space and Illusion in the Japanese Garden*. 1965. Reprint: New York, Tokyo, and Kyoto: Weatherhill/ Tankosha, 1988.

Kuck, L. *The World of the Japanese Garden*. New York, Tokyo: Walker/Weatherhill, 1968.

Nitschke, Günter. *Japanese Gardens*. Cologne: Taschen, 1993.

Onishi, Hiroshi, et al. *Immortals and Sages: Paintings from Ryoanji Temple*. New York: Metropolitan Museum of Art, 1993.

Stanley-Baker, Joan. *Japanese Art*. London: Thames and Hudson, 1984.

Tanizaki, Jun'ichiro. *In Praise of Shadows*. Trans. Thomas J. Harper and Edward G. Seidensticker. Stony Creek, Conn.: Leete's Island Books, 1977.

The Beaune Altarpiece

Campbell, Lorne. *Van der Weyden*. New York: Harper & Row, 1980.

Harbison, Craig. *Jan van Eyck: The Play of Realism*. London: Reaktion, 1991.

Hayum, Andrée. *The Isenheim Altarpiece: God's Medicine and the Painter's Vision*. Princeton, N.J.: Princeton University Press, 1989.

Lane, Barbara G. *The Altar and the Altarpiece*. New York: Harper & Row, 1984.

The Façade and Floor Plan of the Metropolitan Museum

Alpers, Svetlana. "The Museum as a Way of Seeing." In *Exhibiting Cultures: The Poetics and Politics of Museum Display*. Ed. Ivan Karp and Steven D. Lavine, 25–32. Washington and London: Smithsonian Institution Press, 1991.

Benjamin, Walter. *Illuminations*. Ed. Hannah Arendt. New York: Schocken Books, 1969.

Duncan, Carol. *Civilizing Rituals: Inside Public Art Museums.* London and New York: Routledge, 1995.

Heckscher, Morrison H. *The Metropolitan Museum of Art: An Architectural History.* New York: Metropolitan Museum of Art, 1995.

Hibbard, Howard. *The Metropolitan Museum of Art.* 1980; Reprint, New York: Harrison House, 1986.

Hobsbawm, Eric, and Terence Ranger, eds. *The Invention of Tradition.* Cambridge and New York: Cambridge University Press, 1983.

Kostof, Spiro. *A History of Architecture: Settings and Rituals.* 1985; 2nd ed. New York and Oxford: Oxford University Press, 1995.

Upton, Dell. *Architecture in the United States.* Oxford and New York: Oxford University Press, 1998.

Wharton, Edith. *The Age of Innocence.* 1920; Reprint, New York: Macmillan, 1986.

THE MENDE MASK

Bakhtin, Mikhail. *The Dialogic Imagination.* Ed. Michael Holquist. Austin: University of Texas, 1981.

Boone, Sylvia Ardyn. *Radiance from the Waters: Ideals of Feminine Beauty in Mende Art.* New Haven: Yale University Press, 1986.

Brett-Smith, Sarah C. *The Making of Bamana Sculpture: Creativity and Gender.* Cambridge: Cambridge University Press, 1994.

Clarke, Duncan. *The Art of African Textiles.* San Diego: Thunder Bay Press, 1997.

Cosentino, Donald. *Defiant Maids and Stubborn Farmers: Tradition and Invention in Mende Story Performance.* Cambridge: Cambridge University Press, 1982.

Geertz, Clifford. "Art as a Cultural System." *Local Knowledge: Further Essays in Interpretive Anthropology.* New York: Basic Books, 1983.

MacCormack, Carol. "Sande: The Public Face of a Secret Society." In *The New Religions of Africa.* Ed. Bennetta Jules-Rosette. Norwood, N.J.: Ablex, 1979.

McClusky, Pamela. *Long Steps Never Broke a Back: Art from Africa in America.* Seattle: Seattle Art Museum; Princeton: Princeton University Press, 2002.

Nooter, Mary H., ed. *Secrecy: African Art That Conceals and Reveals.* New York: Museum for African Art; Munich: Prestel Verlag, 1993.

Elements of Visual Analysis

Phillips, Ruth B. *Representing Woman: Sande Masquerades of the Mende of Sierra Leone.* Los Angeles: Fowler Museum of Cultural History, 1995.
Van Wyk, Gary N. *African Painted Houses: Basotho Dwellings of Southern Africa.* New York: Harry N. Abrams, 1998.

The Museum
as Context

Display and Representation

4

"[*In Fred Wilson's installation*] *A man's suit and tie are placed in the center of a group of Cameroonian art from the late nineteenth or early twentieth century. At first, the mix* [*is*] *disturbing. Museum curators strive to create orderly themes. Grants are awarded based on superior strategies for thematic displays. But are we overthematizing the world? Doesn't indifference and apathy set in if the packages of art history are too tightly wrapped?*"
—*Pamela McClusky, Curator of Art of Africa and Oceania, Seattle Art Museum, from* Mining the Museum

"*. . . My project was not only about the artworks on the wall. It was about how the whole museum environment affects us. If no dialogue arises, then to me the work is not so successful.*"
—*Fred Wilson, from* Mining the Museum

I n Chapter 3 we considered diverse art objects in their "home" environments. The present chapter brings us back into the museum, the scene of most Westerners' encounters with art. How is cultural context reconstructed or rephrased, erased or distorted, in the museum environment? How do the conditions of the display influence our perceptions of art, particularly of non-Western art?

The questions discussed in this chapter (and posed in the writing assignments on pages 92 and 102) have larger implications for the way art history is presented in classrooms, in textbooks and critical studies, and in guides to writing about art like this one. Art survey courses and museum collections have opened up during the past few decades to represent a greater portion of the world's population and a more inclusive definition of art. Formerly marginalized categories such as folk art, fiber art, ceramic art, and so on, now figure more prominently in textbooks, slide libraries, and museum catalogs. In studying and

writing about art from a variety of cultures, we engage issues that extend beyond classroom walls—questions concerning the representation of others, the diversity of criteria for aesthetic evaluation, and the complex embeddedness of art in people's everyday lives.

Writing Assignment
Analysis of an Exhibition

Analyze a museum or gallery exhibition you have recently visited. What is the theme of the display? How are items related, arranged and mounted? Are objects illuminated with an overall, diffused wash of light; with variable natural light; with pin lights and "boutique" spotlighting? What role do labels, wall texts and brochures play in shaping the viewing experience?

As an alternative, you might compare two current museum or gallery shows that explore the same general theme. What do these two exhibitions have in common? What differences do you observe in presentation? Which display do you prefer, and why?

Every exhibition is an artificial construct, the result of countless decisions on the part of curators, designers, educators, museum directors, and patrons. We begin to deconstruct an exhibition, to appreciate its particular challenges and solutions, when we stop to consider alternatives. Below, we'll look at four museum exhibits, using as our point of departure the example of the Mende mask discussed in Chapter 3. As you read through the chapter, imagine the Mende mask as if it were displayed in each of these four contexts. How does the method of exhibition affect your perceptions of the work of art? What kinds of sensory and intellectual connections does the museum create by drawing together this particular group of objects? What do you see as the advantages and drawbacks of each strategy for display?

Case Study: Methods of Display
"Fine Art" Display: Fang Masks at the Royal Academy

For much of the 20th century, objects such as the Mende mask were displayed in the West in the context of an-

thropology rather than art. Travelers to Africa during the second half of the 19th century generally preferred to collect figural sculptures and masks, and as a result, these pieces came to be regarded by Western viewers as the canonical forms of African art. Early collectors seldom recorded data concerning an object's ceremonial significance, the date and location of its production, or the name of the artist or artists who made it (MacGaffey 2000: 37). In museums of natural history, many of which were established at the end of the 19th century to accommodate growing public interest in the trophies of colonial exploration, tribal artifacts were exhibited as ethnographic specimens, classified according to type, and packed tightly in glass vitrines.

Today, the Mende mask discussed in Chapter 3 is housed in a Plexiglas case in the Rockefeller Wing for the Arts of Africa, Oceania and the Americas in the Metropolitan Museum. Opened in 1982, the Rockefeller Wing represented one alternative to the "natural history" installation. In these spacious galleries, geographically grouped objects are accompanied by explanatory texts to provide cultural context, but the isolated placement and dramatic lighting of items in the darkened rooms emphasize visual appeal over ethnographic significance.

The characteristic features of a fine-arts display of African art are illustrated in fig. 4.1 on page 94, showing a room from an exhibition entitled "Africa: The Art of a Continent" at the Royal Academy in London (1995).

In this installation of art from Central Africa, large freestanding works such as the Fang figures in the background of the picture are displayed on open platforms in the center of the room. Two large Fang masks are hung on either side of the archway. Smaller items such as the Kota sculptures at the right of the photograph are arranged together in shallow wall cases; other pieces, like the Kongo figures in the foreground, are set apart in plastic cubes. Spotlights in the darkened gallery isolate objects for aesthetic contemplation. Minimal cultural context is provided. The combination of broad regional groupings and fine-arts installation is what museum-goers in recent decades have come to expect in Western presentations of African art. (For an excellent summary of critical

4.1 Installation of art from Central Africa in "Africa: The Art of a Continent," an exhibition at the Royal Academy in London in 1995.

commentary on the show at the Royal Academy, see Elsbeth Court's essay in Barker, ed., 152–164.)

Formalist Display: Bamana Masks at the Barnes Foundation

Consider an alternative proposal. Instead of grouping an object like the Mende mask with similar items from the same region of Africa, why not place it among various pieces from around the world with which it shares formal and expressive characteristics? A room in the Albert C. Barnes Foundation in Merion, Pennsylvania (fig. 4.2), illustrates this approach. Bamana masks hang at either end of the wall; a glass case displays two rows of smaller sculptures and masks from Africa. These sculptures are shown alongside a carved European triptych, a horizontal shallow relief from Madagascar, several pieces of medieval metalwork, and twentieth-century paintings by Modigliani, Demuth, Picasso, and Matisse.

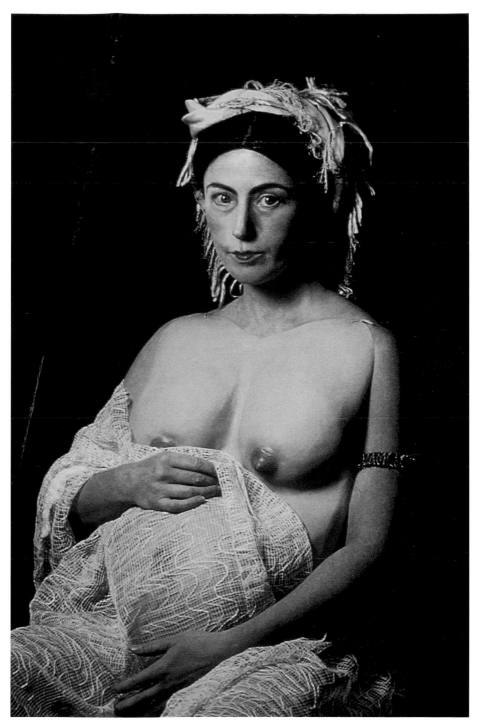

Color Plate 2. Cindy Sherman, *Untitled #205*, 1989. Color photograph, 135.9 × 102.2 cm. (53$\frac{1}{2}$ × 40$\frac{1}{4}$ in.). Courtesy of Metro Pictures, New York.

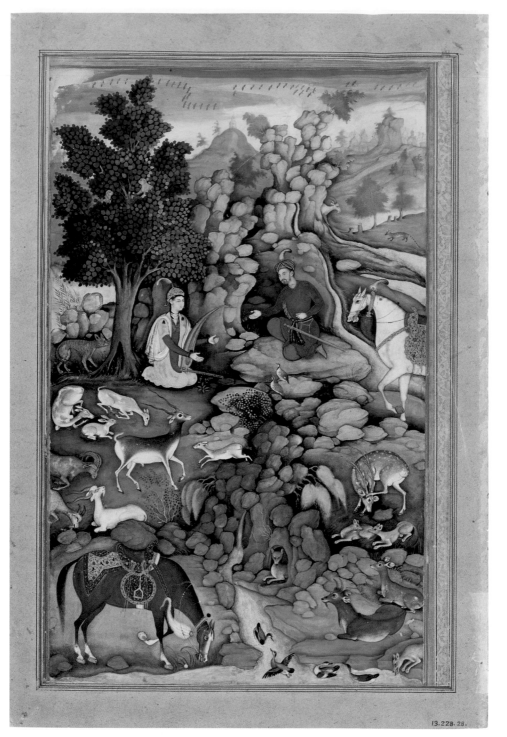

Color Plate 1. Miskin, *Bahram Gur Watching Dilaram Charm the Wild Animals with Her Music,* a leaf from a *Khamsa* by Amir Khusran Dihlavi, Indian, c. 1575. Ink and opaque watercolor on paper, 24.5 × 15.1 cm. (9⅝ × 6 in.). The Metropolitan Museum of Art, New York. Gift of Alexander Smith Cochran, 1913. (13.228.28)

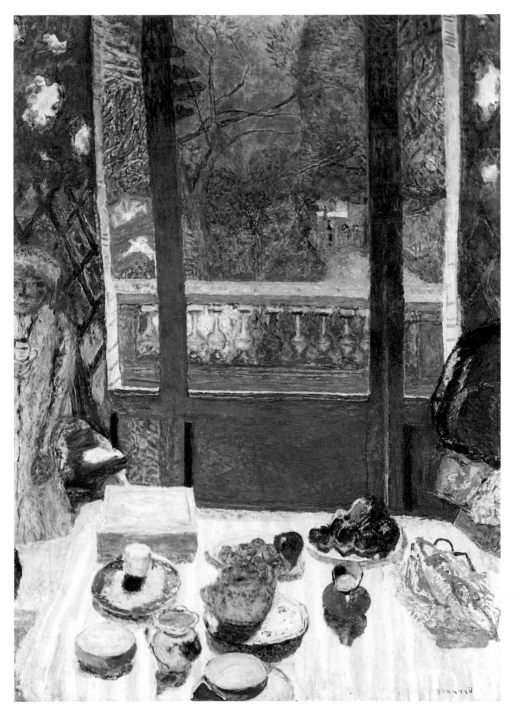

Color Plate 3. Pierre Bonnard, *The Breakfast Room,* c. 1930–31. Oil on canvas, 159.6 × 113.8 cm. (62⅞ × 44⅞ in.). The Museum of Modern Art, New York. Given anonymously.

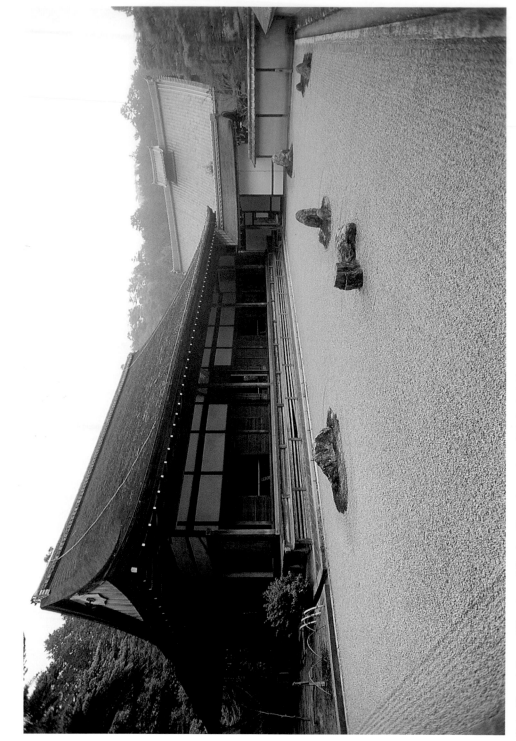

Color Plate 4. Ryoan-ji Temple and Garden, Kyoto, Japan. Late 15th–Early 16th century.

Color Plate 5. Rogier van der Weyden, Open panels of the altarpiece of *The Last Judgment* from the Hôtel-Dieu, Beaune, France. c 1443–1448.

Color Plate 6. Mende Helmet Mask, Sierra Leone, 19–20th century. Wood and metal, Height 38.1 cm. (15 in.). The Metropolitan Museum of Art, New York. Gift of Robert and Nancy Nooter, 1982. (1982.489).

Color Plate 7. Fred Wilson, installation view of *The Museum: Mixed Metaphors*, an exhibition at the Seattle Art Museum, 1992–93.

Color Plate 8. Eugène Delacroix, *Women of Algiers in their Apartment*, 1834. Oil on canvas, 180 × 229 cm. (70⁷/₈ × 90¹/₈ in.). Musée du Louvre, Paris.

4.2 Room 22, South Wall, in the Albert C. Barnes Foundation, in Merion, Pennsylvania, a suburb outside Philadelphia.

A self-educated and self-made millionaire, and an early champion of modernist painting, Dr. Albert C. Barnes was something of an outcast from conservative museum circles in Philadelphia, and all the more combative for it. Barnes styled his private Foundation as his envoy to the world, representing his commitment to the ideals of self-improvement and social equality. The room pictured in fig. 4.2 sums up Barnes's outlook.

The Barnes method defies art history categories of chronology, geography, national school, and period style. Walls are dense with items from various eras and genres; no identifying labels or wall texts are provided. Barnes wanted visitors to make the kinds of visual connections he had made in each carefully composed exhibit; he even stipulated in his will that the galleries could not be altered after his death.

Barnes's philosophy challenged viewers to see aesthetic affinities among artworks across cultures, regardless of

time period or artist's medium. His idea was that masterworks transcend their social milieus by virtue of their universal expressive qualities. Some visitors to the Barnes Foundation are simply frustrated by the welter of unidentified and undated items; others welcome the invitation to trust their own perceptions. What correspondences, for instance, do you perceive among the pieces in the Barnes installation?

Contextualized Display: Yorùbá Masks at the UCLA Fowler Museum of Cultural History

Figure 4.3 illustrates another possibility for exhibiting a ceremonial mask. The display comes from a show entitled "Beads, Body and Soul: Art and Light in the Yorùbá Universe," mounted in 1998 at the Fowler Museum of Cultural History on the campus of University of California at Los Angeles. In contrast to the exhibits we've just considered, this group of Egúngún ensembles—worn in ceremonies honoring Yorùbá ancestors—is embedded in

4.3 An installation from "Beads, Body and Soul: Art and Light in the Yorùbá Universe," at UCLA Fowler Museum of Cultural History in Los Angeles, 1998. The display features mannequins wearing Egúngún costumes and masks.

cultural context. The exhibition focuses on how art functions in the life of the community that produces it.

The floor plan shown in fig. 4.4, below, gives us an overview of the ways in which visitors are guided through this exhibition. The show traces the route of the African diaspora by showing how Yorùbá rituals and art forms are maintained among immigrants from western Africa to the New World. Small circles on the floor plan,

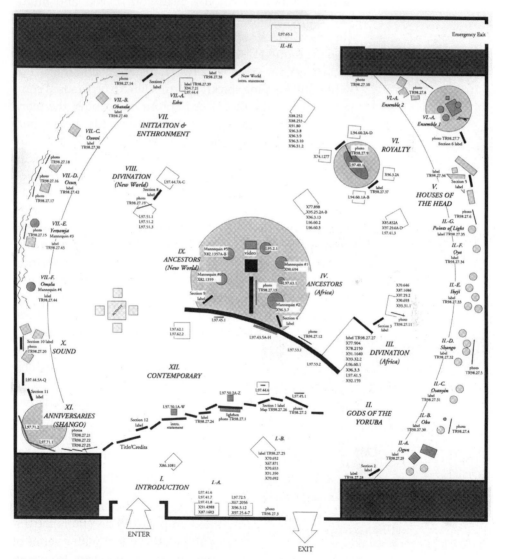

4.4 Floor plan of "Beads, Body and Soul" exhibition, UCLA Fowler Museum of Cultural History.

each representing an item on display, indicate how the objects are clustered and spaced. Panels of text and enlarged photographs are distributed so as to pace the visitor's movement through the gallery and to communicate information about Yorùbá beliefs and practices without overwhelming the viewing experience.

The large circle at the center of the floor plan shows the location of the Egúngún display pictured in fig. 4.3. As you can see in the photograph of the display, mannequins wearing vibrantly colored beadwork masks and multi-layered costumes have been placed on a stagelike perimeter deck. The foot-high platform, as the exhibition's designer, David Mayo, explains, "is meant to put as little barrier as possible between the object and the visitor while still keeping the art at arm's length" (personal communication, May 2001). A photomural behind the mannequins shows an Egúngún masquerade being performed, as does the field footage playing on a nearby video monitor. Ambient sound from the filmed ceremony floats through the exhibition space. A text panel explains how the objects are used to celebrate the memory of Yorùbá ancestors. Focused overhead "task" lighting picks out glittering details and casts deep shadows to convey the kinetic impact of the pieces on display.

The show encourages spectators to inquire into their own viewing habits and expectations. For instance, the curators at the Fowler were at a loss to explain the original use of an object (fig. 4.5, shown at left) that had been lent by a private collector. "Eventually," David Mayo recalls, "we decided to make the mystery part of the exhibition—to present this as a puzzle. Occasionally you find objects that have escaped documentation; yet they deserve to be seen and enjoyed. There's always the possibility that a visitor will be able to identify the object, so that it can then become part of the academic discussion." The label for the "mystery object" (reprinted on page 99) decenters the authority of the official text with a series of questions that invite viewers to join in the investigation.

4.5 "Mystery object" from "Beads, Body and Soul" exhibition. Cotton cloth, beads, thread, leather. 107.5 cm. (43¹/₃ in.). Private collection.

The show thus extends Western viewers' perceptions of Yorùbá art in several ways. Theatrical effects suggest the way movement alters the appearance of the artworks; multimedia installations emphasize the interrelationship of music, mask, and costume. Viewers are encouraged to see ceremonial objects in light of their performative power.

In showcasing ensembles made of fabric, shells, and beads, the exhibition unsettles the customary hierarchy of genres in Western art history. According to this evaluative scheme, textiles are relegated to the category of crafts or decorative art as opposed to fine art. Yet the rubric of fiber art includes examples as intricate and various as Amish pieced and quilted coverlets, Persian knotted rugs, Pueblo woven blankets, Japanese embroidered kimonos, cut-pile raffia cloth from Zaire (fig. 4.6), and Cubist couture fashioned by Sonia Delaunay (fig. 4.7)—using the same designs that were regarded as fine art when she painted them on canvas.

As we noted in the discussion of Raphael in Chapter 1, the study of Western art history has traditionally focused on the creative genius of individual artists. Textiles, which are typically produced collectively and anonymously, often by women, have come to be assigned to a different category of value, however artfully designed and finely wrought they may be.

Standing before the Egúngún masks, viewers begin to notice how the crisp patterns of line and color imbricate all the items on display. These rhythmic patterns, in turn, are echoed in the dances shown and heard on the video monitor and throughout the gallery, further linking object and performance. The art historian Robert Farris Thompson has pointed out how such offbeat or syncopated metrics characterize many forms of African and African-influenced music and visual art (207). The exhibition at the Fowler helps spectators see visual rhythms as part of a performance-based aesthetic.

Artist's Installation: Fred Wilson's "Mixed Metaphors" at the Seattle Art Museum

Museum professionals nowadays are openly concerned with the problematics of exhibition. It has become an increasing preoccupation among artists, as well, to examine the methods of museum display. Artists like Sophie Calle,

Here is the Fowler team's label for fig. 4.5:

A Puzzle of an Object

This perplexing object raises many questions and offers few answers. What was its function? Consider the possibilities that are suggested below and decide for yourself!

• It may be a beaded mat and bag for a semicircular divination tray that would have been placed in its central pouch. However, the beaded flap does not cover the open end of the pouch and its text is oriented in the opposite direction from that on the pouch.
• Perhaps it is a cover for a royal cushion. Its central semicircle would have been stuffed and the ruler's feet placed on either side of the flap.
• It might be a beaded saddle blanket for the ruler's horse; its semicircular (seatlike) shape could have been padded and the two leather tassels on one end may have been used to throw it on the horse's back.
• Maybe it is part of the headdress of an Egúngún ensemble, perhaps of the type that has a flat board at the top with panels and the sides and serrated borders.

4.6 Shoowa tribe cut-pile cloth. Zaire, nineteenth century. Hand woven raffia, 58.4 × 49.5 cm. (23 × 19¹/₂ in.). Peter Adler Gallery, London.

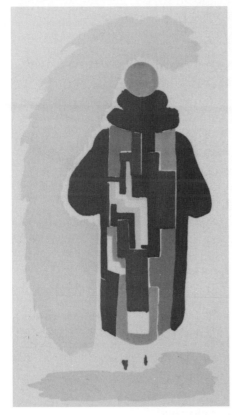

4.7 Watercolor of costume by Sonia Delaunay, c. 1923. Courtesy of the Fashion Institute of Technology Library, New York.

Thomas Struth, Louise Lawler, and Fred Wilson often take the museum as the subject of their work. Fred Wilson's installation at the Seattle Art Museum (*The Museum: Mixed Metaphors,* 1992–1993, detail shown in Color Plate 7 in the color gallery of this book) questions the assumptions behind conventional museum displays of African art. Turn for a moment to the photograph and note your impressions of the piece.

Having considered other exhibition methods, we can appreciate the ways in which Fred Wilson's installation disrupts the traditional narratives that encyclopedic institutions such as the Metropolitan Museum often construct for their displays of African art. In his work, Wilson "mines" the storage rooms and permanent collections of museums around the United States to compose installations that combine familiar and unfamiliar material. He rewrites labels and scrambles the kinds of display techniques commonly associated with certain genres. For instance, at the center of his grouping of 19th-century Cameroonian robes, sculpture, and carved thrones, Wilson has placed a television and a man's business suit. The suit bears this tongue-in-cheek label:

Certain elements of dress were used to designate one's rank in Africa's status-conscious capitals. A gray suit with conservatively patterned tie denotes a businessman or member of government. Costumes such as this are designed and tailored in Africa and worn throughout the continent.

Wilson's installation points up the way Western museums have traditionally represented "other" societies as fixed and unchanging, all past and no present. He resists an essentialist view of difference—a view that would make cultures, especially non-

Western cultures, transparent reflections of some stable and inherent ethnic essence.

The exhibitions discussed in this chapter encourage viewers to reflect on their expectations and biases, and to consider commonalities as well as differences among cultural traditions. For instance, every society produces artworks not meant for public display—because the images are private, sacred, or taboo. Many art objects in museums around the world were meant to be viewed exclusively by a specific audience: possibly Raphael's portrait of La Fornarina, and certainly the sexually graphic cabinet pictures Gustave Courbet painted for a private client; bronze plaques from the palace in the city of Benin; Heian hand scrolls intended for courtiers; Egyptian funerary sculptures meant for the solitary gaze of the deceased. Museums, books, classrooms, and Web sites remove strictures and create access to these objects. The challenge for art communities—for collectors, dealers, curators, artists, students, teachers, critics—is to maintain the institution of art history as an open forum, rather than an impregnable palace or tomb, while still respecting the original sacred or private meanings of art objects.

Continuing Controversies

In the past few years alone, dozens of books and hundreds of news articles have scrutinized the way private collectors and national museums acquire, restore, and exhibit their collections. Museums have become a flash point for controversies over aesthetics, ethics, and politics, and these are matters that involve not only professionals in the art world but the general public as well. The items featured on the next few pages—news articles, ads, posters, and Web postings—show how the questions raised in the foregoing pages have become vital topics in the public discourse.

These examples are offered as starting points for further research and debate. You might begin your research by using the World Wide Web to sort through databases of published material on current issues in the international art world. Alternatively, you might research a local debate

Two excerpts from E-mail correspondence with Pam McClusky of the Seattle Art Museum (June 2001): Author: "Can you tell us more about the textiles in the Wilson exhibit?" McClusky: "The Wilson installation of altered Cameroonian art has a sequence of "classic" *ndop* cloths (tie- or stitch-dyed indigo cloths used as signifiers of a royal presence) and one gown and hat appropriate for greeting a *fon*, or king. Balancing the past with the present, Fred added a suit that he borrowed from a guard on staff named Saye Kinnay, who happens to be Liberian and a police officer. On the identifying label, Fred just stated that this was Saye Kinnay's suit, thereby conferring prominence to the individual who wears the clothes rather than calling attention to anonymous clothing from unknown makers. Next to the business suit, Fred displayed a very flashy agbada gown (i.e., a big, flowing gown) that I collected for the museum in 1990 in Ede, Nigeria. It is laced with lime green Lurex thread, imported from Japan and hand woven into a strip cloth that has more lime green embroidery added to surround the neck...." (Second E-mail excerpt is on page 102.)

Author: "In designing permanent installations of African art at the museum, how did you negotiate the paradox of publicly displaying sacred/secret objects?"

McClusky: "I remember thinking that yes, this art does deserve the sanctity of a reverential space, but that visitors also need to know that reverence doesn't always mean quiet reserve. Just adding a hint of cultural context, not a re-creation, was enough to put the art into something other than (what I called at the time) the plexi box that treats it like toxic waste. We gambled with curtain alarms and set backs [as security measures] to keep the plastic to a minimum, and then made sure that videos and photographs of the artist, the owner, or the performer were always on view to suggest who the curators and collectors were in cultural frameworks other than those of the museum environment. In our labels and brochures, individual voices were quoted wherever possible. These written voices were supplemented with the cadences and inflections of a variety of narrators in our audio tours."

in your own neighborhood—perhaps a case of competing claims for the historic preservation of a landmark versus an urban development project. You'll find background material on museum debates in the books listed in the bibliography at the end of this chapter. (*Law, Ethics and the Visual Arts* by Merryman and Elsen is an especially helpful reference work, as it explains a range of legal issues and offers numerous case histories.)

Writing Assignment
Position Paper on a Current Museum Controversy

Pick a museum controversy you'd like to explore. Research related articles on the subject, and briefly summarize both sides of the argument. Then take a position in the debate, supporting your view with evidence from your research. Your written commentary may take the form of a letter to a museum director or newspaper editor, a posting on a Web site, or a formal essay for an academic conference on the subject.

What Is Exhibited?

Should publicly funded museums display artworks with controversial sexual, religious or political content?

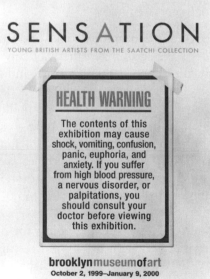

4.8 Advertisement from "Sensation," an exhibition of contemporary British art at the Brooklyn Museum of Art, October 1999–January 2000.

Figure 4.8 shows an advertisement for a controversial exhibition at the Brooklyn Museum of Art. The ad recalls the warnings issued in 1865 to viewers of Manet's "shocking" painting of the nude Olympia, which flouted accepted ideas of beauty and propriety in art. The mayor of New York City, offended by items in "Sensation" (in particular, by a picture of the Virgin Mary executed in paint and elephant dung), threatened to withdraw public funding and filed suit to evict the Brooklyn Museum from its city-owned premises. The museum sued the city for infringement of its First Amendment rights. After six months of costly litigation, both sides agreed to drop the case.

In courtroom battles of the past few decades, controversies have swirled around highly charged images

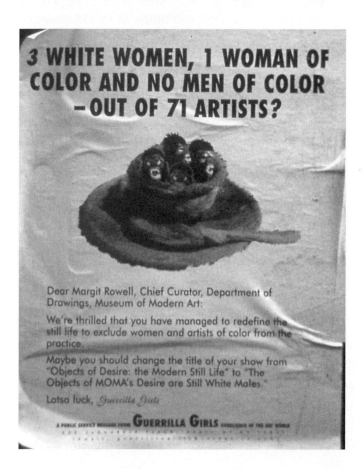

4.9 On a building in downtown Manhattan: A poster by the Guerrilla Girls protesting a still-life show at the Museum of Modern Art in New York.

displayed in public spaces—artworks that are sacrilegious, sexually explicit, racially offensive, or personally insulting. You might research one such conflict that pits First Amendment rights to free speech against public outrage at art with inflammatory content. Which side of the debate do you support, and why?

Who Is Represented?

Is the artist's gender or ethnicity a relevant criterion in the selection of artworks for public exhibition?

The Guerrilla Girls are a New York-based collective of anonymous women artists. Their posters, which began appearing on the sides of city buildings in the mid-1980s, constitute a witty and provocative intervention in traditional museum practices. The poster shown in fig. 4.9 (on page 103) criticizes a 1997 exhibition at the Museum of Modern Art for its underrepresentation of women artists and men and women artists of color. In a more recent poster spotted around town, the Guerrilla Girls continue the argument by pointing out how the power structure is reflected and perpetuated on the Internet:

> "The Internet was 84% male and 82.3% white. Until now. Guerrilla Girls have invaded the world wide web. Join us. http://www.voyagerco.com/gg."

Museum officials, on the other hand, maintain that they have simply selected the best examples they could find in putting together their permanent collections and temporary exhibitions. How would you respond to either side, in a letter to museum board members or in an E-mail to the Guerrilla Girls organization?

Who Owns the Object?

Should museums return artifacts taken from archaeological sites?

The following excerpt comes from a report in the *New York Times* (July 1998) on the contested provenance of pre-Columbian artworks in the Boston Museum of Fine Arts.

Looted or Legal?
Objects Scrutinized at Boston Museum

by Susan Diesenhouse

BOSTON, July 22, 1998—In its first effort to make art from Africa, Oceania and pre-Columbian America part of its permanent exhibit, the Museum of Fine Arts here has stepped into the storm over the questionable provenance of art, which is buffeting major museums and private collectors.

Museum officials curtly rejected a request from Guatemala to eventually return a 138-piece collection of Mayan art that is the jewel of its pre-Columbian display. In a two-paragraph letter written a month ago to a Guatemalan official, Malcolm Rogers, director of the museum, said that its board of trustees "found no basis" for Guatemala's ownership claim because the country could not produce legal title to the pieces.

Guatemala, meanwhile, charges that the museum has refused to produce documents that prove the collection was legally removed from a region where the United States Government has long recognized that Mayan sites are endangered by looters.

"I can no longer consider the M.F.A. to be an ethical art institution," said Carlos Enrique Zea Flores, an archeologist who is Guatemala's Vice Minister for Culture and Sports. "It's more like a collector who buys and sells pieces looted from the Mayan world."

Last December, the 128-year-old museum opened three permanent galleries for art, artifacts and cultural objects from Africa, Oceania and Latin America, which feature collections from two longtime patrons.

The African collection of about 150 pieces includes 13 pieces that are on long-term loan from a museum overseer. The Malian Embassy in Washington has asked the United States to help it repatriate two of the African antiquities that are on loan. The Malian Government said the items were smuggled out of the country probably after 1993 despite Malian laws prohibiting their excavation or export and a United States law forbidding their import.

Mr. Rogers, the museum director, said that his institution is not responsible for settling the dispute because the artifacts are on loan from a private collector, William E. Teel.

The November Collection of Mayan works from Guatemala was purchased for the museum by a trustee in 1987 who officially donated it in 1988, the museum said.

"Since we have legal title to it, we have the right and the duty to display these works, which are extraordinary advocates for their culture," Mr. Rogers said. Otherwise, he continued, they would be closeted away in private collections.

Mr. Zea Flores said the high-quality Mayan burial urns, gold adornments and polychrome ceramics with hieroglyphics, all from El Petén jungle, were stolen from Mayan sites and smuggled from the country without the export permits that Guatemala has required since 1947. This removal also violated a 1970 United Nations accord intended to stem the looting of cultural property, Guatemalan officials said.

"I asked the museum to show me their export permits; they haven't," Mr. Zea Flores said.

He added that the best way for museums, universities and private collectors to support Mayan culture is to help the Guatemalan Government preserve what remains of its art and return what has been looted. . . .

In the past, museums around the world collected antiquities with little concern for how these items had passed into private hands. Perhaps the most famous case of appropriation concerns the Elgin Marbles in the British Museum. In 1801, Lord Elgin, the British ambassador to Constantinople, was permitted by corrupt local officials to remove a series of important sculptures from the Acropolis in Athens and ship the pieces to London, where they eventually became part of the collection of the British Museum. Should the British honor the repeated ap-peals of Greek nationals to restore the sculptures to their homeland?

The historian William St. Clair (1999) has documented how museum "restorers" using abrasive cleaners have done considerable damage to the Elgin marbles over the years, although museum officials have consistently denied the charge. St. Clair argues that the British Museum, like many arts institutions, legitimates its claims to cultural property with a "rescue-and-stewardship mythic narrative": according to this narrative, the artifacts were

acquired legally, saved by the museum from local theft and destruction, responsibly cared for, and made available to the general public and to scholars in ways that would not have been possible at the original site.

Today, issues of ownership of cultural property are still argued along the same lines, as you can see from the *Times* article quoted on the preceding pages. The acquisition of pre-Columbian art has occasioned particularly rancorous debate in museum circles. Some art historians contend that these objects would have been damaged and looted if left unattended on site, and that they will reach a wider viewership if they enter the public domain. On the other hand, many archaeologists argue that when we remove an artifact from its excavation site, its functional and iconographic meanings are lost to us forever. The strictest legal view on this side of the debate is that stolen artifacts should not be displayed, nor should photographs of the artifacts be published.

The Boston Museum of Fine Arts has proof of legal ownership of the Mayan collection in dispute; Guatemalan officials claim the museum is in violation of the 1970 UNESCO accord to stop the plunder and export of antiquities. Should the Boston Museum cede artifacts that are suspected to have been exported illegally?

Should museums return objects taken as "war booty"?

Here are excerpts from two articles on paintings confiscated during World War II. The first item, from *HoustonChronicle.com*, concerns the return of a Matisse painting looted by Nazis during the War. The second excerpt comes from a review in the *Boston Globe* of an exhibition at the Hermitage Museum in St. Petersburg, Russia.

Seattle Museum to Return Painting Stolen by Nazis

Houston Chronicle; Houston, Tex.

SEATTLE, June 16, 1999—The Seattle Art Museum, acting to end a controversy over artwork looted by Nazis during World War II, has agreed to return a painting by

impressionist master Henri Matisse to heirs of a French art dealer, museum officials said Tuesday.

The museum's board of trustees voted to return the 1928 oil painting *Odalisque*, reportedly worth $2 million, to heirs of prominent Paris collector and dealer Paul Rosenberg, whose collection was stolen from a vault as part of a systematic Nazi looting campaign during the occupation of France in 1941.

The museum, which has been embroiled in litigation over the painting, made its decision Monday after the nonprofit Holocaust Art Restitution Project confirmed, after a 16-month study, that the painting belonged to the Rosenberg estate.

"This report confirms the Rosenbergs' claim, and we are pleased to return *Odalisque* to its rightful owners," said museum director Mimi Gardner Gates.

Elan Steinberg, executive director of the World Jewish Congress, hailed the decision and said he hoped it would spur other museums, particularly in Europe, to return the "tens of thousands" of works stolen by Nazis from Jews and other Holocaust victims.

The Seattle museum acquired the Matisse in 1991 as a bequest from timber baron Prentice Bloedel and his wife, Virginia, who purchased it in 1954 for $19,000 from New York's Knoedler & Co. gallery.

In 1997, the Rosenberg family demanded the return of the vividly colored red-and-blue oil painting, also known as *Oriental Woman Seated on a Floor.*

The Matisse has not been exhibited at the museum since 1997.

Unhidden Treasures
Russian Museum Unveils 74 Long-Lost Masterpieces of Art

by Fred Kaplan, Boston Globe Staff

ST. PETERSBURG, Russia, March 30, 1995—The Hermitage Museum, gargantuan, gilded palace of the czars, has cast a magic spell for centuries by stirring lightning bolts of history in a fairy-tale ambience, but yesterday the place nearly outdid itself.

Seventy-four long-lost Impressionist and Modernist masterpieces—by Van Gogh, Gauguin, Monet, Manet, Matisse, Pissarro, Renoir, Seurat, Daumier, Picasso and Degas, to name a few—suddenly materialized in cavernous Nikolaevsky Hall, looking as if they had just been painted last week. . . .

Many have not faced the public eye for well over 50 years, since they hung in private collectors' homes before being captured by the Soviet Army.

The most intriguing of these collectors was Otto Krebs, a wealthy boiler manufacturer of the 1920s who developed an uncanny eye for modern art. Fifty-five of the exhibit's 74 paintings were taken from Krebs' holdings, including all the Pissarros, Gauguins, Van Goghs and most of the Cézannes, Monets and Renoirs. His collection was never shown, lent out or photographed; he kept them strictly for his own pleasure.

Was Krebs a Nazi? The Red Army's list of his collection, found in the archives, refers to "the Nazi Otto Krebs," but Hermitage director Mikhail Piotrovsky said yesterday this citation may be incorrect. Krebs died in 1941, after the war started; his business prospered through Hitler's rise in the 1930s, suggesting he at least tacitly supported the regime.

The issue of his loyalties is not an academic matter. It goes straight to the controversy that has surrounded the war treasures since 1991, when their existence was revealed in a series of articles by two Russian art historians in the American magazine *ArtNews:* Who owns this art?

The Nazis and the Soviets both grabbed tons of cultural treasures while occupying each other's territory during World War II. Their armies even formed special brigades of art historians to seek out particularly valuable items.

After the war, the Allied victors compelled the new West German government to return its share of war booty to the Soviet Union. The Soviet Union returned some of its goodies, but only to Hungary, Poland and the new East German state—that is, to countries in the Soviet bloc.

The topic went undiscussed during the Cold War. A German-Russian commission has recently started negotiations, but the decades of tensions have not yet settled.

A German-Russian treaty states that cultural artifacts and private property, illegally taken as war booty, must be returned. But Russian officials say their booty was not taken illegally; rather, it was rightful restitution for the immense wartime damage that the Nazis inflicted on Russia.

Some Western historians think the Russians have a point; if Otto Krebs was a Nazi, maybe they are right to hang on to his treasures. But what about Friedrich Siemens, from whose collection the Hermitage is showing a Degas and a Delacroix? After his brother-in-law was executed for plotting to assassinate Hitler, Siemens, fearing family-wide punishment, took his paintings to the director of the Pergamon Museum, a friend of his, who stored them, with many other works, in the museum's vault. When the Soviet Army liberated Berlin, it raided the entire vault, including Siemens' pictures.

Siemens' daughter, Daniela Brabner-Smith, who now lives in Florida, was at the Hermitage yesterday. She remembers seeing the two paintings in her Berlin home as a child, has the documents to prove it, and wants them back. . . .

As you can see from the articles quoted above, more than fifty years after Holocaust-era assets were confiscated by Nazi soldiers, the question of rightful ownership is still being argued. In several recent cases, the return of artworks legally acquired by museums but originally seized from private citizens during World War II has been resolved in favor of the heirs of the original owners. But who are the "rightful owners" of the trove of Impressionist paintings unveiled at the Hermitage Museum in Russia? The paintings were seized by Russian troops as war booty from Nazi Germany—illegally, according to the Germans. Russian officials claim that the treasures are restitution for war damage inflicted by the Nazis. Yet some of the private owners in Germany were clearly not Nazi partisans; should the paintings be returned to their descendants?

In a related series of cases, the question of ownership rights for Native American ceremonial objects is being reevaluated in museums around the United States. The

Native American Graves Protection and Repatriation Act of 1990 requires federally financed museums to work with Indian nations on the return of ritual objects. Does the issue of cultural appropriation pertain to artifacts that show up in private collections as well? For example, I have before me a Hopi bowl, squarish in shape. Stylized "Kachina" faces are outlined in black and red on its surface, which has the opalescent yellow sheen typical of Hopi clay when it is fired. This is a medicine man's bowl, very likely made in the 1920s. If this sort of bowl is used in religious ceremonies within the Hopi community in Arizona, how has it wound up on my living room shelf?

4.10 Hopi bowl and other Native American pottery and baskets, author's collection.

Since the early decades of the twentieth century, as the first waves of Anglo tourists ventured West on newly constructed railways, Native Americans have created numerous objects expressly for sale. But this particular bowl bears traces of use, seen in the powdery discoloration of its interior. As an amateur collector, was I trespassing on sacred territory, a latter-day Raider of the Lost Ark? When I questioned the art dealer in New Mexico about whether the bowl should be sold at all, he assured me that the item had been acquired legally—a justification that, depending on your point of view, is ethical or merely convenient. As the foregoing discussion attests, questions about cultural property and representation have become pressing matters not only in galleries and classrooms but in the discourse of daily life.

WORKS CITED AND SUGGESTED READING

Barker, Emma, ed. *Contemporary Cultures of Display*. New Haven and London: Yale University Press and The Open University, 1999.

Clifford, James. *The Predicament of Culture: Twentieth-Century Ethnography, Literature, and Art*. Cambridge: Harvard University Press, 1988.

Corrin, Lisa, ed. *Mining the Museum: An Installation by Fred Wilson*. New York: New Press, 1994.

Drewal, Henry John, and John Mason. *Beads, Body and Soul: Art and Light in the Yorùbá Universe*. Los Angeles: UCLA Fowler Museum of Cultural History, 1998.

Duncan, Carol, and Allan Wallach. "The Museum of Modern Art as Late Capitalist Ritual: An Iconographic Analysis," *Marxist Perspectives*, I (1978), 28–51.

Greenberg, Reesa, Bruce W. Ferguson, and Sandy
 Nairne, eds. *Thinking about Exhibitions*. London and
 New York: Routledge, 1996.
Henderson, Amy, and Adrienne L. Kaeppler. *Exhibiting
 Dilemmas: Issues of Representation at the Smithsonian*.
 Washington and London: Smithsonian Institution,
 1997.
Karp, Ivan, and Steven D. Lavine, eds. *Exhibiting
 Cultures: The Poetics and Politics of Museum Display*.
 Washington, D.C.: Smithsonian Institution, 1988.
MacGaffey, Wyatt. "The Kongo Peoples." In *In the
 Presence of Spirits*. New York: Museum for African
 Art; Gent: Snoeck, Ducaju & Zoon, 2000, 35–54.
Merryman, John Henry, and Albert E, Elsen. *Law, Ethics
 and the Visual Arts*. 3rd ed. London, The Hague,
 Boston: Kluwer Law International, 1979.
Roberts, Mary Nooter, et al. *Exhibition-ism: Museums and
 African Art*. New York: Museum for African Art, 1994.
Schaffner, Ingrid, and Matthias Winzen. *Deep Storage:
 Collecting, Storing and Archiving in Art*. Munich and
 New York: Prestel, 1998.
Senie, Harriet F. *The "Tilted Arc" Controversy: Dangerous
 Precedent?* Minneapolis: University of Minnesota
 Press, 2001.
_____, and Sally Webster, eds. *Critical Issues in Public
 Art: Content, Context, and Controversy*. Washington
 and London: Smithsonian Institution Press, 1992.
⌐herman, Daniel J. and Irit Rogoff, eds. *Museum Culture:
 Histories, Discourses, Spectacles*. Minneapolis:
 University of Minnesota Press, 1994.
Sims, Patterson, et al. *The Museum: Mixed Metaphors*.
 Hong Kong and Seattle: Seattle Art Museum, 1993.
Stack, Trudy Wilner. *Art Museum*. Tuscon: Center for
 Creative Photography, University of Arizona, 1995.
St. Clair, William. "The Elgin Marbles: Questions of
 Stewardship and Accountability," *International Journal
 of Cultural Property* 8, no. 2 (1999): 391–521.
Thompson, Robert Farris. *Flash of the Spirit: African and Afro-
 American Art and Philosophy*. New York: Vintage, 1984.
Vergo, Peter, ed. *The New Museology*. London: Reaktion,
 1989.
Vogel, Susan M. *Baule: African Art, Western Eyes*. New
 Haven: Yale University Press, 1997.
Wattenmaker, Richard J., Anne Distel, et al. *Great French
 Paintings from the Barnes Foundation*. New York:
 Knopf, 1993.

Part One Conclusion

The Elements of Visual Analysis

Observe and question: As an active observer, you enter into a dialogue with an artwork.

Respond in writing: Writing is a visual record of your impressions. Through writing you explore and amplify your responses.

Describe form: Discussion of an artwork begins with careful description of visual elements—line, shape, color, value, texture. "Intelligent seeing" means recognizing and understanding the choices the artist has made regarding medium, subject, form and design.

Analyze effects: Formal analysis is a way of explaining how the visual elements you've described work together to form a whole composition.

Consider context: The context in which an artwork was produced and the setting in which it appears now are both part of the viewing experience. When you understand how an artwork functions in its culture of origin, the object resonates more powerfully in your own perceptions and thoughts.

Part One of this book has introduced you to the basic tools and methods for describing and interpreting visual artifacts. In Part Two, the case histories of individual writers will help you develop and organize your observations into clear, persuasive essays.

Essay Writing Strategies

PART TWO

5 Planning and Developing an Essay

"I write entirely to find out what I'm thinking, what I'm looking at, what I see and what it means."
—*Joan Didion, "Why I Write"*

In Part One of this book you've seen how writing is called into play from your earliest encounter with a work of art, whether you're scribbling notes on the back of a museum brochure or E-mailing a friend about an artist's Web site you've just visited. You've written personal responses, observations, descriptions, comparisons and brief analyses. Part Two presents a variety of strategies for developing these exercises into full-fledged essays. The chapters in Part Two follow the paths of individual writers as they address a range of essay assignments in art history. Taken together, these examples will guide you through the processes of planning, developing, structuring, and revising any essay you write.

It's important to keep in mind that although our discussion of essay writing is organized for the sake of clarity into separate chapters, the activities of drafting and revising are not so much consecutive stages as interwoven strands in the writing process. Thought patterns proceed in leaps and recursions rather than in a straightforward sequence of steps. This is how successive drafts operate in the writing process. Each insight leads you back to a revised view of your subject, initiating changes in the structure and content of your composition.

As we've seen in earlier chapters, the composing process usually begins with the writer's private notations. A writer's journal is like an artist's daybook or sketch pad: it is a place to work out a theme, try out various approaches to a subject, and pose questions for further study. Figures 5.1 and 5.2 illustrate the way one artist refines her idea into a finished composition.

5. 1 Mary Cassatt's sketch for the painting *At the Opera*, c. 1878. Graphite pencil on paper, 10.2 × 15.2 cm. (4 × 6 in.). Courtesy Museum of Fine Arts, Boston. Gift of Dr. Hans Schaeffer, 55.28.

5. 2 Mary Cassatt, *At the Opera*, c. 1878. Oil on canvas, 81.3 × 66 cm. (32 × 26 in.). Courtesy Museum of Fine Arts, Boston. The Hayden Collection, 10.35.

The page from Mary Cassatt's sketchbook (fig. 5.1) shows a preparatory study for her painting *At the Opera* (fig. 5.2). On the drawing, Cassatt has penciled a few notes to herself about the colors she plans for the painting. Take a moment to compare the study with the completed work, noting any changes you see between Cassatt's first thoughts on the subject and her "final draft."

For instance, if we follow the curve of the balcony on which the sitter rests her elbow, we find that Cassatt has added a small figure to the painting: a man peers through opera glasses in the direction of the woman in the foreground. Consider how this subtle change affects your "reading" of the painting. The man mirrors the viewer's gaze. We too are staring at the woman, who faces left, her eyes hidden by her opera glasses, just as her figure, hair, and hands are obscured by pose, dress, bonnet, and picture frame. Immersed in the spectacle, she resists being "read." Cassatt's idea of a spectator at the opera has been refined into a study of the act of looking: the object of contemplation is also an active viewing subject.

Cassatt has altered the main idea or "thesis" of her composition as she moves from the early drafting process to her final painting. Similarly, you'll find that elements of your written composition, including your thesis, may change, perhaps substantially, as you move through successive drafts to a version of the essay that satisfies you. Artists and writers typically develop a flexible model of composition. Sketching or drafting ideas on paper is a way of discovering meaning. The point of both the artist's sketchbook and the writer's journal is to provide a sheltered environment where the seed of an idea can germinate.

Case Study
Contextual Analysis of a Work of Art

Our first case study follows a writer along the exploratory route from first journal sketch to final draft of an essay. The student's writing assignment was similar to the one described in Chapter 3 of this book: analyze the forms and images of an artwork of your choice, taking into account the cultural context in which the object was created. You've already encountered the student and the

painting she writes about in Chapter 1 (you might want to have another look at Color Plate 1 before reading further). Below, we'll go through the steps that helped this writer develop her topic.

The techniques demonstrated in this chapter will help you plan and focus your essay, whatever topic you choose. Obviously, no single composing method works for all writers. Think of the following guidelines not as immutable rules but as suggestions and prompts for your own writing.

Recording Impressions

While visiting an exhibition entitled "Indian Court Painting, 16th to 19th Century" at the Metropolitan Museum of Art, our first writer, Mahwash Shoaib, was particularly taken with a painting that brought back memories of her native Pakistan. Touring the exhibition with an American-born companion, she was struck by differences in the way she and her friend responded to the painting. Out of their conversations grew the general idea for her essay.

At the outset, of course, the writer did not yet have a focus for her essay. She simply took careful notes on the dimensions, colors, and design of the painting so as to jog her visual memory later on. She was also fortunate enough to find a reproduction of the work (along with some brief commentary) in an exhibition catalog at the museum's bookshop. Reproductions can be deceptive: hues vary and subtleties are lost. As there is no substitute for face-to-face encounters with the object itself, many assignments ask you to write about a work of art you have visited (and, ideally, revisited) rather than one you know only from photographs. Still, it's best to keep a reproduction before you while you write.

Freewriting

At home, Shoaib transferred her thoughts from her notebook to the computer screen. Many writers today feel comfortable enough in front of the word processor to use it as a kind of "electronic journal." I've found that students tend to be less daunted by a blank screen than by a

blank legal pad, partly because the computer allows the user to cut and paste and generate clean copy so easily. The medium seems to free thoughts and facilitate revision. If, however, you're more comfortable drafting on paper, by all means stay with this method for the preliminary stages of your essay. Do try to put a draft on the processor as soon as you're able, for the purposes of revising, proofreading, spell-checking, formatting, and so on.

The writer let loose on her computer screen a flurry of impressions about the painting she had seen. This process is called *freewriting* because the writer simply lets the inner monologue flow onto the page with little concern for order or mechanics. Most students have experimented with this technique in their English composition courses. You freewrite to find out what you're thinking, as Shoaib does in these musings:

> Unraveling the fabric . . . Picking a painting to write about because you know its whole history is like playing a game in which all the rules have already been decided in your favor. On the other hand, you probably won't be attracted to a painting that is absolutely outside your frame of reference. . . . This work of art alludes to its contemporary world. Its original audience would have appreciated the historical, literary and artistic clues packed into this Persian miniature. A lot of these clues were lost on me, but I still immediately responded to the painting. [My friend] didn't like the painting as much as I did—she didn't seem to see as much in it as I did. But I think that with a little background information, any modern (or Western) viewer can understand and appreciate what is distinctive about the painting.

Shoaib reasoned that her companion hadn't been able to "see" the distinctive elements of this painting because she was unfamiliar with the artistic conventions of Mughal miniatures. (Mughal paintings are those produced in Islamic India, principally during the sixteenth and seventeenth centuries.) She concluded that "with a little background information," any viewer can appreciate the work. But what kinds of background information, and how much, should the author supply?

Browsing: Conducting Preliminary Research

Shoaib began browsing in secondary sources on Mughal art. For some writing assignments your instructor will ask you to rely on your own observations, without the help of secondary research. For most assignments, however, some outside reading on the topic at the outset of your project will help you focus your thoughts. You might begin by researching the historical era in which an artist worked, or the relationship of the work to the artistic trends of its time. The important point to remember is that your own observations of the artwork are paramount; research, when used, helps you substantiate your analysis.

The writer began her library research by consulting general surveys of Mughal art but found little written specifically on her painting. I asked Shoaib how she proceeded at this point. Here's her explanation:

> I carried out preliminary research in the campus library, where I found excellent material on Indo-Persian miniatures, and in the Modern Language Association (MLA) bibliography, which directed me to various books. I soon realized that besides the sketchy information provided in the catalog for the exhibition of "The Court Paintings of India," where I first saw *Bahram Gur Watching Dilaram Charm the Wild Animals with Her Music,* there wasn't much specific material on my painting.
>
> I decided to do research on Khusraw, the poet who wrote the story, both on the computer (where I made two positive hits) and in books on Persian literature. I also researched the real-life figure of Bahram Gur and found several references to the legend of Dilaram, his harp-playing female partner, pictured in my painting. I then turned back to some of my preliminary sources for commentary on other paintings by the artist, Miskin.

Narrowing the Topic and Formulating a Thesis

Shoaib typed out questions prompted by her notes on the painting and her outside reading. Her list of questions, below, shows a number of interesting roads she might have

taken. For instance, she might have written about parallels between the Greek myth of Orpheus and the Persian legend illustrated in the painting, or focused on the political and social climate of the Mughal court during the reign of the emperor Akbar, or discussed the religious significance of various iconographic elements in the painting.

Obviously, Shoaib could not have treated all these subtopics adequately in an essay of three to five pages. She had to limit the topic to get a handle on it. As you can see, she eventually crossed out half the items on her list. She narrowed the focus of her essay by process of elimination.

> Questions:
> Do I like this miniature more than [my friend] does because I know more about the subject? What else does the viewer *need* to know? e.g.:
>
> What is the exact narrative scene this painting is meant to illustrate?
>
> How does the scene change in different versions of the story?
>
> ~~Is Dilaram the harp-player and enchantress related to a figure from Western mythology like Orpheus?~~
>
> ~~How does she change from one version of the poem to another?~~
>
> ~~Regarding the title of the manuscript, does the Islamic tradition of *Hasht Behesht* (Eight Paradises), that is, of paradise as a garden and vice versa, have any relation to the layout of the painting?~~
>
> ~~Who is the "author" of the work: Akbar, the emperor who commissioned the work; Miskin the main artist; Miskin's assistant(s); the two poets who wrote versions of the story illustrated here; or the viewer?~~
>
> How is this painting "typical" or "atypical" among Persian miniatures?
>
> Which characteristics are typical of Miskin's paintings?
>
> What are the features of art produced in Akbar's court?
>
> ~~What changes occurred when the Mughal court shifted to Lahore?~~

Having limited her topic, Shoaib was able to formulate a thesis for her essay. In Chapter 2, we looked at how authors use a thesis, or controlling idea, to give shape and purpose to their observations. The thesis of an essay is

the central idea of the paper; your thesis statement is the specific assertion you intend to "prove" with concrete illustrations in the rest of the paper. The thesis should be focused and stated up front (in a short essay, this usually means by the end of the first paragraph or two), so that readers quickly understand the gist and direction of the essay. The thesis of Shoaib's essay, stated in the second paragraph of her final draft, is this: Miskin's painting of *Bahram Gur* "illustrates the way various artistic traditions came together to form a distinctive Mughal style of painting in the court of the emperor Akbar."

Outlining: Mapping a Route through the Essay

To guide her in drafting the essay, Shoaib made a *topic outline:* she listed the main points she wanted to cover and then experimented with reordering them to form a rough map of the direction she planned to follow in her paper. Some writers choose to make a more detailed formal outline of topics and subtopics. Others prefer to jot down notes on index cards and then rearrange the cards to organize the essay. I've even seen writers sketch out diagrams and flowcharts with arrows and thought balloons as a way of shaping their ideas. Choose whatever method you're most comfortable with. These planning techniques are simply meant to help you envision a coherent structure for your material—to see how the pieces fit together.

It goes without saying that you can add to or subtract from your topic outline, or reorder its elements, or incorporate new research, after you've begun writing. The point of the exercise is that you (and eventually your readers) should be able to see clearly how and why you move from one paragraph to the next. In fact, the best way to check the structure of your final essay is to make an outline of what you've written, after the fact. Here is the map of topics Shoaib eventually produced, arranged in the order in which she thought they might logically be discussed in her essay:

Intro: Contrast cultural perceptions of the Mughal miniature. Viewers from any culture can appreciate this artistic form if given basic background information.

Definition of Mughal miniature, showing confluence of
several different artistic traditions: Persian, Indian,
Chinese, European. (But note that influence flows in
both directions: Western artists such as Rembrandt
were influenced by Persian miniatures.)

Formal description of the painting, taking into account
the various elements that go into the production of
Mughal manuscript illustrations.

—Patron: Akbar (the most influential and cosmopol-
itan of the imperial patrons).

—Workshop: Akbar's international atelier.*

—Poet and story: Khusraw's manuscript, his 2
sources, and the particular scene depicted here.

—Artist: characteristic style of Miskin, the main
artist who painted the miniature.

Conclusion: how all these elements come together in the
formation of a Mughal artistic tradition.

*An *atelier* is a collabora-
tive studio or workshop
of artists.

Drafting the Essay

Shoaib began drafting by filling in details under each of
the paragraph headings on her list, using her own obser-
vations and insights together with information she con-
tinued to gather in her ongoing reading. She roughed out
and rearranged her ideas in several drafts. Since essays
have a way of morphing and shifting direction during
the drafting process, Shoaib did not compose an intro-
ductory paragraph until most of the essay had been com-
pleted. Writers typically hold off writing the final version
of the introduction until they are satisfied that their ideas
have jelled.

Composing an Introduction

An effective introduction accomplishes several objec-
tives. Its first purpose is to engage readers. As you write,
imagine reading your essay aloud to your classmates as
well as your professor. Your goal is not only to please
yourself and your professor but to appeal to this broader
audience of educated readers who might be less familiar
with your topic—and who might need convincing that
the subject merits their attention.

The opening of a short paper invites readers into the
essay by providing context and direction. If you spend

too much time clearing your throat, so to speak, before coming to the point, your audience will wander. No one wants to read a paper that begins, "Making art is often a painstaking process. One of the most challenging feats of human ingenuity is the painted miniature. Many of these tiny masterpieces were produced in India, particularly between the sixteenth and eighteenth centuries . . ." or some such general blather. If your introductory paragraph doesn't have bite, doesn't contribute anything of note to the essay, try lopping it off and opening instead with a revised form of your second paragraph. In the introduction to her completed essay, Shoaib establishes the background and purpose of her discussion, provides identifying data for the object (title, artist, medium, date, size, collection), suggests a framework for the essay that follows, and leads into her thesis statement in the second paragraph.

Developing Conclusions

Students sometimes tell me they've been taught to conclude an essay by saying "In conclusion . . ." and then repeating the thesis of the paper. This is puzzling advice. If an essay ends where it began, why bother with the middle? The purpose of the conclusion is to show what has happened to the thesis during the course of the essay: it has been proved or substantiated by means of illustrations, examples, analysis. Your conclusion should imaginatively restate the thesis in light of the evidence you have provided in the intervening paragraphs.

If you end your paper without tying up loose ends, or you suddenly introduce a new topic in your last paragraph, readers may think they've misplaced the last page of your essay—our expectation of closure is that powerful. You convey to your reader a sense of completion not with repetition but with proof. If the illustrations are inadequate, the conclusion is unearned. In the final paragraph of her essay, Shoaib gathers up the main points she has discussed earlier and uses her research to restate her observations about this particular manuscript illustration within the larger context of Mughal painting.

Please keep in mind that Shoaib's completed work, like all the final drafts reprinted in the next several

chapters, is the product of considerable revision. As you read, note how each paragraph moves the argument forward by illustrating some aspect of the thesis with *specific examples* drawn from the writer's observations of the painting as well as from outside sources. Once you have read through the essay, we'll go back for a closer look at the author's strategies for incorporating research into the essay.

Reading a Mughal Miniature

by Mahwash Shoaib

Looking at Mughal miniatures can be physically exhausting for Western observers who are new to this art form. The lack of illusionistic perspective confuses many viewers. The abundance of paintings illustrating the same literary theme becomes tiresome. Unfamiliarity with the rich tradition of manuscript illustration generally undermines the viewing experience. For the Eastern viewer versed in these matters, however, each miniature possesses distinctive elements that set the work apart from others of its kind. The trained eye can detect the focal point and distinguishing characteristics of such paintings. For instance, in the manuscript illustration at the Metropolitan Museum entitled *Bahram Gur Watching Dilaram Charm the Wild Animals with Her Music* (gouache on paper, 24.5 × 15.1 cm. [$9^5/8$ × 6 in.]; 1597–1598), the focal point of the rather crowded composition is the literary heroine Dilaram, seen in the upper left quadrant of the picture.

With a little background information about Mughal painting and about the literary text on which this particular painting is based, viewers can understand and appreciate the miniature for the highly refined and distinctive masterpiece that it is. The painting presents an interesting case for contextual analysis because it illustrates the way various artistic traditions came together to form a distinctive Mughal style of painting in the court of the emperor Akbar.

During the reign of Akbar (1556–1605), the most influential Mughal emperor of India, artists working in the

here, however, Bahram watches Dilaram, emphasizing her central role in the action. Dilaram, wearing a pinkish robe over a pale-violet dress, plucks the strings of a swan-shaped harp. She sits on the ground in the upper left quadrant of the painting, seemingly oblivious of her audience, a small smile playing upon her lips. Bahram Gur, bearded and wearing a golden-orange robe, sits across from her, though on a higher pedestal-like rock. Bahram extends his palm upward toward Dilaram, either in praise or in token of friendship: she appears to ignore—or rebuff—his gesture by not even meeting his glance. His sword, parallel to her harp, rests on the ground. It is as though Bahram, like the animals that fill the rest of the landscape, has fallen motionless, powerless, under the spell of Dilaram's music.

Miskin, to whom *Bahram Gur* is attributed, was the artist in the royal atelier best known for his prowess in animal painting and thus was the logical choice to illustrate this subject. The painting demonstrates what Amina Okada identifies as Miskin's "adeptness at dense, swarming yet perfectly balanced composition" (128). In keeping with the hypnotic subject of the painting, a consistent mood of serenity and stillness characterizes all the creatures, animal and human. A golden-antlered antelope, its body curved in profile to the viewer, scratches its ears with its back hoof. A fox grins straight at the viewer from his rocky cave. Indeed there seems to be more expressiveness in the animals' faces than in the humans'. This last feature seems to be a drawback of Miskin's painting in general; the limitations of his skill as a portraitist (Okada 133) are evident in the almost expressionless faces of Bahram and Dilaram.

Several other features mark the painting as Miskin's. The grinning fox resembles the "dippy lioness" Stuart Cary Welch observes staring out at the viewer in other illustrations by Miskin (57). The touch of evening in the smoky, muted foreground, the darker tints of green in the foreground, and the leaves of the tree caught in the last rays of the sun are Miskin's trademark lighting effects. The precarious and slightly zoomorphic* outcropping of rocks behind Dilaram and Bahram is a Persian convention, while the bluish-purple haze and the distant village

*Animal-like in form.

royal atelier, or workshop, were able to draw inspiration from a number of cultures. Working collaboratively, they combined existing Indian subjects with a concern for naturalism (probably stimulated by Chinese drawings that had been brought into Central Asia a century earlier) and with the precision and elegance of Persian miniatures. In addition, Akbar actively collected European prints of Flemish masters, from which his artists copied the spatial depth and shading effects missing in earlier Indo-Persian manuscripts (Rogers 61–73).[1]

The painting of *Bahram Gur* is part of a manuscript illustrated by Akbar's atelier. The author of the manuscript, entitled in Persian *Hasht Behesht* (Eight Paradises), was the poet Amir Khusraw (1253–1325), a trilingual man of letters as well as a musician. Khusraw's poem was a variation on two earlier versions of the legend of the hunter-king Bahram Gur. The episode of Dilaram and Bahram is as follows (I've noted important variations in details from one manuscript to the next): Bahram and Dilaram go out hunting and come upon a herd of gazelles. Dilaram challenges Bahram to pin a single arrow through a gazelle's ear and hoof. Bahram succeeds, but Dilaram refuses to acknowledge his skill. They quarrel, with different consequences in the three versions of the story. In the earliest version the heroine is trampled to death. In the second version she proves herself by an extraordinary feat of physical strength, whereupon Bahram marries her. In Khusraw's version, Dilaram goes into exile and is tutored by a wise man who teaches her the art of hypnotizing creatures with music. Hearing of her fame, Bahram comes to see her. She revives the dead animals he has killed and shows him the folly of his deeds, at which point Bahram repents and marries her.

With this story in mind, we can see the painting's details and images more clearly. In earlier illustrated versions of this story, Bahram occupies the more prominent position in the composition, and the heroine is seen watching Bahram perform. In the episode reproduced

[1]We should note here that these cultural influences flowed both ways: Ettinghausen cites Rembrandt as a major collector of Mughal miniatures who "not only copied them . . . but . . . introduced certain of their motifs into his own work" (*Paintings* n.p.).

of tall buildings is Miskin's acknowledgment of the European techniques of atmospheric recession he learned while in the royal atelier.

Even in this brief analysis we can see how the poet, the patron, and the artist left their distinctive imprint on the art form of Mughal manuscript illustration. The poet Khusraw made use of earlier versions of the legend and then let his heroine evolve into a more significant character in the story. Under Akbar's patronage, court painters were exposed to, and borrowed from, international artistic trends. And Miskin's art, particularly this *Bahram Gur*, shows how the Mughal form evolved from its Persian and Chinese roots by assimilating Western elements into the continuum of Indo-Persian miniature painting.

Works Cited

Ettinghausen, Richard. *Paintings of the Sultans and Emperors of India in American Collections*. New Delhi: Jaipur House, 1961.

Okada, Amina. *Indian Miniatures of the Mughal Court*. Trans. Deke Dusinberre. Paris: Flamarion, 1992.

Rogers, J. M. *Mughal Miniatures*. New York: Thames and Hudson, 1993.

Welch, Stuart Cary. *Imperial Mughal Painting*. New York: Brazillier, 1978.

Incorporating Research into Your Essay

Research should help you develop and corroborate your thesis, not act as a substitute for your own thoughts. As you read what others have said about your subject, you compare opinions, make inferences, and choose the evidence you think most effectively supports your ideas. In the essay reprinted above, notice that the writer uses quotation sparingly. You make the material your own by putting your own ideas in the foreground, by using fewer and shorter quotations, and by paraphrasing—that is, by restating an idea in your own words.

Of course, even when paraphrasing, you must cite the source of an idea or statement. If you fail to do so, whether intentionally or because of carelessness, you are plagiarizing: that is, taking someone else's perceptions or research and passing them off as your own. Here are the

ground rules for using research in your essays, with examples drawn from Shoaib's final draft:

- Don't depend heavily on just a few sources. If you have more than a couple of notes for any one page of your essay, or too many notes from a single source, you're probably not using research judiciously.
- Quote accurately. This means careful notetaking during your research as well as meticulous proofreading of your final copy against the original.
- Use a quotation as a springboard for your own thoughts; in other words, when you use a quotation to state a theme, go on to develop the paragraph by offering your own observations and conclusions. Try to fit the quotation or paraphrased idea smoothly into your paragraph. For instance, Shoaib writes in her final draft, "Several other features mark the painting as Miskin's. The grinning fox resembles the 'dippy lioness' Stuart Cary Welch observes staring out at the viewer in other illustrations by Miskin (57)."
- Be scrupulous in acknowledging indebtedness to others. Cite the source of any ideas you've borrowed, whether you're quoting a single significant phrase (as in the foregoing example of the "dippy lioness"), paraphrasing, or applying a writer's observation to your own subject, as in this sentence from Shoaib's essay: "This last feature seems to be a drawback of Miskin's painting in general; the limitations of his skill as a portraitist (Okada 133) are evident in the almost expressionless faces of Bahram and Dilaram."
- Introduce direct quotations by identifying the speaker ("demonstrates what Amina Okada identifies as") or the source (e.g., According to several recent reviews in the *Art Journal* . . .); don't just leave the quotation hanging out there anonymously.
- Consult Chapter 9 of this book for instructions on how to document your sources in footnotes and bibliography—and be consistent in the citation format you use. Instructors usually recommend one of two methods for citing sources in researched essays: the *MLA Handbook* style or the *Chicago Manual* style. In the case studies in this chapter and the next, therefore, both formats are illustrated.

The writer quoted above uses the parenthetical method of citation recommended in the *Handbook* of the Modern Language Association and generally favored in the humanities. According to this method, brief parenthetical citations within the text refer to a list of "works cited" at the end of the paper. In contrast, the writer quoted in Chapter 6 uses the *Chicago Manual* method, which is favored by art historians. According to this format, footnote numbers in the text refer to a list of detailed citations, in addition to a list of "works cited." Chapter 9 explains both methods of documentation.

6 Structuring an Essay

"The whole of anything is never told; you can only take what groups together."
—*Henry James, notebook entry, December 1880*

Cognitive psychologists tell us that humans tend to organize visual data into recognizable patterns. This seems to be an instinctive process of perception that allows us to spot inconsistencies in point of view or "holes" in the logic of a visual image. Remember those childhood puzzles that asked, "What's Wrong with This Picture?" William Hogarth's famous illustration of inconsistent perspective (fig. 6.1, on facing page) depends on the viewer's ability to identify visual incongruities.

Similarly, readers look for consistent patterns in writing. They're likely to become lost or nettled if there are gaps in the logic of an argument or if some element in a paragraph seems out of place. It is the writer's job to put the picture straight by making the organizing principle of the essay clear and accessible to the reader. This chapter illustrates methods for organizing paragraphs and structuring essays.

Case Study
Formal Analysis and Comparison/Contrast

In Chapter 5, we observed how a writer develops her topic from first impressions to final draft. In this chapter, conversely, we'll start by looking at the final draft of an essay, to see what techniques the author has used to structure her argument. As you read the finished essay (again, remember that this student's essay is the product of much revision), note how the author, Baz Dreisinger, nails down the framework of her argument with sharp

6.1 William Hogarth, "Frontispiece" engraving for J. Kirby's *Dr. Brook Taylor's Method of Perspective Made Easy in Both Theory and Practice,* Volume 2, 1753.

introductory sentences for each paragraph and supports each statement with concrete, observable details.

Note, too, farther along in the essay, how the author uses another common strategy for developing and structuring analysis: comparison/contrast. For this assignment, students were asked to describe the distinctive features of a portrait and to analyze the means by which the artist conveys the sitter's personality, gender role, and social position. Although the assignment did not specifically call for comparison/contrast, this author chose to develop her analysis by comparing her subject with two other portraits by the same artist. To highlight the author's techniques for organizing the essay, I've outlined the progress of her argument in the margins.

The Private Made Public
Goya's *Josefa Castilla Portugal de Garcini y Wanabrok*

by Baz Dreisinger

When Josefa Castilla Portugal de Garcini had her portrait painted in 1804 by the highly acclaimed artist Francisco Goya, she was well into her pregnancy. A woman of majestic proportions and, owing to her Flemish ancestry, light hair and features, Doña Josefa posed in what Ives and Stein call "confined-to-the-house hair and dress."[1] But how can this informal state be depicted appropriately in a formal portrait? Can the private be made public? Goya seems to have grappled with these questions as his subject sat before him. His portrait of the sitter probes the tension between her public and private selves, ultimately presenting us with an intimate—almost intrusive—look at a woman who is not quite in a state to be gazed upon. Doña Josefa, whose portrait hung in the Garcini home in Madrid together with Goya's portrait of her husband, Don Ignacio Garcini, is simultaneously uninhibited and contained. She radiates informality and fecundity, but at the same time, Goya makes us, and himself, present in the work by suggesting in several ways the sitter's tense awareness of a voyeuristic eye.

In her portrait (oil on canvas, $41'' \times 32^3/\text{8}''$), now in the Metropolitan Museum in New York, Doña Josefa, wife of the Brigadier of Engineers, wears a white, empire-waist dress that resembles a nightgown; she sits on a cushion, possibly a bed or couch, which Goya painted in shades of red, yellow, and orange. Doña Josefa faces us, her elbows bent and her hands joined over her belly, where they clutch a small, closed fan. Her straight blond hair falls loosely down to her buttocks on her left side, brushing past her breasts and reaching her arms. Below the horizontal line formed by her joined arms, Doña Josefa's legs turn to her right and are cut off at the knees by the picture frame. Goya uses shades of gray to render the creases at the bottom of her dress, and a thin blue line marks its empire waist. Doña Josefa's fair skin is marked by pink blushes on her cheeks, chest, and fingers. The painting's stark black background contrasts with her pallid features.

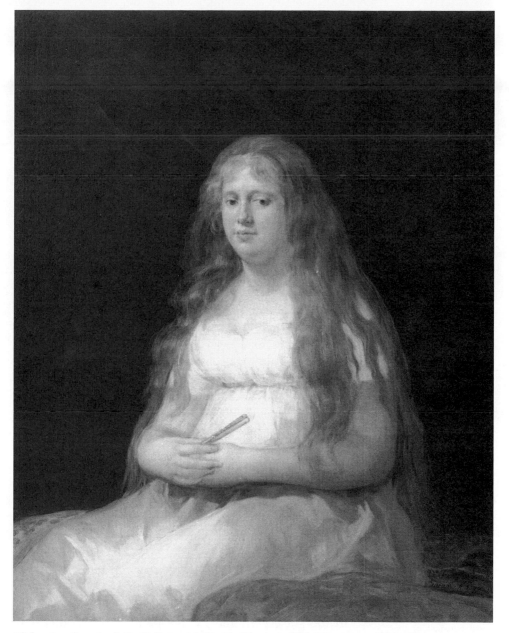

6.2 Francisco Goya, *Josefa Castilla Portugal de Garcini y Wanabrok*, 1804. Oil on canvas, 112.4 × 78.1 cm. (44^{1}/4 × 30^{3}/4 in.). The Metropolitan Museum of Art, New York. The H. O. Havemeyer Collection, Bequest of Mr. H. O. Havemeyer, 1929. (29.100.180)

3.
Begins interpreting elements of the painting in light of thesis

Although Doña Josefa poses for a formal portrait, her appearance is marked by informality. She does not sit on a chair or stand in a dignified pose; she sinks into a soft cushion. If this surface is a bed, we may be intruding on the sitter in her boudoir, where she perhaps has donned a nightgown. Doña Josefa is quite close to the picture plane, heightening our sense of intimacy with her. Though, as Ives and Stein note, Josefa "guards her midsection apprehensively," Goya places her pregnant stomach at eye level, thus calling attention to the intimate thing she seeks to conceal.[2] She is also placed rather low on the picture plane: a full quarter of the painting, consisting simply of a dark background, hovers over her head. She seems a compact and weighty figure who is sinking toward the bottom of the canvas. Instead of an ethereal type in lace and corsets, this is a robust woman who has not taken the time to contain herself in formal attire. Doña Josefa's heavy physicality, in conjunction with the healthy pink flushes that speckle her skin, is a mark of her pregnancy.

4.
Discusses technique

Observes how Goya's loose brushwork enhances the impression of informality

Goya's painting technique complements the unconfined image he paints of the sitter. Like many works of Velasquez, Goya's Spanish predecessor whose work he knew well, Goya's portrait of Doña Josefa has a visual realism that looks best from afar. The creases in her dress, for instance, attain their dimensions from a distance. Goya paints her hair, particularly the wisps framing her face, in diaphanous strokes. Few sharp lines delineate her body outline; her arms, for instance, are of one texture, with no defining wrinkles. Just as the sitter herself is unbound, so Goya's brushwork is loose, soft, unbound.

5.
Introduces first comparison/contrast

Two similar subjects painted by the same artist: but the Chinchón portrait is less intimate than the Garcini portrait

(See fig. 6.3.)

Painting women who were well into their pregnancy was not a new challenge for Goya, but with Doña Josefa's portrait he seems to have taken a more intimate approach to the subject. In 1801, Goya painted the Countess of Chinchón, who, like Garcini, was pregnant at the time of her sitting and holds her hands atop her belly as though to conceal this fact. The countess sits on a chair wearing a white empire-waist dress, her blond hair gathered atop her head and shaped by wheat sprigs, traditional sym-

6.3 Francisco Goya, *Countess of Chinchón*, 1800. Oil on canvas, 215.9 × 143.5 cm. (85 × 56³/₄ in.). Duque de Sueca Collection, Madrid.

bols of fertility. Perez Sanchez and Sayre note that Chinchón "has an air of timidity that is magnified by the emptiness of the sitting room" in which she sits.[3] Many of these elements—Chinchón's fecundity, her style of dress, her timidity—parallel Garcini's portrait. But unlike Doña Josefa, the Countess of Chinchón appears ready to receive the public. She sits on a chair, not a bed; her hair is

Essay Writing Strategies

6.
Transitional phrase

Develops contrast by
elaborating on Goya's
depiction of Josefa's
sensuality

styled; she wears bracelets and a bonnet; and she is placed farther back from the picture plane, which distances her from our gaze.

Doña Josefa, on the other hand, radiates a sensuality that seems unfit for public consumption. Her hair, perhaps her most prominent feature, cascades down her figure. If a woman's hair is the symbolic barometer of her sensuality, then Doña Josefa's loose-flowing tresses mark her as an erotic object. Significantly, Goya emphasizes her genital area by darkening it into a prominent gray triangle, the darkest spot on her white dress. Beneath this triangle, the outline of Josefa's legs is sharply defined in light shades of gray. A number of triangles characterize the composition, Josefa's head forming the apex of each. The first ends with a blue line marking her empire waist; the second with the arms she folds across her stomach; the third at the line where her buttocks meet the cushion; and the fourth at the bottom of the painting. This triangular format serves to enclose Josefa, as though Goya is attempting to contain her unbridled sensuality. The position of the sitter's arms forms the most complete triangle in the portrait; her rigid arm position indicates Goya's effort to impose a formal pose on his subject's informal appearance as well as her attempt to conceal her pregnancy, to enclose herself and thereby keep viewers at a distance.

7.
Examines tension created
by the artist's/spectator's
transgression of private
space

Thus Doña Josefa's enclosure within the composition is one way in which the artist incorporates the public gaze into a seemingly private encounter. Goya draws us further into the portrait by dropping additional clues that this private self is indeed in the process of receiving the company of Goya and, by implication, a larger audience. Doña Josefa's blush, as well as the tension in her arms, suggests her discomfort. The unrelieved blackness of her backdrop heightens our sense of her anxiety: that is, the stark background engulfs her already compact figure, making her appear apprehensive. Moreover, following the line of Doña Josefa's hair brings our attention to Goya's signature and his subject's name, placed right beside her buttocks. It seems as though Goya is reminding us of his—and by extension, the viewer's—transgression of Doña Josefa's privacy.

Even the subtlest details of Goya's portrait convey tension between revealing and concealing, between public and private personae. Doña Josefa's right eye avoids our gaze while her left eye engages it. Half of her ear is revealed while half is obscured by her hair. Above the sitter's arms, her torso faces us directly; her legs, however, turn away from us toward the left. The closed fan that Doña Josefa holds atop her stomach, pointed toward her enclosed womb, seems a mere trapping of formality in an otherwise informal setting. The fan reminds viewers that though we intrude on private domain, Doña Josefa remains aware that she is indeed receiving company. Thus while our glimpse of her is, in many ways, an intimate one, Goya never allows us to forget that through the act of portraiture this private self is being brought into the social sphere—and that our voyeurism has not gone unnoticed.

8.
Shows how subtler details of the work contribute to the viewer's awareness of intruding on private domain

Finally, Goya calls attention to Doña Josefa's private self by way of contrast with her stately "other half." Whereas the artist places Doña Josefa in a space that is somewhere between the boudoir and the salon, he paints her husband in an unambiguously public light. Indeed, the two portraits could not be more mismatched. Don Ignacio Garcini stands in his uniform of the Corps of Engineers, thrusting his chest out proudly. One of his hands clutches his phallic sword hilt, as though to assert a masculine pose, and the other is placed beneath his jacket. While Goya paints Don Ignacio as an external, active man of the world, he presents his wife as one who should not even be receiving company. Garcini's insignias and uniform suggest his rank and position, while Doña Josefa could be of any class. The precise, bold lines with which Goya paints the husband contrast with the diaphanous brushwork that characterizes the portrait of the wife. These contrasts between the pair of portraits clearly fall along gendered lines: the husband is allotted a public, exterior position in the world while his wife is relegated to the interior realm of the home.

9.
Concluding transition

Introduces second comparison/contrast: the companion portrait of Doña Josefa's husband, Don Ignacio. Differences reveal gendered nature of each portrayal

(See fig. 6.4.)

Goya's portraiture was, according to Sarah Symmons, "his glory, the greatest source of artistic freedom." The original achievements of the individual portraits, she

6.4 Francisco Goya, *Ignacio Garcini*, 1804. Oil on canvas, 104.1 × 83.2 cm. (41 × 32³/₄ in.). The Metropolitan Museum of Art, New York. Bequest of Harry Payne Bingham, 1955. (55.145.1)

10.
Conclusion

Elaborates thesis in the larger context of Goya's achievements in the art of portraiture

Underscores role of viewer/voyeur in the creation of the work of art, through sitter's and viewer's awareness of the gaze

continues, "are clearly meant to intrigue and perplex the spectator."[4] Goya's portrait of Doña Josefa engages viewers in just this sort of conscious participation. Doña Josefa's portrait is riddled with paradoxes: she is simultaneously public and private, rigid and relaxed, external and internal. Unlike her husband, whose role in the world is clearly established in his portrait, Doña Josefa remains on the cusp of two demarcated, and opposite, worlds. The uneasiness of her position mirrors the viewer's. We are invited into her private space, but we are never quite at home there; instead, we are perpetually aware of the invasiveness of our gaze.

End Notes

1. Colta Ives and Susan Alyson Stein, *Goya in the Metropolitan Museum of Art* (New York: Metropolitan Museum of Art, 1995), 23.

2. Ibid.

3. Alfonso Perez Sanchez and Eleanor Sayre, *Goya and the Spirit of Enlightenment*, exh. cat. (Boston: Museum of Fine Arts, 1989), 141.

4. Sarah Symmons, *Goya in Pursuit of Patronage* (London: Gordon Fraser, 1988), 126, 131.

Linking with Transitional Words and Phrases

Let's begin by considering a rather superficial device for structuring essays. Writers often link paragraphs by means of connecting words and phrases called transitions. As illustrated in the essay reprinted above, such devices include the repetition of key words ("portrait"; "private"; "Doña Josefa"); demonstratives ("*this* painting"); and specific transitional phrases and words ("on the other hand"; "but unlike Doña Josefa"; "for instance"; "thus"; "moreover"; "finally"). Writers use transitions like these to indicate relationships between units of discourse—similarities and differences, causes and effects, sequences in time, and so on.

Unfortunately, inexperienced writers overdepend on these connectors as a kind of cosmetic solution for smoothing the surface of an essay. Keep in mind that such devices, while indispensable, merely create what linguists call "surface cohesion"; they won't disguise illogic or an insufficiency of proof. What really unifies your argument and propels your thesis is your ability to develop the essay by moving comfortably from each general statement to its concrete illustration.

Structuring with Topic Sentences

One of the most effective methods for unifying your essay is to formulate a topic sentence for each paragraph, showing your reader how each paragraph is related to your thesis. Just as your thesis statement announces the main idea of your essay, a topic sentence lets the reader know what aspect of the thesis you intend to substantiate

in this particular paragraph. It is the general point that the paragraph goes on to corroborate with specific illustrations, examples, and descriptive details.

Of course, a page in any book will show you that some paragraphs lack clear topic markers and that some topic sentences are placed at the end of the paragraph as a summation of evidence. Still, at the risk of sounding like a martinet, I usually advise essay writers that it's simplest to state the point they want to make at the opening of each paragraph of analysis. Why?

The fact is that in exposition and analysis, topic sentences provide guidance for writers and readers alike. You've probably noticed that when you narrate a story or give someone directions, the sequence of events or steps seems to evolve fairly naturally (insofar as any rhetorical technique can be said to be natural), because one event or step follows another in time: yesterday, this morning, an hour ago; first, second, third. But there's no comparably "natural" sequence of steps in description or analysis or argumentation: the rhetorical choice is up to you.

Remember that the structure of your reasoning in an essay may be obvious to you but invisible to your readers. You need to make the organizing principle of your writing apparent by bringing the underlying framework of the essay up to the surface. The details you've grouped together in a given paragraph should be related to one another in a way that is clear to your readers.

Organizing Description and Formal Analysis

We've remarked that readers need to see larger patterns first, to understand how each element fits into the picture. Dreisinger begins by sketching the outlines of the composition before filling in the specifics. Following her introduction and statement of thesis ("His portrait of the sitter probes the tension between her public and private selves . . . "), the writer gives us, in paragraph 2, an overview of the basic components of this portrait: the sitter's identity, pose, clothing, props, and general features; the painting's stark background, composition, colors, and patterns of light.

Having thus set the scene, the writer is able, in paragraph 3, to make inferences on the basis of what she has observed—that is, to move from description to formal analysis. She explores the significance of the individual elements she has described by analyzing how they work together in the composition as a whole. At the opening of paragraph 3, the topic sentence focuses on the informality of the portrait. The rest of the paragraph then supports the abstract idea of "informality" with further concrete description: the unadorned setting seems to be a boudoir; the sitter wears a light garment resembling a nightgown; her robust and unbound figure is positioned low on the canvas and close to the picture plane, in intimate relation to the viewer. In paragraph 4, the author elaborates on her thesis by showing how Doña Josefa's "unconfined image" is conveyed, as well, by Goya's loose, "unbound" brushwork.

In other words, description and analysis should begin with an overview rather than proceeding arbitrarily from point to point around an object. You describe with your thesis in mind. The author makes her point with the introductory sentence of the paragraph, and then marshals evidence to support that assertion.

Structuring Comparison/Contrast

We've seen how Dreisinger introduces, describes, and analyzes the prominent features of her portrait in the first half of her essay. But she wants to draw further implications from her material, and for this she employs another analytic strategy, one we know from earlier chapters of this book: comparison/contrast. Art historians use comparisons and contrasts (that is, they point to similarities and differences between two like objects) as a way of examining the choices an artist has made.

In Chapter 1, we noted that the comparative method has been fundamental to art-historical analysis virtually from the inception of the discipline. The comparison of two artworks remains one of the most frequently assigned writing exercises in art history courses. In a full-fledged comparison/contrast, you give equal weight to both items of comparison and cite the same kinds of

evidence for both sides. For instance, in our comparison of Raphael's and Sherman's "versions" of "La Fornarina" in Chapter 1, we compared the two works with regard to medium, formal arrangement, subject matter, iconography, and so forth.

Although our author was not assigned a comparison/contrast essay, the comparative method suggests itself quite naturally in this case: as Dreisinger points out in paragraph 1, Goya painted a companion portrait of Doña Josefa's husband. The two paintings were originally hung together in the Garcini home in Madrid, and they are still paired on display today at the Metropolitan Museum. The contrasts between the two pictures help Dreisinger clarify (in her own mind as well as her reader's) what she believes to be Goya's formal and thematic concerns in the painting of Doña Josefa. In addition, Dreisinger compares Doña Josefa's portrait with a second portrait by Goya of a pregnant woman. Both comparisons are used to underscore the unusually private and informal nature of Goya's portrayal of Doña Josefa.

You can see more clearly what is distinctive in example A by placing it side by side with example B. A few key points will guide you in writing comparative analyses:

- Choose objects that share at least some fundamental characteristics: your comparison shouldn't seem forced or arbitrary.
- Keep in mind that the object of a comparative essay is to highlight one or two special features of the artwork or works you're considering.
- Begin with a general statement about what you intend the comparison to reveal.
- Cite the same kinds of evidence for both items you're comparing.
- Adopt a consistent method for structuring your comparison/contrast: either the *alternating method* or the *block method*, both described below.

The two methods for structuring a comparison/contrast, the *alternating method* and the *block method,* are both illustrated in the essay you've just read. In the *alternating method* of comparing and contrasting, discussion of both works is interwoven and evidence is organized point by

point. Dreisinger uses this structure in paragraph 9 of her essay, where she contrasts Goya's portrait of Doña Josefa Garcini with the companion portrait Goya painted of her husband, Don Ignacio Garcini. The author begins by stating the main point she wants to prove: "Goya calls attention to Doña Josefa's private self by way of contrast with her stately 'other half.'" She proceeds to alternate between the two portraits by comparing and contrasting them feature by feature:

Compared Feature	Don Ignacio	Doña Josefa
I. Space	Unabiguously public, formal	Between boudoir and salon
II. Pose	Stands, chest out proudly	Sits, hands tense over belly
III. Clothing	Uniform, sword	Loose night dress
IV. Social status	Insignias of rank	Of indeterminate class
V. Brushwork	Precise, bold	Diaphanous
VI. Gender role	Assertive, active, external, worldly	Private, passive, interior

The alternating method is best suited for brief comparisons of a paragraph or two. If you continue at length to bounce back and forth between the two examples, your analysis becomes wearying for the reader to follow.

For extended comparison and contrast, most authors find the *block method* easier to work with. Using the block method, an author discusses all the features of artwork A in one large block or chunk, and then goes on to discuss artwork B in another block by considering the same features in roughly the same order. If Dreisinger wished to use this method for the foregoing comparison, she would first discuss in one block of prose the wife's portrait in terms of space, pose, clothing, and so on. Then she would discuss the husband's portrait in

another block of prose, describing the second painting in the same terms of space, pose, clothing, and the like.

We can see how Dreisinger uses the block method for a longer comparison in her essay, this one spanning paragraphs 5 and 6. In this instance she compares Goya's portrayal of Doña Josefa with his portrait of another pregnant woman, the Countess of Chinchón. Again, Dreisinger begins by stating the purpose of the comparison: her objective is to highlight the unusual degree of intimacy achieved in the painting of Doña Josefa. Here is how the author structures a comparison by the block method:

I. States the *main point of the comparison*—i.e., of two portraits by Goya of pregnant noblewomen (Chinchón and Garcini), the portrayal of Garcini is more intimate.

II. *Discusses Portrait B* (Chinchón)
 A. *Similarities:* pregnant sitter, hands on belly, wears white empire-waist dress, appears timid.
 B. *Differences:* ready to receive public, sits on chair (not bed), hair is styled, wears bracelets and bonnet, sits farther back from picture plane.

III. *Discusses Portrait A* (Garcini)
 A. *Similarities* in subject (same fecundity, style of dress, timidity). *But . . .*
 B. *Differences, stated in roughly the same order, are more significant:* seemingly unfit to receive public, hair loose-flowing, dress revealing, sinks into cushion close to picture plane.

As you can see, it is virtually impossible *not* to refer to artwork A in your discussion of artwork B, and vice versa. In discussing the portrait of the Countess of Chinchón, Dreisinger keeps Doña Josefa in view, as in "the Countess of Chinchón, who, *like Doña Josefa*," and "*But unlike Doña Josefa*, the Countess of Chinchón . . ." You look at one item in the comparison with the other in mind. Whether you're writing a full-fledged comparison of two works or simply using a comparison to flesh out your analysis of a single artwork, as Dreisinger does, make sure that the purpose and structure of the comparison are clear, and that you cite the same kinds of evidence for the items you're comparing.

Unifying Verb Tense

So far we've discussed methods for organizing evidence. But an essay is also structured grammatically, beginning with a dominant verb tense. This is not to say that you cannot use different tenses within a paper, but inconsistency or frequent switching of tenses breaks up the coherence and unity of your argument. Return for a moment to the first paragraph of Dreisinger's essay. Note that although she begins in the past tense, she soon shifts to the present tense, which she uses, with a few exceptions, for the remainder of the discussion. What determines the dominant verb tense, and what triggers the occasional switch?

A few simple conventions dictate verb tenses in written analysis. Dreisinger begins her essay in the past tense because she is recording finite actions, circumstances that began and ended in the past: Josefa *had* her portrait painted, she *was* well into her pregnancy at the time, she *posed* for Goya in informal dress. Later on in the essay, Dreisinger uses the past tense at several points when she mentions other finite actions: you might take a minute now to locate these points.

For the most part, however, writers use the present tense for describing and analyzing artworks. Goya completed his portrait of Josefa in 1804, but in the portrait that appears before us now, the life of the sitter is suspended in the present. The person named Josefa posed for the artist; but the painted subject *sits* facing us, *guards* her midsection, and so on. Similarly, writers use the present tense when summarizing what other commentators have written on the subject. When Dreisinger paraphrases the comments of other critics or introduces a quotation, she uses the present tense: Ives and Stein *note;* Symmons *continues,* and the like.

Unifying Tone and Diction

Consistency of tone and diction, or word choice, also unifies an essay. Each of us has a repertoire of voices in speaking, which we adapt to the subject, listener, and occasion. Recounting a story to a friend, you would most likely use slightly different details, vocabulary, tone of

voice, and so forth from those you would use if you were telling the same story to your employer. Finding the right tone for your essay involves similar kinds of choices, dependent on the topic and the audience you're writing for.

In the next chapter, which presents a case study of a collective writing project, the writers' voices are generally more conversational than in the essays we've examined so far. For this group project, students were invited to write about the private scrapbooks and collages made by Louis Armstrong, one of the most popular and accessible figures in American music of the twentieth century. The comparatively casual tone of their essays suits the more informal nature of the subject material and the assignment. It seems appropriate for one writer to say of Armstrong's "hobby" of making collages: "Louis Armstrong created collages in his scrapbooks; others, much to his wife Lucille's dismay, he *slapped* onto the ceiling of his den in Corona, Queens."

On the other hand, as we've seen, Mahwash Shoaib and Baz Dreisinger, writing formal essays about canonical artists from a distance of several centuries, adopt a more formal academic tone. Casual diction or slang would be unsuitable to their topics and assignments, as these examples from Dreisinger's first draft illustrate:

> [Doña Josefa's] appearance *smacks of* the informal.
>
> Goya presents a robust woman who essentially *lets it all hang out*.

As you can see, another disadvantage of using slang is that it dates so quickly. In her final draft the author avoids such colloquial expressions.

Finally, authors reinforce structural clarity in writing by making their sentences precise. Imprecision—whether the result of hazy thinking or scrambled syntax—disrupts the flow and persuasiveness of your argument. Again, Dreisinger has indulgently permitted me to cite two examples of vague and ambiguous language from an early draft of her paper. In the sentence, "The portrait [of Doña Josefa] radiates informality and is female in its essence"—what exactly does she want to convey by her choice of the word "female"? And in this example—

"Doña Josefa's blushing cheeks and tense arms indicate that she is uncomfortable. The unrelieved blackness of her backdrop heightens this anxiety"—to whose anxiety does the author refer? Does she mean "the viewer's sense of Josefa's anxiety"? Or, if she means "Josefa's anxiety," can the subject of a portrait be made anxious by a painted backdrop?

These latter considerations are more than simply a matter of editing: inconsistencies in voice, diction, and verb tense can clarify or obscure the structure of your essay. As for other, minor wrinkles in tone and usage: these can be ironed out in the course of revising and editing. The crucial and ongoing process of revision is the topic of our third case study, in Chapter 7.

7 Revising an Essay

"No art was ever less spontaneous than mine"
—*Edgar Degas, quoted in Lemoisne*, Degas et son oeuvre

A lthough the terms are sometimes used interchangeably, revising and editing are very different operations. Editing generally occurs in the later stages of writing, when an author corrects mistakes in grammar, manuscript mechanics, punctuation, and spelling (you'll find guidelines for editing your essay in Chapter 8). Revision, in contrast, is an ongoing and integral part of the writing process; it's not unusual for an essay to go through numerous and extensive revisions before the editing stage. In revision you attempt to see your material with fresh eyes.

The revising process gives writers an opportunity to review their observations, add to their research, tease out further implications from the topic, modify earlier hypotheses, and restructure or tighten the organization of the material. The essays and articles you read in magazines and scholarly journals may appear perfectly seamless and logical, as though they had emerged fully formed from the author's pen or word processor, but in fact they are the result of the messy process of trial and error. This is the behind-the-scenes work that doesn't come to light in the finished written product.

By the same token, viewers don't normally get to see a visual artist working through various alternatives, except as these early moves are revealed in X-radiographs or *pentimenti* (that is, images that become visible when the surface of a painting becomes transparent with age, exposing an underlayer of paint). Michelangelo's last *Pietà* (fig. 7.1), left uncompleted at his death, gives us a rare three-dimensional image of the radical revisions the

7.1 Michelangelo, *Pietà* (known as the *Rondanini Pietà*), 1555–1564. Marble, height 161 cm. ($63^3/8$ in.). Castello Sforzesco, Milan.

sculptor made in the treatment of his subject over time. His original conception is glimpsed in the massive arm of Christ that remains at left. Returning to the piece near the end of his life, the artist began to carve the grieving mother and her dead son out of the same block of marble. Even in this rough form—and displayed at present in a cramped alcove of the Castello Sforzesco in Milan—the compressed power of revision is palpable. Revision in writing is a similarly evolutionary process.

Case Study
Exhibition Catalog (A Group Project)

The students who participated in this group project* were given the opportunity to mount a mini-exhibition in a museum space at their college. They worked with artifacts found in the Louis Armstrong Archives, which is located on the campus of Queens College in New York and houses the jazz musician's memorabilia and personal documents. In a series of workshops, the students revised their essays for an exhibition catalog with the help of their colleagues' suggestions. The writers generously allowed early drafts of their work to be used for the following discussion of revision. For simplicity of reference in this chapter, I've taken the liberty of referring to the authors by their first names.

Their assignment, which is printed in the margins on pages 154–155, illustrates one format for an original research project. Versions of the project can be adapted for any class. You needn't have museum space to design an exhibition on paper, any more than you need an official archive to conduct original research. Visual artifacts for study surround you on your own campus and in your

* The seminar was composed of the following students: Elina Bagdasarov, Diana Conte, Ellie Fertig, Giuliano Fontanez, Esther Hoffman, Saul Kane, Sarika Kapoor, Jeffrey Leitman, Angela Montefinise, and Elana Pepper, all of whom contributed to this chapter.

Once the finished essays were compiled, Ellie Fertig created a collage for the cover, and the students wrote an acknowledgments page in which they gave special thanks to the director of the Armstrong Archives, Michael Cogswell; and to his administrative assistants, Dwan Reece-King and Deslyn Downes.

7.2 Louis Armstrong, mixed media collage from scrapbook, c. 1956. The musician composed his collages with cutout photographs and other print media taped or pasted onto a support, sometimes adding ticket stubs, snippets of telegrams, and other memorabilia.

neighborhood. (Several suggestions for projects like this one are also provided in the margins of Chapter 3.)

The following revision checklist is structured as a series of questions to ask yourself as you work through your own essays, whatever the assigned topic. These questions will help you sharpen and clarify your writing whether you work individually or with a group.*

Note on collaborative revision: If you're able to exchange drafts with a classmate, so much the better. I'm continually struck by my students' ability to pinpoint the most effective portions of one another's essays simply by listening to drafts read with a partner (or in a group, if class structure permits). Briefly, here's how to proceed. After the author reads from his or her work in progress, jot down whatever elements you find memorable—in this way, you help identify for the author portions of the essay worth expanding and emphasizing. Then, by asking questions such as those listed in this chapter, you alert the writer to rough spots and inconsistencies that need addressing: missing theses, incoherent paragraphs, murky sentences, and the like.

7.3 Louis Armstrong, mixed media collage from scrapbook, c. 1956.

7.3 Louis Armstrong, mixed media collage from scrapbook, c. 1956.

Here is the assignment students were given for designing a museum exhibition called "Louis Armstrong and the Art of Collage":

Louis Armstrong composed and revised his autobiography throughout his life: in his letters, books, and articles; in the hundreds of audiotapes he recorded privately; in his scrapbooks and photo collections; and in the collages that papered the boxes of his audiotapes and the walls of his den. In fact, the technique of *collage* can be said to run through all of Louis's creative activities, from scat singing to quotations of other musical phrases in his playing to the wonderful "slanguage" of neologisms he came up with in his writing. Obviously, Armstrong's gifts were musical more than visual; what is unusual is the creative drive, the near-obsessiveness he applied to what he called his "hobby" of collage-making.

Armstrong's collages have never been studied in depth. You are now invited to do so. We've been given permission to design a "mini-exhibit" for the Armstrong Archives. Each of you is asked to pick one object illustrating Armstrong's

Reexamining the Thesis

What further conclusions can be drawn from the material?

Even when you think you've mined all the rich possibilities of your material in your latest draft, the fact is that you can usually dig deeper. The participants in the seminar discovered, by talking out their ideas with their classmates, that they were able to tease further implications from their original research, each time reading more closely. The turning point in the life of an essay always recalls for me the moment in Tina Howe's play *Museum*, when a museum visitor touches a secret spring on a piece of sculpture and releases from the object a burst of light and music. I don't mean to suggest that every essay need contain a dramatic revelation, but your investigations should lead you to a few conclusions you hadn't foreseen when you began the project.

Several writers in the seminar found the discovery process so energizing that they decided to include a paragraph or two about the growth of their ideas in their final papers. In the following excerpt, one writer discusses how her perception of a collage became more nuanced

through research and successive viewings. This paragraph from Sarika's earliest draft shows her fishing for a theme:

> The collage Louis Armstrong created for this tape box documents his travels to Buenos Aires with his All Stars band in 1957. It is a narrative of his success there. At length, Armstrong's travels around the globe became a metaphor for his life. His tours paralleled his personality: Louis was a genius at crossing boundaries—musical, racial, and geographic. The title "Ambassador Satch" suited him perfectly.

On her second visit to the Armstrong Archives, Sarika noticed that although most of the headlines and photographs in this particular collage were taken from Argentinean newspaper reports of Armstrong's concerts in Buenos Aires, two items didn't seem to fit. At the center of the collage, Armstrong had placed a photo of Lawrence Olivier in the role of Richard III. And over his own photograph, Armstrong had superimposed the words "The Lone Ranger." What were these two "cryptic additions," the photo and the phrase, doing in a travel piece? In this excerpt from the final version of her essay, Sarika describes her growing awareness of the complexity of the public performer and his private art form:

> In the course of working with this piece for several weeks, I have found the collage to be an intense narrative addressing issues central to Armstrong's art and career. Having been born in India and being a novice in the study of American music and art, I was first introduced to Louis Armstrong in an American Studies seminar. I understood his fame after looking through a number of biographies written about this American icon. I also learned that his genius on the trumpet was not the only aspect of his life surveyed by the public eye; rather, the media reported on the minutest aspects of his personality and lifestyle. Yet what was strange to me was how the public never realized that Armstrong had so much to say in his written manuscripts and his visual art, and in fact communicated his private feelings via his collages.

use of collage— scrapbook page, tape cover, manuscript page, even a transcription of one of his audiotapes— that you'd like to have exhibited. Then:

- *Describe* the item— materials used, size, approximate date, condition.
- *Research* as much as you can about the iconography of the collage—that is, the images or references "quoted" in the collage. Your reading may take you into Armstrong's biography, the history of jazz, and the history of collage in twentieth-century art movements such as Dada and Surrealism.
- *Compose a label* (under 100 words) for the item.
- *Write a 3–4 page essay* that will serve as a "catalog essay" for your object. Working in groups, you will revise and edit these essays for publication as a collection.

Those few commentators who mention Louis's collages read them simply as autobiographical marginalia. For instance, the art historian Marc Miller writes, "Although Armstrong made collages for more than 15 years and nearly 500 survive, his works were made primarily for his own satisfaction" (209). Yet I believe that Louis's collages, and this tape box collage in particular, constitute the artist's dialogue with the mute public.

How did Armstrong express his identity and emotions in these very personal artworks? On my first "reading" of this collage, I saw nothing more than a compilation of souvenir items from the musician's trip to Buenos Aires. On second glance, I recognized a broader theme: the pictures and articles represented Armstrong, the hugely popular and tireless traveler and cultural ambassador. But those two cryptic additions to the collage continued to gnaw away at me. By conducting further research, I have now developed further inferences.

In the context of Armstrong's career, the date of the collage is especially significant. It was during September of 1957, *one month* before he compiled this collage, that Armstrong, in a famous incident in his career, publicly criticized President Eisenhower for ignoring racist incidents at a school in Little Rock, Arkansas. For his outspoken comments Armstrong was widely ridiculed and attacked in the U.S. media, even as he was being hailed as a hero in South America. When viewed in this context, the various elements of the collage suggest that Armstrong's trip to South America paralleled an inward journey, and that central to this example of Armstrong's visual art there is an expression of pain.

I've quoted the foregoing example at length to emphasize the difference between editing and rewriting. When you revise, you do more than correct mistakes: you reenvision and rework the material at hand.

Is the thesis clear and the discussion focused?

If you're having trouble honing your thesis, you might try the following exercises. Exercises 2 and 3 are purely optional devices, but I've found that they do help writers solidify their ideas.

EXERCISE 1: TITLES

Every respectable essay deserves a good name. Make sure your title specifies the subject and suits the tone of your discussion. As you've seen, the two essays reprinted in Chapters 5 and 6 announce their themes in straightforward titles. Some essay titles for the Armstrong project were similarly plainspoken—as in Esther's "Armstrong's Images of Inclusion"—while others took a more freewheeling approach, befitting the private and informal nature of the visual images under consideration. Diana's paper on the theme of spectatorship became "Here's Looking at You, Louis." Ellie's title became downright playful, in her punning conflation of Armstrong's most famous hit song and his surrealist collages: "Hello Dali." When Jeff first looked into one of Armstrong's unpublished manuscripts, he saw a stew of unrelated anecdotes, but by his final draft he had picked up a unifying theme in Armstrong's writing. At this point he changed his nondescript first title, "The Barbershop Manuscript," to the far more specific (and fanciful) "Amor Musicae Omnia Vincit: The Love of Music Conquers All."

EXERCISE 2: EPIGRAPHS

Another useful device for focusing your topic is to find an apt epigraph. An epigraph is a quotation that precedes the text and is used to set the tone for a piece of writing. The quotation can be drawn from any source—poem, review, artist's letters, you name it—but should illuminate the topic in some way. In her introductory essay for the exhibition catalog, Angela sets the stage with two epigraphs, one from an art historian and the other from a popular song recorded by Armstrong:

> "With its emphasis on ready-made forms that are largely the product of urban culture, collage has been long understood as the quintessential modernist medium."
> —Dorothea Dietrich

> "My imagination will let that moment live."—Lyrics from "A Kiss to Build a Dream On," performed by Louis Armstrong.

Should you decide to use an epigraph, don't rush to Bartlett's *Familiar Quotations;* an epigraph ought to be thought-provoking, not predictable.

EXERCISE 3: LABELS

The participants in the seminar were asked to compose labels for the objects they had selected for display. The results demonstrate how useful this exercise can be for any art history assignment, since labels require writers to boil down commentary to its essence. Try writing a succinct museum label for the artwork you're discussing. What is the essential point you'd like viewers to see, the idea that the rest of your essay supports? Saul's example illustrates how the exercise works:

> Collage from Scrapbook 20, put together by Armstrong. The making of this collage, which explores the career of African-American baseball great Jackie Robinson, was Louis's creative way of both exhibiting pride in his racial heritage and making a more covert statement about his personal encounters with racism. See Catalog Essay 3 for an analysis of this collage.

Rewriting Paragraphs

Will they want to read past the introduction?

It's no accident that public speakers often hook their audiences with a joke or an anecdote. When Esther read her first draft aloud to the class, she ended by observing: "This is so dry!" She decided to enliven the introduction by quoting from a popular song Armstrong had recorded, as a way of stating what she believed to be the theme of the collage she'd chosen. Similarly, in the following excerpt, Saul introduces his essay with a brief narrative in which he imagines Armstrong creating the object Saul now has before him (see fig. 7.2). The paragraph ends with the author asking a key question, which is another effective way to lead readers into your essay:

> It might have been an emotion-filled night in 1952. Louis Armstrong was in his dressing room cutting out magazine and newspaper photographs again. With the help of some Scotch tape, the clippings would soon be pieced to-

gether in Louis's scrapbook to tell the life story of a fasci-
nating man. . . . Interestingly, this was the only collage
that Louis was to devote solely to one figure other than
himself. What was the significance of his dwelling on the
life of Jackie Robinson more than on any other figure in
his scrapbook?

Are paragraphs unified and specific?

Have I used present tense for description and analysis?

Giuliano's task in structuring the paragraph reprinted
below was particularly challenging: he had chosen to
write about one of Armstrong's original tape recordings
rather than a visual collage; the hour-long tape contained
dozens of songs and conversations, all of which Giuliano
had painstakingly transcribed. How to get a grip on this
material? In his first draft, the writer began by summa-
rizing the contents of the tape, without telling his readers
what to make of these details—and without explaining
why an essay on an audiotape belongs in a discussion of
Armstrong's collages. By his final draft, Giuliano had
made his point with introductory and concluding sen-
tences for the paragraph. Here's how Giuliano's addi-
tions [which I've placed in brackets] make sense of the
jumble:

[Louis Armstrong made hundreds of reel-to-reel tapes
that form a kind of "sound collage" of his personal life.
Reel 39 is of particular interest because it is one of the
most diversified and colorful in Louis's collection.] Louis
begins by recording his secretary reading a thank-you let-
ter and then singing a popular song for him. Next Louis
records snippets of two songs taken from the radio, fol-
lowed by a long private conversation with his wife Lu-
cille. The scene abruptly changes to a hotel room, where
Louis introduces the maid to his "audience," reads from a
TV script, and jokes with his friends. From there he cuts
to Kay Starr's rendition of "I'm Gonna Sit Right Down
and Write Myself a Letter" and ends by recording a con-
versation with a journalist who is interviewing *him*. [In
this tape, in other words, Louis is writing himself a letter,
recording in his "audio-journal" the voices of his daily
life.]

Giuliano and the other writers quoted in this chapter also illustrate the general rule for verb tense in analyses of art objects: use the present tense for description, analysis, and literary summary.

Does the essay conclude (or does it just stop)?

The conclusion of an essay should bring a thesis and its proof together in a memorable way. Jeff examined a six-page handwritten manuscript by Armstrong with this question in mind: "I decided to see if any themes in the 'collages' that Louis made with his music and his audiotapes are also present in his writing." Here's how Jeff wrapped up his findings in the conclusion of his final draft:

> Now we can understand how Armstrong's manuscript of "The Barbershop," which covers so many different topics on the surface, is actually unified. There's an underlying theme in this collage: the glue that holds everything together and gives it life and larger meaning. That binding element is the idea that music bridges gaps between people—regardless of social class, color, nationality, or religion. This is a seemingly omnipresent theme in every creative activity this musician undertook. Whether in collages, reel-to-reel tapes, or written manuscripts, the same expression of Armstrong's love for music draws everyone together, connecting the man to others and others to him. Armstrong turns the barbershop, a commercial venue, into a zone of personal interaction through music.

Revising the Essay Structure

Is the essay organization easy to follow, and is the purpose of each paragraph clear?

We've noted in Chapter 6 that your reader should be able to follow your reasoning from one paragraph to the next, ideally through a map of topic sentences. Having said this, I want to pause for a moment to demonstrate how a clearly marked structure allows you to incorporate an occasional digression into the body of your paper. In general, readers don't mind a side trip so long as the writer justifies its relevance beforehand.

Let's say, in a personal response paper, you'd like to cite an example from your own experience to make a point. Or perhaps you believe a brief look at another piece or two by the same artist might be helpful by way of contrast. If you explain how this excursion is related to your thesis—if you show where you're going and why you're taking this route—readers can more easily follow along.

For example: although the assignment asked students to focus on one collage, Diana wanted to show how Armstrong carried out a particular theme in several collages in his scrapbook. But when she read an early draft in the seminar, her colleagues were confused as to what point Diana was trying to make with these examples. After considerable experimentation, Diana decided to focus on one collage but to refer to two related artworks in the introduction and conclusion of her essay. With her audience in mind, she made sure to structure her examples clearly with explanations, transitions, and topic sentences. These excerpts from the beginning and end of her essay show how Diana managed the task:

> Louis Armstrong, the consummate entertainer, was accustomed to being stared at. What is surprising is that Armstrong, himself the object of the spectator's gaze, should explore the idea of *scopophilia* in his numerous scrapbooks and tape box covers. Freud defined scopophilia, or the "pleasure of looking," as a fundamental component of the human sexual disposition (Young 15). Looking through the many collages he created for his personal scrapbook, we begin to see how Armstrong, an innovator who changed the face of American music, was a fan of, and fascinated by, other famous people.
>
> I believe that Scrapbook No. 20 is itself a collage, each page forming a part of the whole picture. Therefore, although I have focused on one page of collage in this essay, I have also chosen to illustrate my points by discussing two additional pages of the scrapbook. These collages (pages 14, 5, and 8), while different in form, are all related to the theme of spectatorship, an issue that Louis Armstrong repeatedly explored through visual means.

> A brief look at page 14 of the scrapbook will serve as a preface to our discussion of Armstrong's theme. . . .
>
> Finally, let's look at the way Armstrong has constructed page 8 of the scrapbook along the same lines. I believe this collage forms an appropriate conclusion to Armstrong's visual "essay" on spectatorship and fame. . . .

Reviewing Your Use of Sources

How might additional research strengthen the essay?

Even in the latter stages of composition, you may find that further reading in secondary sources will help you refine your discussion. For instance, in early drafts of her paper, Ellie observed that Armstrong's art had something in common with the art movement called Surrealism, which brought to the foreground the hidden life of the mind, often through the medium of collage:

> . . . As I flipped through the pages of Louis's personal scrapbook, I learned how his visual collages were a means of personal artistic expression. The scrapbook communicates in a private language Louis had created for himself, one that differed from the language of his public persona. The scrapbook pages often contain images that the viewer cannot understand logically; here is a dreamscape in which Louis's subconscious was allowed to have free rein. I could not help drawing parallels between Louis's collages and the aims and methods of the Surrealists.

Here's how Ellie used additional research to sharpen and amplify this insight in her final draft:

> The driving aim behind the Surrealist movement seems to have been captured on page 4 of Armstrong's scrapbook. The term *Surrealiste* was first used in 1917 by Guillaume Apollinaire to mean "pure psychic automatism . . . freedom from the exercise of reason" (Forty 31). In 1924, a group of artists in France led by the poet André Breton founded the Surrealist movement, defining "psychic automatism" as their aim. This autonomatism, or accidentality, would allow the artist to use his or her unconscious

to create art. The result is art that expressed the process of thought without being hindered by logic and reason; this sort of freedom corresponded closely to the "state of dreaming" or the literary device known as stream of consciousness (Rubin 41, 64).

In his scrapbook collages, Armstrong seems to be having a private conversation with himself. Using the basic elements of the everyday language of mass media such as newspapers, photographs, and other ephemera, he imposes his own private dream-logic and syntax on the material. . . .

Have I used different kinds of research?

Have I acknowledged sources and introduced all quoted material?

Does research fit into the paragraph without disrupting the flow?

The revision process allows you to make sure your "voice" fits comfortably with the sources you quote. In her introduction for the exhibition catalog, Angela needed to provide readers with background for understanding the art of collage in the broader context of twentieth-century art, as well as for seeing these particular collages in the context of Armstrong's better-known accomplishments. Initially, Angela had trouble weaving scholarly commentary into her own breezy, journalistic style. She eventually incorporated the material and added quotations and paraphrases from several interviews she conducted on her own.

Interviews or written correspondence with experts in your field can contribute information that published sources don't provide. Over the years, I've found that curators and artists are often willing to talk with students. If you wish to interview someone, write a request stating the purpose of your project; keep the meeting, telephone conversation or E-mail manageably brief so as not to impose on the hospitality of the interviewee; and send a follow-up note of thanks.

In the following excerpt from her final draft, Angela demonstrates the use of secondary sources—including her interview with the director of the Armstrong

Archives and her research on the Dada artist Kurt Schwitters—and of primary sources such as Armstrong's unpublished letters.

> Armstrong called his collages a "hobby" despite evidence that he created them obsessively. In a letter to Ms. Marili Mardon dated September 27, 1953, he wrote, "My hobby is to pick out the different things during whatever I read and piece them together and make a little story of my own" (box 1 folder 12). Like Kurt Schwitters, Armstrong liked to surround himself with these artifacts. Dorothea Dietrich describes the all-encompassing Merzbau constructions created by Schwitters as "an assemblage always expanding towards architecture" (3). Armstrong made an environment for himself by pasting his collages onto the walls and ceiling of his den. His wife Lucille might have preferred a different environment, but collage was a part of Louis, and so his photo-plastered den was his natural habitat.
>
> In fact, Louis incorporated collage into every creative medium he ventured into. In his songs, for example, Louis was constantly quoting other pieces and thus making musical collages. Michael Cogswell, director of the Queens College Louis Armstrong Archives, says, "Bebop is known for weaving quotes into songs, but people forget Louis did that 15 years earlier" (personal interview, April 11, 1999). Louis also made collages on his reel-to-reel tapes, combining elements that had nothing to do with one another (or so it seems on first hearing; Giuliano Fontanez argues otherwise). And as Jeff Leitman points out in his essay, Louis's manuscripts, too, are a kind of literary collage.

Revisiting Sentences

Are tone and diction appropriate to the audience and topic?

In Chapter 6 we noted the more informal tone of the writing for this project (for instance, one writer, below, refers to Armstrong's "stack" of manuscripts). Keep in mind, though, that casual transcriptions of the way we talk, while acceptable in fiction or drama, are inappropriate in academic discourse. In the sentence, "Sure, Arm-

strong was displeased by their comments," the first word should be stricken, along with conversational asides in sentences such as, "That's right, Armstrong created hundreds of collages from pictures of his friends and family."

A word on names. Because so many writers are quoted in this chapter, I've used their first names in the informal workshop context, though not elsewhere in this book. You've doubtless noted, as well, that the authors sometimes refer to Louis Armstrong by his first name, a practice professional writers tend to adopt when discussing one of the most familiar figures in popular culture. In most cases, though, first-name reference is inappropriately familiar, just as referring to artists as "Mr. ___" or "Ms. ___" is overly formal. The safest course is simply to use the artist's last name, the few exceptions being celebrated artists of the past who have become known by their given names, such as Raphael, Michelangelo, and Leonardo (da Vinci, not a family name, refers to Leonardo's place of birth).

Have I avoided sexist and Eurocentric language?

In an excerpt quoted earlier in this chapter, Ellie originally wrote: "This automatism, or accidentality, would allow the artist to use his unconscious to create his art." The traditional use of the masculine pronoun for nonspecific references is subtly sexist, suggesting a generalized male artist. There are several ways to revise the sentence to include all artists. You can say "his or her," as Ellie has done in her final draft. Frequent repetition of "he or she," "his or her" can get rather cumbersome, however; try where possible to change the subject and possessive pronoun to plural forms. The sentence might thus be changed to: "would allow artists to use *their* unconscious drives in *their* art."

Some writers prefer to alternate the gender of nonspecific pronouns in every other paragraph, or even to use the feminine pronoun throughout an essay, as the masculine pronoun was formerly used. (Writers occasionally substitute hybrid forms like s/he, (s)he, him/her, and so forth; but these constructions strike me as an uncomfortable compromise.) For gender-specific nouns like "chairman," "mankind," "sculptress," and the like,

substitute nongendered alternatives such as "chairperson," "humankind," and "sculptor."

It's equally important to replace Eurocentric terms—that is, those that give a privileged place to European perspectives and art forms—with terms that honor differences in ethnicity, nationality, religious belief, and so on. The terms *Native American* and (in Canada) *First Nations People* are used to identify indigenous peoples of North America because the outdated term "Indian" is inaccurate and reflective of a European-centered view of the world.

Consult the most recent scholarship on your subject to avoid mistaken nomenclature. For instance, the slightly disparaging name Papago ("the bean eaters"), for a specific Native American group of the Southwestern United States, has been superceded by "Tohono O'odham," meaning "the People" in the group's native language. Other non-Eurocentric references include *Asian* as opposed to "Oriental"; *East Asian* rather than "Far Eastern"; *Inuit* instead of "Eskimo." As a rule, it's preferable to specify the individual culture you're discussing ("Mende," "Yorùbá," "Hopi") rather than to use more general categories for identification.

Have I rewritten sentences to clarify meaning, trim wordiness, and eliminate vague diction and weak constructions?

I've said earlier that sentences should be "memorable," but how do writers make them so? In revision, you have an opportunity to hone your sentences for concision, precision, and freshness of expression. Try changing passive constructions to the active voice ("the collage was an artistic creation *made by Armstrong*" becomes "*Armstrong made* the collage"). Unpack overloaded sentences. This sentence from Diana's draft is brimming with important information—so much so that it's difficult to sort out:

> What is surprising is that Armstrong, himself the object of the spectator's gaze, should explore the idea of *scopophilia*, or the "pleasure of looking"—which, according to Freud, is a fundamental component of the human sexual disposition (Young 15)—in his numerous scrapbooks and tape box covers.

This is an example of "embedded" construction, in which clauses are nested within larger clauses. Try pulling apart the components of the sentence to let each unit of information breathe. In the revised version that appears on page 161 of this chapter, the sentence has been split into two:

> What is surprising is that Armstrong, himself the object of the spectator's gaze, should explore the idea of *scopophilia* in his numerous scrapbooks and tape box covers. Freud defined scopophilia, or the "pleasure of looking," as a fundamental component of the human sexual disposition (Young 15).

Let's take one last exercise in sentence revision, using this example from an early draft:

> Everyone knows Louis Armstrong was the "King and Father of Jazz," but there are many other creative modes of expression he used that the average person doesn't connect with his illustrious name. Most people aren't aware that he kept his own personal tape collection, or that he wrote a stack of manuscripts.

In class, we practiced rewriting these two sentences. The first element most classmates jettisoned was the opening clause. If everyone knows something, why mention it again? And for those readers unfamiliar with Armstrong, mightn't the writer find more dynamic descriptors than "King and Father"?

Among other suggestions for revising the passage:

- Tighten flabby constructions such as "there are . . . he used."

- Sharpen vague phrases such as "creative modes of expression."

- Avoid repetition if it serves no discernible purpose: both sentences in the passage comment on what "the average person" and "most people" don't know. What can be eliminated from these sentences?

The author's revised passage reads: "Louis Armstrong's artistry extends beyond music in ways that the average person doesn't connect with his illustrious name.

Most people aren't aware that he recorded hundreds of reel-to-reel tapes, or that he wrote a stack of manuscripts."

Have I proofread carefully?

Everyone blunders. That's why we have rough drafts. We've all had the experience of proofreading our final copy several times, only to have another reader find a typo in the first sentence. Once you've arrived at a satisfactory draft of the essay, you might wish to exchange papers with a partner and edit each other's hard copy. If you're unable to work with a colleague from your class, read your paper aloud to yourself to listen for clarity, check for missing words, ensure fluid transitions, and so on. Don't rely too heavily on word-processing functions like the spell-checker and grammar-checker: sometimes these electronic aids can correct or change elements you don't want changed, or miss major errors entirely. Proofread the grammar and mechanics of your manuscript against the editing guidelines provided in Chapter 8.

Editing an Essay: Grammar, Punctuation, Usage

<div style="text-align:right">8</div>

"Again it is good to place yourself at a distance from [your work] because the work will look smaller and more can be taken in at a glance: discordances, ill-proportioned limbs and the colours of things can be recognised more easily."
—*Leonardo da Vinci,* On Judging Your Painting

I t should go without saying (but I'll underscore the point all the same) that all grammar, spelling, and punctuation must be proofread and corrected before you submit your written work. Take my word for it: nothing vexes your reader more than a trail of errors littering the path of learning. When the reader happens to be a professor reviewing dozens of students' essays, the frustration factor increases exponentially. Careless mistakes sabotage the hard work you've already put into your essay and undermine the audience's faith in the reliability of your research and conclusions. This brief chapter provides you with a guide for editing your essay. We'll begin with a general list of the most common pitfalls in grammar and usage, after which I've reprinted the *Art Bulletin*'s editing guidelines specific to art history manuscripts.

Editing for Consistency

To be consistent, the chief elements of a sentence—subjects, pronouns, verbs—must adhere to grammatical rules for agreement. The following are common trouble spots to watch for when you are editing for unity and clarity of expression.

Subject/Pronoun Agreement

Pronouns (= words that can be substituted for nouns, such as he, she, it, they, and so on) and their *antecedents* (= the nouns they refer to) must agree in person and number (= singular or plural). In the following sentence, the writer shifts from "an artist," a singular subject, to "they," a plural subject pronoun:

> **X** When an artist creates a collage, they create their own museum.

To correct the mistake, use pronouns consistently in the sentence. Change the singular subject and pronoun in such sentences to plural when possible—simply because in many cases, as we discussed in Chapter 7, the repetition of *he or she, his or her* gets tiresome. Thus the first of these two examples is preferable:

> When artists create collages, they create their own museums.

> When an artist creates a collage, he or she creates his or her own museum.

SUBJECT/PRONOUN REFERENCE: THIS, THAT, WHICH, AND IT

A pronoun should refer clearly to a specific antecedent. In the following example, what does "this" refer to?

> **X** Armstrong recognized that his fans were essential to his success. *This* is represented in the collage by a prominent picture of the audience at one of his concerts.

In the foregoing example, "this" might refer to Armstrong's success, to the presence of his fans, or to his recognition of their importance. In editing her sentence, the author clarified the reference:

> Armstrong recognized that his fans were essential to his success. His recognition of their role in his career is represented in the collage by a prominent picture of the audience at one of his concerts.

Subject/Verb Agreement

A subject and its verb must agree in number and tense. The following incorrect sentence, for example, has a com-

pound subject, "jazz and collage." Compound subjects take plural verbs.

> **X** Both jazz and collage are a twentieth-century phenom-enon that quotes pieces from other vernacular sources.

The sentence is corrected by making the modifying phrases plural, to agree with the plural subject:

> Both jazz and collage are twentieth-century *phenomena* [= the plural form of *phenomenon*] that *quote* [= plural verb] pieces from other vernacular sources.

Parallel Structure

Items that are classified together should have the same grammatical form. Two or more coordinated elements (items joined by *and, or, but, yet*) should be parallel in grammatical form: two verbs, three adjectives, or the like. In addition, when two or more elements are compared or contrasted, the items—whether single words or phrases—must conform grammatically.

For example, in the following sentence, the writer compares similar elements in two art forms, jazz and visual collage. Yet the elements are not presented in parallel forms:

> **X** Both jazz and collage use *snippets* from popular culture, *improvisations*, fragmented *rhythms,* and *take items* out of their context.

The last item is inconsistent with the form of the other examples in the sequence: the first three items are plural nouns, while the fourth item is a verb.

The sentence is corrected by making the terms consistent—in this case, by changing the fourth term in the list to a plural noun:

> Both jazz and collage use
> snippets from popular culture,
> improvisations,
> fragmented rhythms, and
> *items* taken out of context.

Note that nonparallel elements may be made consistent in several ways. Take this example:

X Armstrong was a trumpet virtuoso, he practically invented scat singing, an accomplished actor, and an ambassador for American culture.

To correct the sentence, you can make each item a separate verb phrase:

Armstrong *was* a trumpet virtuoso,
 practically *invented* scat singing,
 acted skillfully, and
 served as an ambassador . . .

An even more efficient solution is to use the verb *was* as the underlying verb in the rest of the sentence, and to make each succeeding item a noun or noun phrase:

Armstrong was
 a *virtuoso* on trumpet,
 an *inventor* of scat singing,
 an accomplished *actor,* and
 an *ambassador* . . .

Reviewing Word Order

Word order affects the meaning of a sentence in English. The placement of modifiers, for instance, can clarify or obscure what you want to say.

Misplaced Modifiers

When a modifier is misplaced, readers cannot be sure which part of the sentence the word or phrase is supposed to modify:

X Armstrong *almost* played all night long.

Modifying words, phrases, and clauses should be placed so that their intended meaning is clear:

Armstrong played *almost* all night long.

Dangling Modifiers

A modifier "dangles" when it is attached to the wrong subject in the sentence, or when it refers to a subject that isn't actually in the sentence:

X While playing in Chicago with his band, the pianist Lil Hardin met Armstrong.

In this example, the writer is actually referring in the first part of the sentence to Armstrong, although he is not named as the subject. Instead, the sentence structure points to Hardin as the subject. Thus it seems as though Lil Hardin is being introduced to Armstrong while she is playing in his band. To correct a dangling modifier, clarify the subject of each clause, thus:

> While *Armstrong* was playing with his band in Chicago, the pianist *Lil Hardin* met him.

Or better still, make the subject of each clause the same:

> While *Armstrong* was playing with his band in Chicago, *he* met the pianist Lil Hardin.

Split Infinitives

An *infinitive* consists of *to + the base form of a verb:* to sing, to run, to dance, to describe. The two parts of the infinitive should not be separated in your sentence; thus, the following example is awkward:

> **X** The song seems *to* perfectly *describe* a scrapbook collage that Armstrong assembled in 1952.

The word order can be corrected in either of these two ways:

> The song seems *to describe* perfectly . . .

or:

> The song seems perfectly *to describe* . . .

Punctuation: Problems and Solutions

Following is a brief review of methods for correcting the most common punctuation errors: misplaced or missing apostrophes, commas, semicolons, and colons.

Apostrophe for Possessives

Add *'s* to singular words to indicate possession; do so in most cases, even if the word ends in *-s* or an unpronounced *-x:*

Louis's
Ingres's
Delacroix's
Degas's

Here are the chief *exceptions*. The possessive pronouns—
hers, his, ours, theirs, its—do not take apostrophes:

His computer program had its glitches.

Names containing several *s, z,* or *x* sounds would
make an additional *'s* awkward to pronounce; in these
cases only the apostrophe is added for the possessive
form:

Xerxes'
Ulysses'
Moses'
Jesus'

Use of Commas

Following are the chief uses of the comma, along with
common errors and their solutions.

- To set off introductory words, phrases, and
 dependent clauses:

 Clearly, the essay required editing.

 If the final draft were edited, the essay would be more
 effective.

 Note, however, that if the dependent and independent
 clauses were reversed, no comma would be required:

 The essay would be more effective if the final draft
 were edited.

- To separate words, phrases, or clauses in a series of
 three or more items:

 The primary colors are red, blue, and yellow.

- To set off nonrestrictive words, phrases, and clauses
 in a sentence. (A nonrestrictive element gives added
 information but does not limit the meaning of the
 sentence—in other words, the sentence would not be
 altered substantially if the nonrestrictive element
 were removed.)

Armstrong, one of the most celebrated musicians of his time, created collages in his spare hours.

Lil Hardin, whom he met in Chicago, was an accomplished pianist.

These images, however, have come to stand for something greater.

- To separate two independent clauses [= each having a complete subject and verb] that are joined by the coordinating conjunctions *and, but, yet:*

 Armstrong traveled constantly, yet he found time to work on his collages.

Note: In the foregoing sentence, if the two independent clauses were simply joined by a comma, without the use of the coordinating conjunction *yet,* we would have the grammatical error known as a *comma splice:*

 X Armstrong traveled constantly, he found time to work on his collages.

Comma splices can be corrected by joining the two independent clauses in one of several ways.

1. Join with one of the coordinating conjunctions—*and, but, yet.*

 Armstrong traveled constantly, (but, yet, and) he found time to work on his collages.

2. Make the first clause *dependent* on the other by means of a *subordinating conjunction* (subordinating conjunctions include *because, since, if, although, even though, before, when, while, until*):

 Although Armstrong traveled constantly, he found time to work on his collages.

3. Put a *period* between the two clauses:

 Armstrong traveled constantly. He found time to work on his collages.

4. Put a *semicolon* between the two independent clauses:

 Armstrong travelled constantly; he found time to work on his collages.

As you can see, the last two methods, although correct grammatically, are less satisfactory because they don't clarify the relationship between the two clauses.

Use of the Semicolon

The primary use of the semicolon (;) is to separate two independent clauses, as in example 4, above.

There is one further use of the semicolon. When you are listing a number of items, and the items themselves contain commas, use semicolons to set off the main items. For example, without the semicolons in the sentence below, the reader might think that Armstrong was accompanied by five or six people rather than three:

> Armstrong was accompanied by Joe Oliver, another trumpet player; Lil Hardin, a pianist; and Johnny Dodds, a clarinetist.

Use of the Colon

The colon (:) may also be used to join independent clauses that are closely related. The colon calls attention to the element it precedes: it points to a significant detail, example, or explanation. The colon may be used to introduce a list of items or examples:

> Armstrong was accompanied by three musicians: Joe Oliver, another trumpet player; Lil Hardin, a pianist; and Johnny Dodds, a clarinetist.

The colon may also be used to introduce a long or formal quotation:

> Jazz legend Duke Ellington had nothing but praise for his fellow musician: "I loved and respected Louis Armstrong. He was born poor, died rich, and never hurt anyone on the way."

Usage: Commonly Confused Words

The following words and word pairs are frequently confused:

- **affect, effect:** In most cases, *affect* is used as a verb; for example, earlier in this chapter I wrote, "Word order *affects* the meaning of a sentence in English." On the other hand, *effect* is usually used as a noun, as in the sentence, "The *effects* of word order in English

are significant." (*Effect* can also be used as a verb meaning "to bring about," as in "Hardin effected a change in Armstrong's career.")

- **allusion, illusion:** An *allusion* is an implied reference to something, as in "The candle in the painting is a biblical allusion to purity." An *illusion* is an optical effect, as in "linear perspective gives the *illusion* of spatial depth."

- **among, between:** *Between* is used for connecting two items, *among* for more than two items: "The discussion *among* the five students went on for hours."

- **amount, number:** *Amount* is used for noncountable, general, or abstract nouns; *number* is used for nouns that can be counted. Thus: "The huge painting required a great *amount of effort* and an even greater amount of canvas. The *number of canvases* in the exhibition was staggering.

- **complimentary, complementary:** *Complimentary* means "flattering." *Complementary* means "completing or coupled with": Thus: "*Complementary colors* such as blue/orange and red/green are opposite pairs on the color wheel."

- **it's, its:** *It's* is a contraction, or shortened version, of *it is*. *Its* is a possessive pronoun and NEVER takes an apostrophe:

 > *It's* a pity that the essay was undermined by *its* punctuation errors.

- **less, fewer:** The distinction here is like the difference between number and amount—*less* is used with noncountable nouns, whereas *fewer* is used with countable nouns:

 > Because they had *less money*, they bought *fewer tubes* of paint.

- **like, as, as though:** *Like* is used before a noun or noun phrase; *as, as if,* or *as though* is used before a clause:

 > **X** It seemed like the figures in the collage were all part of him.

The foregoing sentence is corrected by using *as if* or *as though* before the clause—

> It seemed *as if* [or: as though] the figures in the collage were all part of him.

- **principle, principal:** *Principle* means "a rule or law," as in the principles of drawing. *Principal* refers to the chief member of an organization or classification, as in the principal of a school or the principal goal of a business.
- **sensual, sensuous:** *Sensual* refers to gratification of the physical senses and is usually associated with sexual gratification. *Sensuous*, which means "pleasing to the senses," usually refers to the properties of an object, as when we speak of "sensuous folds of drapery."
- **that, which:** *That* is used to signal a restrictive clause (i.e., a clause that cannot be removed without changing the meaning of the sentence), whereas *which* usually signals a nonrestrictive clause. Note that nonrestrictive clauses are set off with commas:

 The song that she composed was his favorite.

 The song, which she composed, was his favorite.

Manuscript Mechanics, from the *Art Bulletin* Style Guide

Following is the Style Guide posted on the Web Site of the College Art Association (CAA). It is designed to be used by authors submitting articles to *Art Bulletin*, one of the two art history periodicals published by the CAA, so it addresses in detail the specific style and usage questions that students of art history are likely to ask about spelling, abbreviations, and other mechanical matters.

Titles

Titles of works of art, like those of books, periodicals, exhibitions, etc., should be <u>underlined</u> or in *italic* type. Titles of articles, dissertations, poems, etc., should be given in quotation marks. You may use a short form after the first reference.

Not to be considered titles are: categories of subject matter (e.g., "their rendering of the Annunciation" but "Rogier's *Annunciations* on panel." In the latter, Annunciation is a title, although of several paintings); names acquired by tradition ("the Friedsam *Annunciation*"; Friedsam is not the name of the work); names of persons represented in works of art ("Saint John twists on his column" but "the *Saint John* is exhibited in the Uffizi" since the latter *John* is the name of the work); names of build-

ings and things (Unicorn Tapestries, Lindisfarne Gospels, Hours of Catherine of Cleves, Isenheim Altarpiece).

For note references to titles of books, use an initial *The* (*The Sistine Chapel*), but delete *The* for titles of journals (*Art Bulletin*, not *The Art Bulletin*).

Numerals

Spell out numbers beginning sentences, including dates: e.g., "Seventeen seventy-six lives in American history."

Spell out numbers under one hundred, except in a statistical or similar discussion with numerous such numbers. Numbers above and below one hundred that pertain to the same category should be treated alike throughout a paragraph: "the archives have 140 letters, 42 invoices . . ."

Use Arabic numbers in notes, in page numbers, in dates, and in measurements generally: foot-inch figures, percents, fractions, and ratios (i.e., 5:6). In measurements, type a space after the number: i.e., 45 in., 45 cm (no period after "cm").

Spell out centuries in articles ("seventeenth century"), but use Arabic numerals ("17th century") in notes, book reviews, and captions.

For life dates, repeat the first two digits (1432–1480), but use only the last two digits in all other instances (1923–25), except: 1900–1905; 1805–6; 1793–1802.

Inclusive page numbers: pp. 21–28, 345–46, 105–9, 200–205, 1880–90, 12,345–47 (see *Chicago Manual of Style* 8.69).

When citing internal divisions of a reference, use Arabic numerals separated by periods.

Capitalization

Capitalize names of works of art, including buildings (Cathedral of St. John the Divine, Albani Tomb, Baptistery of Pisa, Sforza Monument) and analogous terms (Lehman Collection), but not generic words in association with titles (tomb of Cardinal Albani, collection of Robert Lehman, church of Notre-Dame, Isenheim Altarpiece, but Lotto's Louvre altarpiece).

Lowercase references to parts of a book: appendix/ app.; bibliography/bibliog.; book/bk.; cat. no.; fascicle/ fasc., figure/fig.; folio/fol., introduction/intro.; line; new

series/n.s.; note/n.; page/p.; plate/pl.; preface; series/ ser.; signature; volume/vol. (Capitalize Fig. in reference to illustrations in your article.)

In titles of publications in English, cap. first word, last word, all nouns, pronouns, adjectives, verbs, adverbs, and subordinate conjunctions. Lowercase articles, coordinate conjunctions, prepositions, and the *to* in infinitives. Follow these rules regardless of the capitalization used on the book's title page.

The capitalization of foreign titles in general follows the capitalization of the language as it is used. (See the chapter on foreign languages in type in the *Chicago Manual of Style*.)

For capitalization of particles, follow the usage of the named individual or tradition: Tolnay, Schlosser, but de la Tour, d'Hulst, de Stall, von Blanckenhagen, Der Nersessian, Van Buren, van Gogh, van der Weyden (in general, lowercase the particle in European names).

In general, sharply delimited period titles are capitalized, whereas large periods and terms applicable to several periods are not, e.g.:

> Archaic, Baroque, Early and High Renaissance, Early Christian, Gothic, Greek Classicism of the fifth century (otherwise, classicism), Imperial, Impressionism, Islamic, Mannerist, Middle Ages, Neoclassicism for the late eighteenth-century movement (otherwise, neoclassicism), Post-Impressionism, Pre-Columbian, Rococo, Roman, Romanesque, Romantic period, Xth Dynasty.

> antique, antiquity, classicism (see above), medieval, modern, neoclassicism (see above), postmodern, prehistoric, quattrocento.

Capitalize theological terms: Apostles, Archangel Gabriel, Baptism, Benedictional, Child, Christ Child, Church Fathers, Crucifixion, Eucharist/Eucharistic, Evangelists, God the Father, Gospel Book, Heaven, Holy Communion, Immaculate Conception, Incarnation, Infant, Judgment Day, Judgment of Solomon, Man of Sorrows, Mass, Massacre of the Innocents, Mother, Nativity, Original Sin, Passion Play, Pontifical, Prophets and Sibyls, Scripture, Three Marys, Virtues and Vices (cap. each of them, e.g., Envy/*Invidia*).

In general, capitalize formally named theological terms and lowercase those generically referred to: archangels, birth and death of Christ, breviary, canon tables, communion, disciples, his birth (no capitalized pronominal adjectives), prayer book, sacrament.

Spelling and Hyphenation

For spelling and hyphenation, use the first choice in *Webster's Third* or *Webster's Collegiate* and follow the examples below:

a historical fact, not an historical fact
aesthetic, archaeology
appendixes, indexes, but codices
Asian, not Oriental
avant-garde (noun and adj.)
bas-relief
B.C.E., not B.C.
black-figure (only as adj.)
catalogue, catalogue raisonné
C.E., not A.D.
draftsman
focusing, modeling, labeling, traveling
freestanding
frescoes, but halos, manifestos, torsos
ground plan
inquiry, but ensure
medium, media
mid-fourteenth century
millennia
molding
practice
preeminent, reevaluation, but re-creation
self-portrait
sketchbook
still-life (adj.), still life (noun)
terra-cotta (adj.), terra cotta (noun)
wall painting
watercolor
well-known (before noun); well known

Use traditional English form for foreign place names such as Florence (not Firenze) and Munich (not München); otherwise, use first choice in *Webster's New Geographical Dictionary.*

Insert all accents given in the foreign language, including those on capital letters.

Abbreviations

In general, use standard abbreviations in footnotes, but abbreviate sparingly in main text.

Cite books of the Bible by short title, usually one word. See *Chicago Manual of Style.*

Do not abbreviate journal titles; *Journal of the Warburg and Courtauld Institutes,* not JWCI.

Manuscript locations: Bibl. Nat. gr. and number; Bibl. Nat. lat. and number; Brit. Mus., Brit. Lib., Vat. lat.

Saint: Use Saint and the standard form of the name in English in referring to saints. For places, churches, etc., use the local form, abbreviating where possible (St. Louis, Mo.; St-Denis; Ste-Chapelle; S. Apollinare, S. Lucia, SS. Annunziata).

Dates: January 6, 1980, in text; Jan. 6, 1980, and Jan. 1980, in notes; use B.C.E. and C.E. in both places.

State names: spell in full in text or when standing alone. Otherwise, use standard state abbreviations rather than the two-letter zip code form (e.g., Calif., Conn., Del., D.C., Ill., Mass., Mich., Mo., N.J., N.Y., Pa.).

Italics

Use roman type for scholarly Latin words and abbreviations: ca., cf., e.g., etc., but retain italics for *sic,* which should be in brackets, i.e., [*sic*].

Italicize words and phrases in a foreign language that are likely to be unfamiliar to readers: for example, *cire perdue; modello* (pl. *modelli*); *ricordo.* A full sentence in a foreign language should be set in roman type. Familiar words and phrases should be in roman type: for example, a priori; cause célèbre; élan; façade; in situ; mea culpa; oeuvre; papier-mâché; pentimento (pl. pentimenti); plein air; repertoire; trompe l'oeil. Please try to limit the use of foreign-language words in text; where it is essential, include the English translation in parentheses.

Quotations

Quotations must be absolutely accurate and carefully transcribed. An ellipsis (three spaced dots) indicates

words dropped within a sentence. A period and three spaced dots indicates a deletion between sentences.

Unless [the material in question is] governed by fair use, authors must obtain permission to quote published material.

If you are responsible for some of the translations, add at the head of the notes: "Unless otherwise indicated, translations are mine."

Extracts of more than 50 words should be typed without opening and closing quotation marks, *double-spaced* in block form, i.e., indented one inch from left margin. Shorter quotations should be run into the text.

Foreign-language quotations of more than a line or two should be translated into English in the text, unless the significance of the quotation will be lost. The original text may be included in a footnote only if it is unpublished, difficult to access, or of philological relevance to the article.

"Emphasis added" indicates your addition to quoted matter. Brackets in quoted material indicate author's interpolation; in inscriptions they indicate letters lost through damage. Parentheses indicate letters omitted as the result of abbreviation in inscriptions.

The *Art Bulletin* also provides guidelines for citing outside source materials in researched essays. Its guide to documentation is reprinted in Part Three of this book, which deals with research and critical methods.

A Note on Captions

When you submit your essay, remember to supply a photocopy of the primary artwork or works you've referred to in your text; your instructor will tell you whether these illustrations should be placed where they are cited in the text or at the end of the essay. If you have more than one illustration, refer to each in the text as Figure (or fig.) 1, Figure 2, and so on. The caption that accompanies each illustration should include the following information: Figure number, artist, title (underlined), date, medium, dimensions (height × width), and present location of the artwork.

Part Two Conclusion

Essay Writing Strategies

Topic: If the topic you choose doesn't interest you, it won't interest your reader.

Response: Use your journal as a sketch pad for exploring your responses and experimenting with essay ideas.

Draft: Writing is a *process*. Ideas and structures don't appear all at once: they take shape in successive drafts.

Thesis: Nail down the main point of your project in a sentence or two, stated clearly for the reader.

Map: Plan your essay route, even if it's only a topic-sentence outline of the chief points you want to cover. Be flexible enough to redraw the map as you continue to explore your topic.

Introduction: The opening of an essay provides context for the discussion, engages the reader, and announces the thesis. Write the final version of the introduction after you've finished drafting.

Description: Describe with specifics and your thesis in mind. You may choose to develop description through comparative analysis of similar works.

Analysis: Analysis is what you infer from what you observe. Each inference must be supported with concrete details or examples.

Structure: The shape of your argument should be obvious and sensible to the reader. Topic sentences show what the paragraph is about and how it is related to the thesis of the essay. Transitional words and phrases make the links between units even more apparent.

Research: If you use outside sources, make sure they support rather than replace your own thinking. Research must be documented whether you are quoting directly, paraphrasing, or using someone else's idea. Consult Chapter 9 for a guide to documentation.

Revision: Rewriting is ongoing and essential. Revise ruthlessly; read aloud or exchange drafts with a partner to ensure clear and adequate development of your topic.

Tone: Suit diction and voice to topic and audience; avoid pretention and slang.

Conclusion: Bring closure to your discussion by recasting your thesis in light of the evidence presented in the body of the paper.

Editing and proofreading: Your reader doesn't want to edit your work. Proofread meticulously to correct careless mistakes.

Part Two of this book has provided examples of how authors incorporate research into their essays—whether to provide background information, to bolster their observations, or to provide corroboration for their theses. Part Three looks at the process by which researchers track down, evaluate, and document their sources.

Research and Critical Methods

PART THREE

9

Researching and Documenting an Essay

"Style comes only after prolonged researches . . ."
—*Eugène Delacroix*, Journal, *March 5, 1847*

T his chapter shows you how to locate and document sources for a researched essay. For the purposes of illustration, I've focused on my experience researching Chapter 10 of this book. As you'll see, Chapter 10 surveys the critical literature on Eugène Delacroix's painting, *Women of Algiers in Their Apartment* (1834); the present chapter is a case history of how I went about finding material for Chapter 10. Using Delacroix's painting as a model subject, the first half of the chapter walks you through the process of gathering research materials. The second half of the chapter uses the list of sources I compiled on Delacroix to demonstrate methods for documenting your research in footnotes and bibliography.

Case Study
Reception History of a Work of Art

In Chapter 5 you've seen how to go about choosing and narrowing an essay topic. Once you've found a subject that meets the requirements of your assignment and engages your curiosity, begin by jotting down a preliminary list of questions you have about the subject. These research questions will become more refined as you delve into your sources.

For example, my objective in Chapter 10 was to provide readers with an overview of the major critical approaches in art history from the mid-nineteenth century

onward. I might have accomplished this goal by quoting critical analyses of a variety of artworks; yet this struck me as an unfocused sort of survey. It seemed to me I could convey the same kind of information by compiling a critical reception of a single work of art: that is, by researching how art historians over the years have written about a single image or object.

But which work of art would be most suitable for my project? I'd need a subject that had received its share of critical attention in the nineteenth and twentieth centuries (in essays that were written in English or available in English translation) but that was rich enough to lend itself to further investigation. Eventually I narrowed my search down to paintings by a handful of well-known Western artists. I decided to focus on Delacroix's *Women of Algiers* because it is a beautifully complex work and because it raises the kinds of aesthetic and cultural issues that increasingly occupy present-day critics. My general research project thus became more specific as I proceeded with my investigation.

Online Research

Visiting the Public Library Online

To get an overview of the information available on my subject, including materials that might not be available in my college's library, I visited the Web site of the major public library in my area—the New York Public Library (www.catnyp.org). The Web site of any central library will suffice, and the investigative method is the same: you'll be given options for searching by author, keyword, subject, or title. It's usually best to initiate the search for your artist by entering his or her name under *subject*. Here's what the other options might yield: when you type in "Delacroix, Eugène" under *author*, you get listings for the journals and articles Delacroix himself wrote (as it happens, he was an accomplished writer as well as one of the most celebrated painters of his era). If, on the other hand, you type in "Women of Algiers" as a *subject*, you'll wind up with studies of women in society; and if you search *"Women of Algiers"* as a *title*, you'll end up with Assia Djebar's novel of the same name.

Under the subject heading for Delacroix, I found 154 entries, grouped in 34 categories. These subcategories will differ depending on your subject, but typical art history rubrics include "exhibitions and exhibition catalogs," "criticism and interpretation," and *catalogue raisonné* (a *catalogue raisonné* is a complete list of every known work of an individual artist, with information about measurements, condition, and provenance—i.e., ownership history). The largest subject category is of course the most general. For instance, "Eugène Delacroix" (84 entries) shows the range of contexts in which an artist's work can be explored: not only in biographical, historical, and interpretive studies, but in studies that group the painter with other artists and subjects—for example, "Delacroix and Images of the Orient," or the artist Paul Signac's treatise on color theory.

Primary and Secondary Sources

For your own project, you'll want to consult a variety of primary as well as secondary sources. *Primary sources* are original documents such as the artist's personal statements or letters, diaries, contemporary reviews, and so on; *secondary sources* provide critical commentary on primary sources. Secondary sources take many forms: traditional *monographs,* or studies devoted to one specific artist or subject; articles from scholarly journals; exhibition catalogs from recent museum shows; essays in books organized around an issue or theme; unpublished material delivered as lectures during symposia; information found on the Internet; and personal communications such as interviews and written correspondence.

Primary sources for my research project on Delacroix included works written during the nineteenth century by Delacroix and his contemporaries, as well as twentieth-century editions of nineteenth-century sources. My secondary sources for Delacroix's *Women of Algiers* included twentieth-century monographs on Delacroix and specific critical publications on the *Women of Algiers,* E-mail communications with art historians who specialize in the study of nineteenth-century paintings, and current books on the history and colonization of Algeria and on women's lives in Islamic culture.

As I've indicated, an online library overview simply gives you a sense of the scope of your topic. You'll need to peruse the shelves in person to judge which sources are "coffee-table books" and general-interest periodicals as opposed to more scholarly resources. Let me underscore this point with the following caveat regarding other kinds of information available online.

A Word of Caution on Using Internet Sources

The Internet has become an indispensable vehicle for researchers, allowing them to sort through huge databases of published material. The World Wide Web provides up-to-the-minute information on contemporary issues, such as the museum controversies discussed in Chapter 4 of this book, as well as on recent art exhibitions. Increasingly, however, students rely heavily on Internet sources, sometimes as their only means of research. I do not recommend this approach. Information on the Web, while accessible and plentiful, isn't subjected to the same processes of evaluation and selection as library holdings, and as a result, Web sites vary wildly in quality, organization, and reliability.

Moreover, a subject search may turn up literally thousands of matches, and it's not unusual to find that once you've narrowed the field by adding keywords, you're left with little usable information for a serious research paper. For example, using Yahoo! (www.yahoo.com) as a search engine and the keywords "Women of Algiers," I turned up some 2,000 records. When "+ Delacroix" was added to the keyword search, my list was cut to 45, but most of these "hits" seemed to be of rather general interest and thus unsuitable for my project.

Museum Web Sites

Happily, though, search engines also provide museum links (most museums and galleries now have Web sites), so it's usually possible to view parts of a museum collection, and in some cases to go on a virtual-reality or interactive tour of a particular exhibition space. Numerous museum sites offer interactive exhibit displays, animations, multiple viewing perspectives, 3-D viewing, and

other enhancements. (Most interactive displays require "plug-ins" such as Quicktime and Realtime Audio; you may be able to download these capabilities on a personal computer or view the sites on your library's equipment.) In most cases, museums put only a fraction of their holdings online: Yahoo sent me to the Louvre website, where I was able to view a (rather meager) sampling from the museum's collection of nineteenth-century French paintings, including two well-known works by Delacroix, although *Women of Algiers* was not pictured. Useful online art directories include Musée <www.musee-online.org>, Art Museum Network <www.amn.org>, and World Wide Arts Resources <wwar.com/museums.html>.

Using the Online Catalog in Your School Library

Most libraries have replaced traditional card catalogs with online catalogs. A few years ago, the novelist Nicholson Baker wrote a fascinating article lamenting the passing of the card catalog, with its quirky personal histories and handwritten annotations. The advantages of the online catalog, however, are clear: the search is faster and more efficient, can be conducted off-site, tells you if a book is out on loan, and may provide access to other library catalogs. In most cases a general subject heading, usually the artist's name, is sufficient to initiate the search. Jot down the call numbers of relevant books on your topic, including exhibition catalogs, and proceed to the library stacks.

Remember that you can always consult the art librarian at your school for help in locating any of these materials. In addition, many libraries provide fact sheets explaining how the institution stores and catalogs its resources.

Searching the Stacks

Art books in the open shelves or stacks are usually grouped by medium (e.g., painting), then by nationality (e.g., French) and date (nineteenth century), and then alphabetically by artist (Delacroix). Selecting volumes

from my library's collection of books on Delacroix, I thumbed through the index at the back of each book to make sure my particular painting was included. I found the most recent monograph on Delacroix and consulted its bibliography for an up-to-date listing of articles on my topic as well as books I might have overlooked in my catalog search. Branching out a bit, I skimmed through the introductions to books about other paintings by Delacroix (for instance, Jack Spector's book on *The Death of Sardanapalus*) to see if the author's approach might help me think about my own topic. Skimming the footnotes in various texts, too, led me to additional reference materials.

Having reviewed the books on the shelves, I proceeded to search for scholarly articles on *Women of Algiers*. For most art history research projects, you'll want to consult current journal articles in the discipline for in-depth treatments of your topic. For a listing of these articles, consult one of the specialized periodical indexes discussed below.

Consulting Art Periodical Indexes

In addition to more general indexes such as *Bibliographic Index* and *Readers' Guide to Periodical Literature* (covering more popular magazines like *Time* and *Atlantic*), your library will subscribe to *specialized indexes* for art criticism and art history. The two most extensive of these bibliographies are *Art Index* and *BHA (Bibliography of the History of Art)*; both provide year-by-year listings of the current literature on visual art, and both are now available online in most school libraries. Other specialized art bibliographies include *Avery Index to Architectural Periodicals* (1934–), *Architectural Periodicals Index* (1973– , and, for listings of books and articles on twentieth-century art, *ARTbibliographies MODERN* (1969–).

Art Index and *BHA*

Art Index covers about 250 journals (providing a summary—called an *abstract*—for each article) back to 1984. In addition, *Art Index* lists any reproductions of individual paintings that have appeared in print, making it a

useful source if you're unable to locate a decent picture of a particular work. The *BHA* contains abstracts for art-related books, exhibition and dealers' catalogs, conference proceedings, dissertations, and articles from more than 2,500 periodicals. The *BHA*'s coverage goes back to 1973, including the listings of its two predecessor art indexes: *RILA (International Repertory of the Literature of Art)* from 1975 to 1989 and *RAA (Répertoire d'art et archéologie)* from 1973 to 1989. The disadvantage of *BHA* is that it covers only Western art (from late antiquity to the present).

Although listings in *Art Index* and *BHA* will overlap to a great extent, you may want to consult more than one index. You then decide whether you want to track down an article, basing your decision on the relevance of the abstract as well as on the quality of the journal in which it appears (with experience, you'll get to know the more serious journals versus those pitched at a more general readership). The *BHA*'s voluminous listings include numerous popular and foreign-language publications that can readily be sorted out.

As with any information search, it's best not to define your field too narrowly. A *subject* search of "Women of Algiers" in the *BHA* index online turned up just two records—a two-pager from a magazine and a book on Picasso's series of paintings inspired by Delacroix. On the other hand, a *keyword* search of "Delacroix" turned up hundreds of records; those in English numbered 317. Further browsing among the abstracts suggested that only six of these records were applicable to my topic. In *Art Index*, a subject search of *Women of Algiers* turned up the same two records; the broader heading of "Delacroix" turned up 240 citations, which I quickly scrolled through, eliminating "Reproduction" entries, and printed out 7 relevant abstracts. I was then ready to locate the articles themselves.

Locating Articles and Taking Notes

Often the online index will tell you whether your library carries a particular periodical. Otherwise, to locate the journal articles you need, consult your school's online

catalog or a printout of its *Serials List,* to find out which periodicals your school subscribes to, the dates of your library's holdings, and where they are found in the stacks or the microfilm section. In addition, your reference librarian can tell you if your school offers access to any *subscription full-text databases,* which reprint entire articles from online periodicals.

Once you've found articles that seem promising, begin by reading the most recent, since it is likely to include a summary of earlier research on the subject. Then skim the remaining articles for their relevance before you start taking notes. (For example, of the six promising leads I found in my *BHA* search, only three eventually proved useful for my project; a fourth looked interesting but turned out to be in Norwegian.) Take careful notes from your sources, summarizing arguments, checking exact wording and punctuation of any quotations you intend to use, and recording page numbers for citation in footnotes. To save time and guard against inaccuracies in my note-taking, I usually photocopy articles for reference at home.

General Reference Works

For explanations of art terms you come across in your research, as well as short biographies of artists, the most current and comprehensive general reference work is the thirty-four-volume *Dictionary of Art* (1996), edited by Jane Turner. Other resources include *The Oxford Dictionary of Art, Adeline Art Dictionary, The Dictionary of Women Artists,* and *Who's Who in American Art. Art Information and the Internet* (1999) by Lois Swan Jones tells you how to find and use online sources. Your art librarian can direct you to additional reference guides; for home use, *The Penguin Dictionary of Art and Artists* by Peter and Linda Murray, available in paperback, is an inexpensive choice.

Visiting Specialized Libraries

If your research leads you to books or journals not carried by your school library, consider ordering these references through interlibrary loan (this may take a week or two) or visiting more specialized art libraries in other schools

and local museums. Often all you need to do is present your student ID card at the library's reference desk, but call the institution first to see if you need special permission to use its facilities and to check on hours and rules regarding photocopying.

Documenting Sources

As you sift through the materials you've gathered, you'll need to evaluate the applicability of the information to your own project. You'll gradually become aware of differences among various critical approaches; Chapter 10 of this book will help you identify and understand these critical perspectives. In the final draft of your essay, of course, you'll need to acknowledge the sources you've used. Following is a discussion of formats for documenting research.

What to Document

Chapter 5 of this book provides you with guidelines for incorporating outside sources into the text of your essay. If you do include the contributions of others, you must credit these sources in your notes and bibliography. Failure to do so is plagiarism: the unacknowledged use of another author's intellectual work is a serious violation of the rules of the academic community. Rules of documentation apply not only to direct quotations but to paraphrases of another author's words (that is, passages recast in your own words), as well as to borrowed ideas and facts not considered general knowledge in the public domain.

Why and How to Document

Giving proper credit to the ideas of others is not only ethical practice but a courtesy to your readers, who may wish to check a reference or read further in some of the sources you've cited. Ideally, members of the various academic disciplines would agree on a standard method of documentation that would serve as a *lingua franca* or common language for readers and writers. Unfortunately, the disciplines tend to differ slightly with regard to footnote and bibliography format. The two most frequently used formats are described in the *MLA* [*Modern Language Association*] *Handbook for Writers*, 5th ed. (New

York: MLA, 1999), which is generally used in the humanities, and *The Chicago Manual of Style,* 14th ed. (Chicago: University of Chicago Press, 1993), widely used in the arts and sciences.

The format described in *The Chicago Manual of Style* is the citation method favored by art historians and recommended by the College Art Association (CAA). One of the CAA's two periodicals, *Art Bulletin,* recommends its own adaptation of the Chicago format, geared to authors who are submitting articles to the publication. Because art history scholarship often involves complex citations of primary sources, *Art Bulletin's* style guide goes into greater detail regarding this kind of documentation.

All three methods of documentation—Chicago, *Art Bulletin,* and MLA styles—are described and illustrated in the following pages, with greater emphasis being placed on the two methods recommended in art history scholarship. Your instructor will tell you which format to use, as well as whether he or she prefers that notes be double- or single-spaced, and whether citations should go at the bottom of each page (footnotes) or together at the end of the paper on a separate sheet entitled Notes or Endnotes. The important point to remember is this: whichever form of citation you use, use it consistently. Over the years I've seen more than my share of careless variations, and the effect, inevitably, is to shake my confidence in the writer's fair and accurate use of researched material.

Chicago Manual of Style Format

Footnotes and Endnotes

You've already seen the two major formats for footnotes used in the students' essays reprinted in Chapters 5 and 6. According to the *Chicago Manual of Style* method illustrated in Chapter 6, you indicate information gleaned from another source by typing a raised arabic number after the sentence in which the material appears, like this.[1]

1. Besides using footnotes to cite other sources, writers occasionally use **explanatory notes** to amplify comments they've made in the text, or to direct readers to a related point that might otherwise interrupt the flow of the paragraph. You are reading an example of an explanatory footnote.

Notes are numbered consecutively throughout the essay. The publication information for the source is provided at the bottom of the page in a footnote or at the end of the essay in a list of endnotes. Footnotes and endnotes are typed single-spaced, with a double space between entries.

Footnote Citations for Books, Dissertations, and Theses

To type a footnote for a book, indent five spaces for the first line; each subsequent line is flush with the left margin. Type the arabic number, followed by a period, that corresponds to the reference in the text of your essay. Skip one space and begin with the author's full name, followed by a comma. (Do not put the last name first: this is done only in the bibliography, which is alphabetized.) Next comes the title of the book, underlined. In parentheses, give the city of publication followed by a colon, the name of the publishing firm followed by a comma, and the date of publication. The end parenthesis is followed by a comma and the page number of the citation. Do not type "page" or "p." or "pp"—simply type in the number. End the note with a period.

This is the basic *Chicago*-style footnote for book citations:

1. Author and second author if there is one, *Title of Book: If There's a Subtitle, Put after a Colon* (Place of Publication: Publisher, Date of Publication), page number.

Following are specific illustrations of book citations.

FOR THE FIRST REFERENCE TO A BOOK WITH ONE AUTHOR

1. Frank Anderson Trapp, *The Attainment of Delacroix* (Baltimore: Johns Hopkins University Press, 1970), 54.

FOR SUBSEQUENT REFERENCES TO THE SAME BOOK

Use the author's last name, followed by a comma and the page or pages cited. If you have more than one book by the same author in your bibliography, include a shortened version of the title (underlined), followed by a comma and the page number. If the subsequent reference

directly follows the first, you may use ibid. to replace the author's name and title, followed by a comma and the page number (Ibid. is an abbreviation of *ibidem*, Latin for "in the same place"), although this term is less frequently used nowadays:

> 2. Trapp, *Attainment*, 53.

or:

> 2. Ibid., 53.

For a Book in a Series

> 3. Jack J. Spector, *Delacroix: The Death of Sardanapalus*, Art in Context Series (New York: Viking, 1974), 15.

For a Book in More Than One Volume

Indicate the volume number with an arabic numeral followed by a colon and the page number. The following citation is for page 43 of volume 3 of Johnson's *catalogue raisonné:*

> 4. Lee Johnson, *The Paintings of Eugène Delacroix: A Critical Catalogue* (Oxford: Oxford University Press, 1986), 3:43.

For a Book With Two or Three Authors or Editors

The following collection of essays has three editors. (For a book by more than three authors or editors, use et al., as in footnote 8, below.) Also note in this example that rules for capitalization of foreign-language titles differ somewhat from rules for English titles. In this chapter, several titles in French are included as examples; for details regarding other languages, consult the *The Chicago Manual of Style* (15.118).

> 5. Laure Beaumont-Maillet, Barthélémy Jobert, and Sophie Join-Lambert, eds., *Souvenirs d'un voyage au Maroc* (Paris: Gallimard, 1999), 56.

For an Edited or Translated Book

Use the abbreviations ed. or eds. (as in the above example) or trans., as in this example:

> 6. Barthélémy Jobert, *Eugène Delacroix*, trans. Terry Grabar (Princeton: Princeton University Press, 1998), 93.

For an Introduction or Foreword
to a Book Written by Another Author

> 7. Barbara Harlow, Introduction to Malek Alloula, *The Colonial Harem*, trans. Myrna Godzich and Wlad Godzich (Minneapolis: University of Minnesota Press, 1986), iii.

For an Exhibition Catalog

Use the abbreviation "exh. cat." In the following example, note that with more than three authors, et al., short for *et alia* (Latin: "and others"), is used:

> 8. Brahim Alaoui et al., *Delacroix au Maroc*, exh. cat. (Paris: Institut du Monde Arabe, 1994-95), 9.

For an Individual Essay in an Edited Collection
or Exhibition Catalog

> 9. Todd B. Porterfield, "Western Views of Oriental Women in Modern Painting and Photography," in *Forces of Change: Artists of the Arab World*, ed. Salwa Mikdadi Nashashibi, exh. cat. (Washington D.C.: The National Museum of Women in the Arts, 1994), 71.

Note that essay and article titles are given in quotation marks, while book titles are underlined or italicized.

For an Essay in a Collection with No Listed Editor

> 10. Mary J. Harper, "The Poetics and Politics of Delacroix's Representation of the Harem in *Women of Algiers in Their Apartment*," in *Picturing the Middle East: A Hundred Years of European Orientalism*, exh. cat. (New York: Dahesh Museum, 1996), 85.

For a Reprint of an Earlier Publication

> 11. Eugène Delacroix, "On Art Criticism" (1829; reprint, New York: The Marchbanks Press, 1946).

For a Book with a Different Editor and Translator

> 12. Eugène Delacroix, *The Journal of Eugène Delacroix; A Selection (Arts and Letters)*, ed. Hubert Welling; trans. Lucy Norton (London: Phaidon Press, 1995), 40.

For a Doctoral Disseration or Master's Thesis

> 13. Kenneth Bendiner, "The Portrayal of the Middle East in British Painting 1835-1860" (Ph.D. diss., Columbia University, 1979), 34-78.

14. Joan DelPlato, "Delacroix's *Women of Algiers* of 1834" (Master's thesis, University of California at Los Angeles, 1980), 63.

Footnote Citations for Articles in Journals and Newspapers

Here is the general footnote format for articles:

Author(s), "Title of Article," *Name of Periodical* Volume Number (Date of Publication): page number(s).

Note: If the journal has continuous pagination throughout the year, no issue number or month is necessary—the volume number is sufficient. But the *Chicago Manual* allows for some variation here: if the publication has an issue number, you may include it and the month of publication in addition to the volume number, as in example 15, below.

Following are specific illustrations of footnotes for periodicals.

FOR AN ARTICLE IN A PERIODICAL WITH CONTINUOUS PAGINATION THROUGHOUT THE ANNUAL VOLUME

15. Frederick N. Bohrer, "Inventing Assyria: Exoticism and Reception in Nineteenth-Century England and France," *Art Bulletin* 80, no. 2 (June 1998): 336-356.

or:

15. Frederick N. Bohrer, "Inventing Assyria: Exoticism and Reception in Nineteenth-Century England and France," *Art Bulletin* 80 (1998): 336-356.

FOR AN ARTICLE IN A JOURNAL WITH NO ISSUE NUMBERS

16. Cissy Grossman, "The Real Meaning of Eugène Delacroix's *Noce Juive au Maroc*," *Jewish Art* 14 (1988): 64-73.

FOR AN ARTICLE IN A NEWSPAPER

17. Jean-Barthélémy Haureau, "Variétés. Salon de 1834," *La Tribune politique et littéraire,* 15 March 1834, 2.

Note that if the above newspaper article were unsigned, the footnote would read:

17. "Variétés. Salon de 1834," *La Tribune politique et littéraire,* 15 March 1834, 2.

FOR A REVIEW OF AN EXHIBITION

18. Jeremy Wood, review of "The Orientalists, Delacroix to Matisse: European Painters in North Africa and the Near East," Royal Academy of London, *Pantheon* 42 (July/September 1984): 285-7.

Footnote Citations for Interviews, Correspondence, and Internet Sources

FOR A PERSONAL INTERVIEW

19. Véronique Chagnon-Burke, interview by the author, New York City, 22 March 2000.

FOR A PERSONAL COMMUNICATION BY LETTER OR E-MAIL

20. Véronique Chagnon-Burke, letter to the author, 10 March 2000.

21. Véronique Chagnon-Burke, E-mail to the author, 22 March 2000.

FOR AN INTERNET SOURCE

Here is the general format for citing documents available on the World Wide Web:

22. Author(s), "Title of Document," *Title of Web Site*, name of institution hosting the site, date of posting, <http://Internet address> (date you visited site).

Bibliography or Works Cited

A bibliography is a complete list of the works you've consulted for your essay, including those you've read for background material. For most assigned essays, a "Works Cited" list is preferable: this kind of list includes only those materials referred to in your paper. Bibliographic entries are not numbered; they are arranged alphabetically by the *last name* of the author. The first line of the entry is flush left, and subsequent lines are indented five spaces, so that the last name is spotlighted. Anonymous works are alphabetized by title (alphabetize according to the first word after the initial *A* or *The*). Entries are double-spaced.

Following are sample entries for the Delacroix bibliography.

Bibliographic Citations for Books, Dissertations, and Theses

FOR A BOOK BY ONE AUTHOR

> Dumur, Guy. *Delacroix et le Maroc*. Paris: Herscher, 1988.

FOR AN EXHIBITION CATALOG

> Alaoui, Brahim, et al. *Delacroix au Maroc,* exh. cat. Paris: Institut du Monde Arabe, 1994-95.

FOR AN ENTIRE COLLECTION OR EXHIBITION CATALOG BY AN ANONYMOUS EDITOR

If no editor is listed, alphabetize under the name of the institution.

> Dahesh Museum. *Picturing the Middle East: A Hundred Years of European Orientalism,* exh. cat. New York: Dahesh Museum, 1996.

FOR A TRANSLATION

> Djebar, Assia. *Women of Algiers in Their Apartment.* Translated by Marjolijn de Jager. Charlottesville and London: University Press of Virginia, 1992.

FOR AN EDITED WORK

> Delacroix, Eugène. *Correspondance générale d'Eugène Delacroix.* Edited by André Joubin. Paris: Plon, 1936-38.

Note: For bibliographic citations of translated or edited works, the abbreviations Trans. and Ed. are permissible. Thus the previous note might read:

> Delacroix, Eugène. *Correspondance générale d'Eugène Delacroix.* Ed. André Joubin. Paris: Plon, 1936-38.

FOR A MULTIVOLUME WORK

> Johnson, Lee. *The Paintings of Eugène Delacroix: A Critical Catalogue.* Volumes 3 and 4: 1830-1863. Oxford: Oxford University Press, 1986.

FOR MULTIPLE PUBLICATIONS BY A SINGLE AUTHOR

Type eight underline keys followed by a period, skip two spaces, and then type the title of the work. Alphabetize multiple entries by title:

> Johnson, Lee. "Delacroix's Jewish Bride," *Burlington Magazine* 139 (1997): 755-59.

_____. "Toward Delacroix's Oriental Sources," *Burlington Magazine* 70 (1978): 144-51.

FOR A BOOK BY MORE THAN ONE AUTHOR OR EDITOR

Note that only the first name is reversed for alphabetizing; the other names are printed as they appear on the title page of the book, first name first:

Beaumont-Maillet, Laure, Barthélémy Jobert, and Sophie Join-Lambert, eds. *Souvenirs d'un voyage dans le Maroc.* Paris: Gallimard, 1999.

FOR A BOOK IN A SERIES

Spector, Jack J. *Delacroix: The Death of Sardanapalus.* Art in Context Series. New York: Viking, 1974.

FOR A DOCTORAL DISSERTATION OR MASTER'S THESIS

Bendiner, Kenneth. "The Portrayal of the Middle East in British Painting 1835-1860." Ph.D. diss. Columbia University, 1979.

DelPlato, Joan. "Delacroix's Women of Algiers of 1834." Master's thesis, University of California at Los Angeles, 1980.

Bibliographic Citations for Articles in Journals and Newspapers

FOR AN ARTICLE IN A PERIODICAL PAGINATED BY ISSUE

Fraser, Elisabeth A. "Uncivil Alliances: Delacroix, the Private Collector and the Public," *Oxford Art Journal* 21, no. 1 (1998): 87-103.

FOR AN ARTICLE IN A PERIODICAL CONTINUOUSLY PAGINATED BY VOLUME

Johnson, Lee. "Delacroix's Jewish Bride," *Burlington Magazine* 139 (1997): 755-59.

FOR AN INDIVIDUAL ESSAY IN AN EXHIBITION CATALOG

Harper, Mary J. "The Poetics and Politics of Delacroix's Representation of the Harem in *Women of Algiers in Their Apartment.*" In *Picturing the Middle East: A Hundred Years of European Orientalism,* exh. cat. New York: Dahesh Museum, 1996.

FOR A REVIEW OF AN EXHIBITION

Wood, Jeremy. Review of "The Orientalists, Delacroix to Matisse: European Painters in North Africa and the

Near East (Royal Academy of London)," *Pantheon* 42
(July/September 1984): 285-87.

Bibliographic Citations for E-mail and Internet Sources

FOR A PERSONAL COMMUNICATION BY E-MAIL

DelPlato, Joan. E-mail to author, 19 January 2000.

FOR AN INTERNET SOURCE

Here is the general bibliographic format for documents available on the World Wide Web:

Author(s), "Title of Document," *Title of Web Site,* name of
institution hosting the site. Date of posting.
<http://Internet address> (date you visited site).

Art Bulletin Style

As previously noted, *Art Bulletin* specifies a modified version of the *Chicago Manual* style for its contributors. One difference is that the bibliography takes the form of a list of "Frequently Cited Sources" rather than "Works Cited." Beyond this, there are variations in the way footnotes and bibliographic entries are presented.

The following material is excerpted from the guide to documentation published on the *Art Bulletin* Web site. The guide can be found in its entirety at <http://www.collegeart.org/caa/publications/AB/ABStyleGuide.html>.

Text References, Footnotes, and Frequently Cited Sources

Note reference numbers in the text should be clearly designated by means of superior figures placed after punctuation. Note reference numbers in the notes themselves should be on the same line as the text, followed by a period and one space (e.g., 1. John Shearman, . . .).

If a work is cited only a few times, it should not appear in the list of "Frequently Cited Sources"; the full reference should be in the first note reference to the work. Subsequent references should then take the short form, referring to the first reference: Smith (as in n. 15), 243.

All references to publications and the like should appear in full form only once, and otherwise in a short

form. Do not use *op. cit.* References will differ slightly depending on whether the work is cited only a few times in the article or more often. In the latter case, the one full reference should be in "Frequently Cited Sources," at the end of the article, and all other references should take the short form of the author's surname and the page (e.g., Smith, 423), or the shortest comprehensible form (e.g., ASR, Cam., 111. Anagni, busta 80, fol. 40r).

If there is more than one author of the same surname, give an initial; in the case of more than one publication by an author, give the date (Smith, 1969, 423). In the case of more than one work by one author of the same date, cite one as "a" and one as "b" (to be specified also in "Frequently Cited Sources"); thus, the maximum short reference would be B. Smith, 1969a, 423.

If a reference is followed immediately by another reference to the same work, "ibid." replaces "Smith" or any longer identification.

References to biblical passages should be made in the text (e.g., Matt. 4:14), but the first citation to the Bible should be a full reference in a footnote, giving the version used, e.g., Vulgate, King James, Douai. Also to be cited in the text are other classic works with standardized systems of subdivision traditionally established, e.g., *Odyssey* 9.266, Timaeus 484b. The one full reference, in a footnote, should note which translation, critical edition, or the like was used.

For classic works that ought to be cited by edition but exist in numerous editions, give an extra reference to the section of the work, since readers may use an edition different from yours. If the section divisions are standard, give them in Arabic numerals separated by periods.

For certain standard reference tools, the first reference may use a short title, notably Thieme-Becker, *Pat. lat., Pat. gr.,* Vasari-Milanesi, *Webster's Third, Webster's International.*

In notes, the form of the full reference is as follows (the form for "Frequently Cited Sources" is the same, except that the author's surname is given first; i.e., Swindler, M. H.).

BOOK

1. Elizabeth Cropper, *Pietro Testa, 1612–1650*, exh. cat., Fogg Art Museum, Cambridge, Mass., 1988, 246. (For England, use Cambridge only.)

2. Annibale Caro, *Lettere familiari*, II, ed. A. Greco (Florence: Le Monnier, 1957), 401–5.

3. William M. Smith, *Medieval Painting*, 2nd ed. (Paris: 1925), 195–96.

4. Henry-Russell Hitchcock, *Architecture: Nineteenth and Twentieth Centuries* (1957), *Pelican History of Art*, rev. ed. (Baltimore: Penguin Books, 1963), 21–42.

5. *Annual of the American Academy in Rome*, III (Rome: Publisher, 1922), passim. ("Passim" should be used sparingly; better to give inclusive page numbers.)

6. Catalogue of the Library, sale cat., Christie's, New York, July 29, 1925.

ARTICLE IN PERIODICAL

1. Wilibald Sauerlander, "Die kunstgeschichtliche Stellung Westportale von Notre-Dame in Paris," *Marburger Jahrbuch für Kunstwissenschaft* 17 (1959): 1–55.

2. Jan Jennings, "Leila Ross Wilburn, Plan-Book Architect," *Woman's Art Journal*, Spring-Summer 1989, 15.

3. Antonio Natali, "Altro da Pontormo e Bronzino?" *Antichità Viva*, nos. 2–3 (1989): 136–37.

Distinguish between vol. and no.: *Art Bulletin*, 52, no. 3 [note: no *The* in titles of journals]. Please note that if issue number is given, it is unnecessary to give the month of publication.

UNPUBLISHED MATERIAL

1. Nancy Elizabeth Locke, "Manet and the Family Romance," Ph.D. diss., Harvard University, 1993, 41; or, M.A. thesis, New York University, Institute of Fine Arts, 1961, 41.

2. Klaus Bauch, *Bildnisse des Jan van Eyck*, University of Munich, 1970 (because German dissertations are published).

ARCHIVAL MATERIAL

1. Rouen, Bibli. Mun. MS fr. 938 (comma only between city and institution).

2. London, Brit. Mus. Add. MS 28134 (not B.M. or BM); or invert sequence at author's discretion: Archivio di Stato, Rome (hereafter ASR), Camerale 111, Anagni, busta 80, Computa Depositaria Munimimis Ananiae, 3 (cap. as given by author; no italics).

In arranging the list of "Frequently Cited Sources," archival material, if of any length, should be cited first,

showing abbreviations as used in the footnotes for names of archives and the like, e.g.:

ASR: Archivio di Stato, Rome

Any other abbreviations, unless numerous, should be alphabetized within the main list. References should appear alphabetically by author. For alphabetization, see *Webster's Biographical Dictionary* or *Who's Who in American Art*.

When there are many contributions by the same author in the list of "Frequently Cited Sources," they should be organized by date, placed after the author's name, with earliest date cited first:

Meiss, Millard, 1956, "Jan van Eyck," *Venezia e l'Europa*, Venice, 58–69.
———, 1967, "Sleep in Venice," *Stil und Uberlieferung*, Berlin, 100–120.
———, 1970, "The Friedsam Annunciation Again," *Art Bulletin*, 52, no. 3, 368–72.

Note that inclusive page numbers of articles must be provided in the list of "Frequently Cited Sources."

MLA Style

Although the recommended format in art history and criticism is that of the *Chicago Manual*, more and more disciplines are adopting the parenthetical style of documentation described in the *MLA Handbook*. In this format, you acknowledge your sources with brief parenthetical citations in your text, referring the reader to the full citation that appears in the "Works Cited" list at the end of the essay. This method is easy to use and doesn't clutter up the page with footnotes and repeated information.

The *MLA* parenthetical method is illustrated in the student's essay quoted in Chapter 5 of this book. Briefly, here's how it works: after you've quoted or paraphrased your source, place the author's last name and the page number of the reference in parentheses before the final punctuation of the sentence; for example, if your source is Guy Dumur's book *Delacroix et le Maroc*, you'd end with (Dumur 25). If you've mentioned Dumur's name in the sentence, only the page number is needed (25). If your

"Works Cited" list includes more than one title by this author, clarify which one you're citing by including a shortened version of the title (Dumur, *Delacroix* 25). Your "Works Cited" will then include the complete publication information for this reference, as in the *Chicago* style.

For a comprehensive discussion of the *MLA* style guidelines, visit the organization's Web site: <http://www mla org>

10

Critical Perspectives

On *Women of Algiers in Their Apartment*
by Eugène Delacroix

"Delacroix is the most suggestive of all painters. . . ."
—Charles Baudelaire, "The Life and Work of Eugène Delacroix," *1863*

"Upon his return to Paris [from Algeria], the painter will work for two years on the image of a memory that teeters with a muted and unformulated uncertainty, although well-documented and supported by authentic objects. What he comes out with is a masterpiece that still stirs questions deep within us."
—Assia Djebar, Women of Algiers in Their Apartment, *1980*

"On a eu raison de dire qu'avec Les Femmes d'Alger *Delacroix conciliait romantisme, classicisme et réalisme. Mais s'en tenir à ces classifications, c'est ne plus voir l'oeuvre en soi, prise dans son ensemble: sujet et peinture pure, nature et composition savante. Rebelle à toute analyse, le* tableau, *dans tous les sens du terme, appartient à la grande anthologie de l'histoire de la peinture."* [*"It's correct to say that with the* Women of Algiers *Delacroix was reconciling romanticism, classicism, and realism. But confining oneself to these classifications means not seeing the work in itself, taken as a whole: subject and pure painting, nature and skillful composition. Resisting analysis, the* tableau *(picture, scene, painting), in every sense of the word, belongs to the great anthology of the history of painting."*]
—Guy Dumur, Delacroix au Maroc, *1988*

"Delacroix's Women of Algiers *is a painting that continues to invite probing but whose meanings defy closure. Perhaps this is the final point: that successful art provides infinite richness for the process of interpretation."*
—Joan DelPlato, "Delacroix's Women of Algiers *of 1834*," *1999*

Not long ago I asked one of my colleagues, an art historian, how she had become interested in archival research. She sent back this note:

> What I like to tell my students is that as I was growing up, I really wanted to be a secret agent, a detective. (Perhaps

this isn't so unusual: remember that Sir Anthony Blunt, the great English art historian, was accused of having spied for the Russians during World War II.) As I did not care for guns and violence, and I was sure that I could not endure being tortured, becoming an art historian seemed the next best career option. Searching to reconstruct what happened, to understand how a work was created, displayed, and evaluated, is one of the most fascinating aspects of being an art historian.

All researchers are detectives, closely examining the physical evidence before them and pursuing a paper trail of clues left by earlier travelers along the same route. This chapter provides an overview of the investigative methods by which critics and historians over the years have examined a single work of art, Eugène Delacroix's *Women of Algiers in Their Apartment* (1834; Color Plate 8; fig. 10.2). The purpose of this sampling is to acquaint you with the range of perspectives from which any text can be explored. The fact that the subject of this chapter has been written about by numerous observers over the past 150 years does not limit further inquiry. Images continue to evolve with their audience. This chapter invites you to take up the discussion where other researchers have left off.

I've chosen *Women of Algiers* as the subject of this detective story for several reasons. To begin with, the painting is rich and strange and absolutely ravishing in its orchestration of form, color, and texture. Little wonder it has influenced generations of artists. This is the canvas Renoir called "the most beautiful painting in the world," a work whose limpid colors, according to Cézanne, "enter your eye like a glass of wine going down your throat." Picasso paid frequent visits to the Louvre to study *Women of Algiers* and in 1954–1955 created a series of variations on the painting. In 1980, the author Assia Djebar composed literary variations on the themes of Delacroix's painting in her collection of stories about women's lives in postcolonial Algeria. Houria Niati based her mixed-media installation, *No to Torture* (1982–1983), on Delacroix's painting. Clearly, *Women of Algiers* inspires repeated viewing.

At the same time, *Women of Algiers* provides an interesting study of how a work of art becomes part of the

10.1 Eugène Delacroix, *The Death of Sardanapalus*, 1827–28. Oil on canvas, 395 × 495 cm. (145¹/₂ × 194⁷/₈ in.). Musée du Louvre, Paris.

canon. When the painting was first displayed at the French Salon of 1834, one could scarcely have predicted its present status as a masterpiece. Instead, most critics turned their attention to other works hanging in the Salon such as Paul Delaroche's *The Execution of Lady Jane Grey* (see fig. 10.6), paintings more in keeping with contemporary tastes for minute realism and historical subjects. Yet it is Delacroix, not Delaroche, who has been canonized in art history courses today—in part, perhaps, because of subsequent generations' preferences for the subjectivity of Romanticism and the ambiguities of modernist painting. Our survey of critical responses to *Women of Algiers* reveals shifting attitudes toward themes and stylistic categories in the history of art.

Equally important, the body of writing on *Women of Algiers* illustrates how responsive a single text can be to an array of critical approaches—"biographical," "formalist," "feminist," and so on. These methods are by no

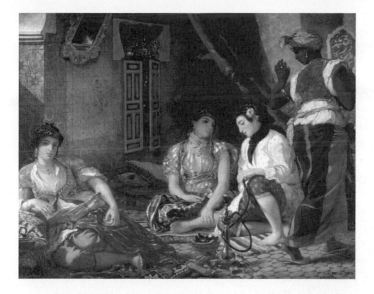

10.2 Eugène Delacroix, *Women of Algiers in Their Apartment*, 1834. Oil on canvas, 180 × 229 cm. (70⁷/₈ × 90¹/₈ in.). Musée du Louvre, Paris. The paintings shown in figs. 10.1 and 10.2 hang side by side in the Louvre. Note relative sizes and stylistic differences.

means mutually exclusive, as we shall see. The literary critic Hans Robert Jauss suggests that to its contemporary audience, each work of art implies a question and an answer arising from certain shared expectations or an understanding of the genres, forms, and subjects of already familiar works. Naturally, viewers in succeeding eras come to the same work with different kinds of questions about form and content. This is how works of art continue to speak to their present-day viewers.

By way of a rather literal-minded detective story, I'd like to relate the circumstances of a recent visit to the Louvre Museum in Paris, where *Women of Algiers* is hung. For several weeks in the summer of 1999, the national museums in Paris were shut down by a strike—strikes being rather common occurrences in that city. I was disconsolate. I had come to Paris on a Delacroix-seeking mission, and although I was on speaking terms with reproductions of *Women of Algiers*, it had been some years since I'd visited the painting in person. Fortunately, an acquaintance who works as a curator at the Louvre secured me an hour's pass into the deserted museum. My privileged entry into rooms closed off to the public had for me all the drama of Delacroix's famous visit to the harem depicted in his *Women of Algiers*. My guide led me up the great staircase of the Denon wing of the Louvre, past the

Winged Victory of Samothrace, past gilded doorways to fabled galleries, past a lone man polishing the parquet floor. I felt vaguely guilty for having trespassed on forbidden territory, but like Delacroix in the story, I was dazzled by the vision down the long corridor.

I record this anecdote to suggest the ways in which encounters between objects and viewers are shaped by context—first of all, by personal and physical circumstances. I had never been so alone with this painting, nor sensed its physical pull. By this I mean that *Women of Algiers* is one of those large and silent paintings—Seurat's *Sunday Afternoon on the Island of La Grande Jatte* is another—that you find yourself falling into, their very stillness exerting the force of gravity.

Then too, the walls of the room were weighted with history. Delacroix had scaled the huge piece to be exhibited in the Paris Salon of 1834, and a gallery in the Louvre, I said to myself, is where it is ideally viewed. The painting now faces the theatrical masterworks of Géricault, Delacroix's most influential predecessor, and is flanked by paintings Delacroix executed before and after *Women of Algiers*. Next to the teeming canvas of Delacroix's *Death of Sardanapalus* (1827–28; fig. 10.1), the stillness of *Women of Algiers* emerges in relief. The balance and tranquillity of its composition appear to have constituted, in some measure, the artist's response to his critics, who had denounced *Sardanapalus* as a flamboyant and incomprehensible mess.

At close range, certain details in *Women of Algiers* now emerged more clearly from the painting's slightly smoky atmospheric effects. I could discern the outline of a glass bottle on a shelf in the half-opened cupboard and the tiny watch suspended on a necklace worn by the cross-legged figure at the center of the canvas. I noted with some surprise that the reclining figure at the left of the composition does not look directly at the viewer but stares into distant space. None of the gazes in the painting, in fact, connects with any other. Eventually I began to trace the network of iconography that viewers have come to associate with Western depictions of "the Orient": the Arabic lettering; the smoking paraphernalia—narghile (water pipe), coal brazier, tongs; the sumptuous clothing and

patterned surfaces; the ornately framed mirror; the vaguely Islamic architectural forms; the languid poses of harem women attended by their servant.

Yet the more I looked, the more these signs seemed to baffle rather than clarify. The watch face, the Arabic cartouche, the mirror with its blank surface, the oblique and shadowed human glances, the figure of the black woman turning her back to the spectator: all these faces were averted, as if refusing to be read. Or perhaps I should say, I was trying to read these signs as part of a seamless pictorial discourse on Orientalism, but the objects weren't cooperating. It was difficult to get one's bearings in the ambiguous space of the Algerian women's apartment. The wall on the left, frankly defined by its patterned tiles, trails off into obscurity toward the middle ground of the painting. Still more disorienting: the angle of the receding wall contradicts the angle of the floor, which tilts upward slightly. Each decorated surface opens one doorway into the scene and seals off another. At length the painting seemed to me a gorgeously seductive maze.

Which leads me to my second point, that we encounter a work of art not only as an object in space but as a process, a movement through time. Each successive pass over the surface of the object raises as many questions as it resolves. Works of art are never perceived in a vacuum; they live in a dialogue with other works of art, other eras, other viewers.

I've said I was alone with the painting, but that's not quite true. As Cézanne observed, "We are all here, in this Delacroix." A whole cast of characters was gathered in front of the painting in the Louvre: the crowds attending the Salon exhibition in the spring of 1834, successive generations of professional critics, and Cézanne, and Picasso, to say nothing of me, my guide, and the floor polisher, all jostling and talking at once. I gave up looking for one thread, one system of meaning to take me through the maze, and began to think of the painting instead as a site where all these strands of discourse meet and intersect.

The critical commentaries quoted in this chapter show how a variety of observers have deepened our perception of the painting over the decades. Interestingly, although Delacroix has been the subject of a number of large-scale

exhibitions and studies in recent years, he has yet to be given a full-fledged "revisionist" critical consideration—that is, a reevaluation in terms of contemporary critical theory. Exhibitions such as "Courbet Reconsidered" or "Mary Cassatt: Modern Woman" are designed to question some of the underlying assumptions and traditional categories of art history. Some observers might argue that this is merely trendy repackaging. Others would reply that rereading and revising keep the text vital. I'd add that critical methodologies are not flavors of the month, tasted and then forgotten. Each interpretation incorporates and enriches the last.

In addition to providing samples of published commentary on the painting, I wanted to focus on new critical work in the field. I turned to two scholars who specialize in nineteenth-century French painting and asked them how they would apply their research methodologies to a discussion of *Women of Algiers*. Taken together, the selections below will acquaint you with the range of critical perspectives and methods you are likely to encounter in your own research projects—not only in art history but in the current literature of all the academic disciplines. Naturally, you'll find some approaches more congenial to your way of thinking or more relevant to a particular topic or assignment. As you read through this chapter, take note of what clues and shades of meaning each commentary contributes to your view of the painting.

Before you read what others have to say, it's important to record your own description of the painting and your responses to it. As we've seen in Chapter 2, the first task of art criticism is to look closely and reflectively, to identify and describe, and to think about the choices the artist has made with regard to technique, composition, color, patterns of light and dark, and so on. Your observations pave the way for further analysis. After you have described what you see, note questions or uncertainties you have about the scene before you. What do you infer about the identity of these figures, about their roles and relationships? What is taking place?

As a side note, you might also compare the painting of 1834 with a version Delacroix painted of the same subject some fifteen years later (fig. 10.3). What changes do you

10.3 Eugène Delacroix, *Women of Algiers in Their Apartment*, 1847–49. Oil on canvas, 84 × 111 cm. (33 × 43²/₃ in.). Musée Fabre, Montpellier, France.

detect from the first version to the second? If you prefer one painting over the other, can you explain your preference by describing features in the painting that particularly appeal to you?

Case Study
Critical Approaches to a Work of Art

What follows is a survey of the interpretive methods commonly used in art history and criticism. The focus here is on what each approach can contribute to our study of a single painting, Delacroix's *Women of Algiers*. Please keep in mind that an overview of this kind is bound to be oversimplified and reductive, rather like those whirlwind package tours that offer fifteen European capitals in seven days. Art and art writing resist being pigeonholed. Categories overlap. Like most areas of study, art history has increasingly borrowed theoretical concepts from other disciplines. As you'll see, the writers quoted in this case study often make use of a range of analytical tools rather than confining themselves to a single perspective. For a fuller account of each critical approach, you are urged to consult the references listed at the end of the chapter.

Biographical Studies

Researchers often begin their projects by looking into an artist's life, using original materials such as autobiographical papers, letters, and accounts by the artist's contemporaries. We're fortunate that Delacroix documented his life and his artistic concerns to an unusual degree in his copious journal entries and correspondence. We also have an extensive visual diary of notes, sketches, and watercolors Delacroix executed during a trip he made to

10.4 Eugène Delacroix, *Double page from North African album*, c. 1832. Folio 24 v-25r. Brown ink and watercolor. Musée du Louvre, Paris.

North Africa in the company of a French diplomatic mission in 1832. His journey yielded material for *Women of Algiers* and was to be a lifelong source of inspiration.

These autobiographical data provide us with more than a fascinating glimpse into the artist's working methods: they are works of art in their own right, like Leonardo's notebooks and Vincent Van Gogh's letters to his brother Theo. In a double leaf from one of the Moroccan sketchbooks (fig. 10.4), we see how Delacroix, although unaccustomed to travel and troubled by physical

ailments, became a dervish of artistic activity. His drawing is sun-drenched, prolific, free.

For secondary sources of information on an artist's career, we turn to biographical studies. The art history biography is a literary subgenre whose conventions for mythologizing the life of the "artist-genius" reach back to Giorgio Vasari's *Lives of the Artists* (first published in 1550). Charles Baudelaire's tribute to "The Life and Work of Eugène Delacroix," published in three newspaper installments following his friend's death in 1863, contains all the elements that characterize this genre. Baudelaire emphasizes Delacroix's "volcanic" temperament and prodigious talent, his kinship with the great masters of painting, his "never-ceasing preoccupation" with technique ("In that respect he comes close to Leonardo da Vinci, who was no less a victim of the same obsessions"), his competitiveness, and his concern for his own artistic legacy. Traditionally in artists' biographies, women are cast in subordinate roles, at best serving as handmaidens or idealized muses. Baudelaire offers the following passage as evidence of Delacroix's single-minded devotion to his art.

From The Life and Work of Eugène Delacroix

by Charles Baudelaire

Sentimental and affected women will perhaps be shocked to learn that, like Michelangelo (may I remind you that one of his sonnets ends with the words 'Sculpture! divine Sculpture! thou art my only love!"), Delacroix had made painting his unique muse, his exclusive mistress, his sole and sufficient pleasure.

No doubt he had loved woman greatly in the troubled hours of his youth. Who among us has not sacrificed too much to that formidable idol? And who does not know that it is precisely those that have served her the best that complain of her the most? But a long time before his death he had already excluded woman from his life. Had he been a Mohammedan, he would not perhaps have gone so far as to drive her out of his mosques, but he would have been amazed to see her entering them, not

being quite able to understand what sort of converse she could have with Allah.

In this question, as in many others, the oriental idea dominated him keenly and tyrannically. He regarded woman as an object of art, delightful and well suited to excite the mind, but disobedient and disturbing once one throws open the door of one's heart to her, and gluttonously devouring of time and strength.

I remember that once we were in a public place, when I pointed out to him the face of a woman marked with an original beauty and a melancholy character; he was very anxious to be appreciative, but instead, to be self-consistent, he asked with his little laugh, 'How on earth could a woman be melancholy?', doubtless insinuating thereby that, when it comes to understanding the sentiment of melancholia, woman is lacking in some essential ingredient.

We might begin by asking how much of this passage expresses Baudelaire's own views of women. Still, particularly in light of Baudelaire's "Mohammedan" analogy, it's tempting to speculate as to how Delacroix's views of women might be reflected in his painting of Algerian odalisques, or inhabitants of the harem. Going forward in time, we might ask how future generations of psychoanalytically trained critics would interpret the preceding passage.

Psychoanalytic Approaches

Some fifty years after Delacroix's death, Sigmund Freud introduced psychoanalytic theory into the literature of artists' biography with his psychosexual study of Leonardo da Vinci. Although the specifics of Freud's conjectures about Leonardo's art have since been questioned, Freud's interpretive principles have influenced generations of biographers. Applying Freudian psychoanalytic theory, a critic would interpret the passage from Baudelaire quoted above as an indication of Delacroix's unresolved childhood conflicts and repressed sexual desires, unconsciously expressed in the adult artist's work. The art historian Jack Spector has analyzed the sadistic and orgiastic nature of the harem scene depicted in Delacroix's *Death of Sardanapalus* (fig. 10.1) in these terms,

citing the artist's extreme attachment to his mother and subsequent emotional distance from other women, whom he either idealized as maternal figures or held in low esteem.

We might say, then, that psychobiographies restate the features of Vasari's *Lives of the Artists* in Freudian terms, focusing on what Freud described as the "family romance" of the oedipus complex. Freud took the name for this stage in a young boy's development from the Greek tragedy in which the hero, Oedipus, unwittingly kills his father and marries his mother. Freud argued that this scenario is the unconscious wish of every male child, who subsequently attains maturity by repressing his incestuous and violent impulses and learning socially acceptable behavior. From a Freudian perspective, the artist's obsession with the creative process is seen as a channeling or sublimation of sexual drives, and his professional competitiveness is analyzed in terms of the artist's rivalry with his siblings and his identification with his father. The artist's work is then examined in part for what it reveals about the artist's subconscious fears and desires.

A recent example of the psychoanalytic approach to an artist's work is particularly relevant to our discussion of Delacroix. At the opening of this chapter I referred to Picasso's series of variations on Delacroix's *Women of Algiers,* and toward the end of the chapter you'll find a reproduction of a lithograph from Picasso's series (fig. 10.8). In her study of *Picasso's Variations on the Masters* (1996), Susan Grace Galassi sees Picasso's obsessive reworking of *Women of Algiers* as prompted by his lifelong competitiveness with the artistic "fathers" who inspired him, beginning with Delacroix. Picasso's work on the series was spurred on by the recent death of his friend and rival, Matisse, whose Orientalist subjects Picasso was now free to adopt. Indeed, Picasso jokingly said of the series, "When Matisse died, he left me his odalisques as a legacy, and this is my idea of the Orient, though I have never been there" (quoted in Galassi 137). Finally, the paintings commemorate the aging Picasso's latest exchange of one mistress for another, a woman whose features appear on one of the nude figures in Picasso's variations on the harem theme.

Since the late 1960s, traditional psychoanalytic approaches to criticism have been modified through the interwoven influences of poststructuralist criticism, feminist scholarship, and the psychoanalytic theories of Jacques Lacan and Julia Kristeva. The result is a rethinking of some of Freud's tenets, beginning with the oedipus complex—a patriarchal master plot from which girls are conspicuously absent. Kristeva, especially, focuses on an earlier, prelinguistic phase of childhood development, when the infant is closest to the mother in a symbiotic and fulfilling relationship. Once the child enters the oedipal stage, this feminized relationship is repressed through the processes of language acquisition and socialization; yet the pre-oedipal phase survives in the adult's life as a subversive impulse that opposes the repressive discourse of patriarchy.

Poststructuralist approaches to psychoanalysis like Lacan's conceive of the unconscious as structured like a language, with all its slippery ambiguities. What we call the self is constructed within a social sphere as a fluid rather than fixed subject position. Expressions of gender and sexuality are seen as the result of cultural conditioning as much as of biological fact. Increasingly, psychoanalytic applications in art criticism have shifted attention from the creative struggles of the individual artist to the psychodynamics of spectatorship, a point we'll explore further on in this discussion.

Owing to these developments in theory, the artist's biography nowadays is more likely to be considered a starting point for critical analysis rather than an end in itself. Biographical and psychobiographical approaches to art history assume an apparent and meaningful causal relationship between the artist's life and work. These connections, however, are speculative and dependent on the reliability of surviving documentation. As an illustration of the challenges posed by biographical sources, let's take the famous anecdote of Delacroix's visit to a harem in Algiers in 1832. Most critical discussions of the painting cite this narrative as corroboration of the "documentary" origins of *Women of Algiers*. Here are the basic elements of the story:

> Delacroix has been frustrated throughout his travels in North Africa by his inability to observe and sketch

Muslim women, whose living quarters are strictly off-limits to male outsiders. Delacroix's friend Monsieur Poirel, the chief engineer of the harbor of Algiers, has an employee who agrees to let Delacroix enter the harem in his home. Accompanied by the husband and, probably, Poirel, Delacroix traverses the length of "some dark corridor" and at last "penetrates" the harem. "It's like Homer's time!" Delacroix exclaims; "The woman in the gynaeceum [women's quarters] took care of her children, spun wool, and embroidered the most marvelous fabrics. This is woman as I understand her!" Intoxicated by the spectacle, the artist begins to sketch.

The tale is only told in retrospect, twenty years after Delacroix's death. It comes to us, moreover, thirdhand: Monsieur Poirel, presumably a witness, reports the details of the adventure to his friend Charles Cournault, who then writes up the account. Oddly, on the subject of the visit Delacroix himself is tantalizingly mum. It's possible that Delacroix never made such a visit, yet the story is repeated, for the most part unchallenged, in most commentaries. The biographical assumption is that the incident is not only factual but somehow important to our understanding of the painting. How so? As we'll see, one art historian takes this question as the starting point of her research, excerpted later in this chapter.

Formalism

The analytic approach known as formalism coincides with the rise of modernism in the early twentieth century. Formalism assumes that the significance of an artwork, and its principal appeal to the viewer, have little to do with the artist's biography or with the cultural context in which the work is situated. Rather, meaning resides in the "intrinsic" features of form itself. Formalist analysis examines painting, for example, as a combination of purely plastic elements such as color, drawing, composition, brushwork, and so on, each element contributing to the overall aesthetic effect of the composition. In this view, art is a self-contained category of human creativity with its own history.

Art history is thus often presented as the story of the evolution of form or stylistic change in visual art. These

changes may be characterized as a cycle of stylistic types (e.g., the Early, Classic, and Baroque phases proposed by the art historian Heinrich Wölfflin) or as a chronological succession of recognizable "period" styles whose favored subjects and techniques reflect the spiritual and material concerns of a given era. Period styles are typically defined by means of pairs of opposing formal descriptors. To describe Renaissance versus Baroque styles (or, analogously, Neoclassic versus Romantic styles) in Wölfflin's terms, we would contrast these pairs: *linear* versus *painterly; closed form* (i.e., a comprehensible, boxlike space) versus *open form; plane* (i.e., an aligned sequence of spacial planes parallel to the picture plane) versus *recession* (a more dynamic spacial ambiguity); *multiplicity* versus *unity* of detail in the overall scheme of a composition; and *absolute* versus *relative clarity* in the play of light and color on the surfaces of depicted objects.

In discussions of Delacroix's work, art historians frequently refer to the contrast between the Neoclassic ideals of late-eighteenth-century artists like Jacques-Louis David and the Romantic impulse that emerged in the following century, with Géricault and Delacroix as its prime exponents. Classicism, defined by art historians in terms of its emphasis on linearity, balance, and clarity, is thus seen in direct opposition to Romanticism, which prizes emotional expressiveness, color, and abstract painterly qualities over precise mimetic representation of the material world.

In the following excerpt from his recent monograph *Eugène Delacroix* (English edition, Princeton University Press, 1998), Barthélémy Jobert offers a formal analysis of *Women of Algiers*, bolstered by his research into the life of the artist. Jobert's thesis is that in *Women of Algiers* Delacroix manages to reconcile the traditionally polarized styles of Classicism and Romanticism. Jobert's formal analysis heightens our appreciation of how the picture succeeds as a complex and fluent interweaving of brush strokes, color harmonies, and design patterns. The nineteenth-century commentators quoted by Jobert in the latter half of his analysis (i.e., the artist Paul Cézanne and the critics Gustave Planche and Charles Blanc) similarly focus on the artist's deft manipulation of form, color, and composition in this painting.

As you read, keep comparing the text with the color reproduction of the painting: you'll most likely find that

Jobert's analysis reveals elements and unities in the painting that you hadn't noticed. At the same time, remember that no description is complete. Which items in the picture have been left out of the account? What is assumed about the subject matter and about the relationships among the figures in the painting? Jobert mentions that the figure of the black servant is an invention by Delacroix, added to enhance the exoticism and verisimilitude of the scene; formally, her standing figure balances the reclining figure on the left. Can you make further inferences about the role she plays in the picture?

From Eugène Delacroix

by Barthélémy Jobert

Like many of his important works, this last painting was not the result of a commission but of the artist's own initiative, and its large dimensions mark it as obviously intended for exhibition. It is not so clearly a manifesto as *Scenes from the Massacres of Chios* or *The Death of Sardanapalus,* but the evidence shows that it is indeed a painting in which the painter affirms his principles and gives his vision of Orientalism at a time when, in France, this current was taking a new turn provoked by the recent conquest of Algeria. We have already seen the circumstances under which Delacroix was able, once he had returned to France, to paint Muslim women in their most intimate interior, a place normally forbidden to Europeans. But if the finished canvas derives from the sketches done on site, it does not scrupulously transcribe what the painter saw in Algiers, as Elie Lambert has shown. In addition to the studies done on the trip, there was another series of preparatory studies, done in the studio in Paris, using a European model and the clothing and documents brought back from Africa, by means of which the process of transformation was achieved, ending in the final subtle equilibrium. Each of the three seated women derives from an Algerian model (their names are even known, thanks to Delacroix's notations on the drawings). But their clothes and jewels have been redistributed so as to

make a gradation, from right to left, from the simplest clothing to the richest and most complicated. The black servant who, at the right of the picture, draws a curtain to display the harem to the spectator, is, it appears, a complete invention of the artist, since she figures in none of the drawings done in Algiers. Delacroix could of course have seen her in North Africa, but this addition to the original scene appears not to have been dictated by considerations of a strictly realist kind. This figure simply adds to the exoticism of the painting, the verisimilitude of which she increases in the eyes of a spectator familiar with descriptions of Turkish harems. She is thus a part of the tradition of European painting since the Renaissance, tying the work to the great Venetian masters, in particular Veronese. As to the setting, if it shows what Delacroix could have studied at Algiers, it has also undergone modifications, particularly in the source of light, which comes from the left in the painting instead of the right, as in the original drawing. Are these liberties in the painter's use of sources surprising? It is, after all, only the normal procedure of an artist concerned for the plastic aspect of his work. The interest here lies in the minute precision with which Delacroix has painted the costumes of these women, the background of the scene, and the different objects offered to the viewer—the narghile, basket, slippers, carpets, and cushions. The almost purely documentary aspect has been carried so far that the painting served as the basis for an exhibit of the clothing of Algerian women at the period of the French conquest, in the museum of ethnography in Algiers in the 1930s. This shows to what extent Delacroix has remained very realistic, as did the other orientalizing painters and engravers of his time, wanting to describe exactly what they had experienced or discovered during their voyages to Africa or the East. But the concern for realism is combined, in Delacroix, with purely formal concerns. The *Women of Algiers* shows, in fact, a unity in the treatment of light, which, in the details, reveals a range of colors much more varied than the general tonality would at first glance lead one to suppose. Each of the four figures has its own harmony: red, blue, and black for the servant; rose, white, green, and orange for the woman holding the stem of the

narghile; blue, red, and ocher for her seated companion;
red, white, brown, and gold for the one partially reclining
at left. The patterns of the rugs, the cushions, and the tiles
of the foreground are pretexts for combinations just as re-
fined as those, of another kind, on the wall and curtain of
the background, left in shadow. The rendition of the light
on the various materials takes precedence over the color
alliances; the vibration of the curtain contrasts with the
flat tone of the tiled floor, the reflections of the mirror
with those of the dishes and the objects in the niche and
cupboard. Notice also the red of the doors, which relieves
the array of browns, somber greens, and ochers in this
part of the canvas. All of Delacroix's talent goes into the
general harmony that arises from the individual ele-
ments. On this point, the effects of the composition
should not be underestimated: in placing his four figures
almost on the same line, in giving much more detail to
the front of the scene than to the background, in concen-
trating attention on the lower half without, however,
falling into artifice and monotony—thanks to the stand-
ing figure of the servant—he leads us to appreciate the
whole as much as the detail, to contemplate the scene in
its totality before letting our eyes turn successively to
each of the figures. The direction of the gaze of the four
figures, going from one to another, explicitly invites us to
move toward the figure at left, and finishes outside the
canvas, directed toward the spectator. It is not only the
still life of the foreground that invites us to wander from
harmony to harmony, with the slippers tossed down as if
by chance next to the narghile and the basket sitting on a
bit of carpet, to discover contrasts and consonances: the
composition would be ineffective except for what
Delacroix has been able to do with the rendering of light,
particularly noticeable on the flesh. This is what Cézanne
felt when he said to Gasquet: "We are all there in this
Delacroix. When I speak of the joy of color for color's
sake, this is what I mean. . . . These pale pinks, these
stuffy cushions, this slipper, all this limpidity, I don't
know how, it enters your eye like a glass of wine going
down your throat, and you are immediately intoxicated.
One doesn't know how, but one feels lighter. These nu-
ances lighten and purify. . . . And it is all filled up. Colors
run into each other, like silks. Everything is sewn to-

gether, worked as a whole. And it is because of this that it works. It is the first time that anyone has painted volume since the great masters. And with Delacroix, there's nothing to say; he has something, a fever that you don't find among the older painters. It's the happy fever of convalescence, I think. For him painting comes from marasmus, from the Carracci malady. He is knocking up against David. He paints by irisation. . . . And then he is convinced that the sun exists and that one can wipe one's brushes in it, do one's laundry. He knows how to differentiate. . . . A silk is a fabric, and a face is flesh. The same sun, the same emotion caresses them, but differently. He knows how to put a fabric on the Negress's thigh that has a different odor from the Georgian's perfumed culottes, and it is in his colors that he knows it and does it. He makes contrast. All these peppery nuances, look, with all their violence, the clear harmony that they give. And he has a sense of the human being, of life in movement, of warmth. Everything moves. Everything shimmers. The light! . . ."

The impression given by the forms and by the management of color finally counts for more than the strict documentary representation of the *Women of Algiers*. Criticism, when the canvas was shown at the Salon, oscillated between these two poles, with the most perspicacious critics, for example Gustave Planche, recognizing how far Delacroix had gone beyond his original subject: "The figures and the setting of this painting are prodigiously rich and harmonious. The color everywhere is brilliant and pure, but never crude and clashing. . . . This canvas is, in my opinion, the most brilliant triumph that M. Delacroix has ever reached. To interest the viewer by virtue of the painting, reduced to its own resources— without the support of a subject that can be interpreted in a thousand ways and that often distracts the eye of superficial spectators, who are busy judging the painting according to their dreams or conjectures—is a difficult task, and M. Delacroix has fulfilled it. In 1831, when he so happily framed historical reality in allegory, his pictorial power did not act on only the minds of the curious. The imagination regularly aided the skill of the brush. In the *Women of Algiers*, there is nothing of the kind; it is painting and nothing more, frank, vigorous painting, vigorously pronounced, with a Venetian boldness, which,

however, owes nothing to the masters whom it recalls."
Charles Blanc, in his obituary of the painter in 1864, also
emphasized this quality, insisting on the fact that it is
only possible because of the indefinite character of the
subject: "It is in this painting that Delacroix displayed all
the resources of an art that he turned into magic. And
first, just as there is here no principal figure, so there is no
dominant color. The painter, wanting to give an idea of
oriental life, represents the women of the harem like
pretty things, beautiful jewels in a case. These are, in ef-
fect, beings without thought, who live the same life as the
flowers. The painter was thus free to set out all the treas-
ures of his palette on this occasion, and he had almost
complete freedom in the choice of color, being able to in-
troduce as he saw fit accessories, fabrics, details of cos-
tume and decoration that he needed for his harmony. His
painting being in a way purely descriptive—since he
only had to express the richness of the interior of a
seraglio, that is, its brilliance, its opulence, and its cool-
ness in a warm country—he has used all his means of col-
oration to achieve a maximum of splendor and intensity,
bringing them into the most perfect and calm harmony
by balancing all these strengths."

The Social History of Art

Analysis of the social contexts of artistic production, a
critical approach formulated in studies of the 1940s and
1950s, came into prominence in the 1970s and 1980s. Con-
textual analysis can be seen as a reaction to the limita-
tions of strict formalist analysis. "Social history" is a
broad category that subsumes a number of overlapping
approaches to contextual analysis, such as Marxism, gender
studies, postcolonial theory, and ethnic studies. All these
approaches proceed from the premise that a purely formal-
ist interpretation fails to account for the social, political, and
economic factors that go into the making and viewing of art.

Marxist Theory

Marxist theory, deriving from Karl Marx's critiques of po-
litical economy in the 1850s, maintains that artistic pro-
duction, like the other practices and institutions that con-

stitute our social lives, both reveals and supports the un-
derlying power structures of wealth and class in the sur-
rounding culture. Social historians would ask to what ex-
tent Delacroix's work of 1834 participated in the
economic and political ideology of his powerful pa-
trons—the French government and the growing bour-
geois class of art spectators and consumers.

There are many social sites we might visit to get a
fuller picture of the conditions of cultural production in
Paris in 1834. One way to understand the role art plays in
its cultural milieu is to look at the *critical reception* of the
work. A *reception history* considers the ways in which crit-
ics have written about an individual piece or a group of
artworks over a period of time. In the foregoing excerpt,
Barthélémy Jobert quotes several nineteenth-century crit-
ics who praised Delacroix's painting. A study of critical
reception inquires further: How was *Women of Algiers*
judged by the majority of Delacroix's contemporaries?

To examine the original reception of a work of art, we
need to understand how critical discourse functioned in a
particular era. I've asked Véronique Chagnon-Burke, a
scholar who specializes in reception theory and nineteenth-
century French painting, to provide us with background
for understanding the critics' appraisal of Delacroix's
canvas when it was first shown in the 1834 Salon. Profes-
sor Chagnon-Burke (who, incidentally, is the would-be
spy quoted at the opening of this chapter) will also take
us through the steps of her research, as this process has
wider applications for any library project.

About Critical Reception
The *Women of Algiers* by Eugène Delacroix*

by Véronique Chagnon-Burke

Among the multitude of approaches that one can choose
to interpret paintings, critical reception attempts to pro-
vide a reading of a specific painting, a body of works,
or even the entire career of an artist, that is grounded in

*Because of space constraints, lengthier quotations from the French crit-
ics have been omitted.

historical context. As is often the case in art history, critical reception is a methodology that was originally used in literary criticism; it is based on the study of texts that have been written about a specific work. Connections between the work of art and its milieu are emphasized. Such a study might ask, for example: Which epoch privileged a more formal reading of the artwork, focusing on issues of style and artistic practice? Were some critics more interested in the significance of the subject matter than in the painterly quality of the work?

Most important, critical reception acknowledges that our perception and understanding of a work of art can change over time. The reaction of the public and critics who saw the *Women of Algiers* when it was exhibited at the Parisian Salon, in the Louvre Museum, in 1834, is unlikely to be the same as the responses of viewers who live in a postmodern, postcolonial era. Works that were considered minor or even failures in 1834 may, as time passes and standards change, become masterpieces. Critical reception provides a window into the history of taste, as well as a window into the ways critics and historians project the concerns of the present onto a work of the past.

Reception theory has greatly benefited from revisionist art history, which in the late 1970s and throughout the 1980s proposed an alternative to formalism. Formalism, the offshoot of Modernism, emphasizes an interpretation of art based on the analysis of the stylistic components of a work; it insists on the physicality and the autonomy of the artwork, rather than seeing it as a cultural product. Critical reception, while recognizing the specificity of the visual language employed by painting, seeks to restore a more holistic understanding of a work, by pointing to the relativity of the interpretive domain.

Obviously, space constraints do not permit a complete study of the critical reception of Delacroix's *Women of Algiers* from its first exhibition in 1834 to the present. Instead I have chosen to focus on the year 1834 and to look at a sample of art reviews published at the occasion of the Salon.

First we need to set the stage. In the 1830s, if one wanted to become a successful artist, one needed to ex-

hibit at the Salon, which was held every spring through-
out most of the nineteenth century in the Louvre Mu-
seum and lasted for three months. For this occasion, the
permanent collection of old master paintings was hidden
from view behind scaffolding; the contemporary paint-
ings were then hung from floor to ceiling on the green
fabric that covered the scaffolding. To exhibit at the Salon
the artists needed to have their works accepted by a jury
composed of members of the Academy. The Salon was a
very official affair: as the State of France controlled the
Academy, the selection of the Salon jury reflected the
dominant ideology and conservative taste for Neoclassi-
cal art. At a time when private art galleries in the modern
sense did not exist, the Salon was truly the only way for
an artist to be recognized and to gain patronage. From an
average of 4,000 works submitted every year, only a third
were accepted, which still provided for a rather spectac-
ular show. Because of the high rate of rejection, it became
a tradition for the art critics to start their reviews of the
Salon by lamenting about the inconsistency and incom-
petence of the Salon jury.

At this time, during the July Monarchy in France
(1830–1848), the profession of art critic was still a sea-
sonal activity, practiced by a wide variety of writers with
established careers in other fields such as politics, litera-
ture, and even public administration. The Salon reviews
were published as a series in every major daily newspa-
per in Paris, as well as in weekly and monthly magazines,
for the duration of the exhibition. They appeared on the
front page, occupying the space usually devoted the rest
of the year to the serial, a popular novel published in
daily installments. The extent of coverage of the Salon in
the daily press points to the extraordinary importance of
such an event in the cultural life of Paris. Everybody
came to the Salon; it was free every day but Saturday,
which was the day the upper classes met and mingled in
front of the artworks. In 1846, it is estimated that one mil-
lion visitors came to the Salon, which was more or less
the entire Parisian population at that time. A contempo-
rary satirical painting of the Salon by François-Auguste
Briard (fig. 10.5), exhibited in the Salon of 1847, shows the
crowds that were drawn to the exhibition.

10.5 François-Auguste Briard, *Four O'Clock at the Salon*, exhibited in the Salon of 1847. Oil on canvas, 57 × 67.5 cm. (22²/5 × 26¹/2 in.). Musée du Louvre, Paris.

In its infancy, then, professional art criticism was essentially a journalistic exercise having little to do with the scholarly field of art history as we know it now. Critical reception of Delacroix's *Women of Algiers* in 1834 shows the confrontation of different points of view published in newspapers with opposing political orientations. Our recognition of a newspaper's political stance is of particular importance when the critical reception of French art is at stake. In France, as we've seen, the arts were strictly controlled by the government through the French Academy, or the *Institut* as it was known then, which was a bastion of Neoclassical ideals. In that highly politicized cultural milieu,[1] if a writer opposed the artistic choice of

[1]See Patricia Mainardi, "The Political Origins of Modernism," *Art Journal* 45, no. 1 (Spring 1985): 11–17.

the Academy, he or she could be seen as challenging the government's opinion.

This situation sometimes actually served the writers who wanted to disagree with the government but could not do so openly for fear of censorship. The art critics implicitly accepted that the health of the cultural life reflected the health of the nation. So writers and journalists created culturally coded discourses in which praising or damning art could be read by the public as the equivalent of praising or damning the government. By the 1830s this phenomenon had become an accepted tradition, practiced by writers to avoid censorship.[2]

With this understanding of the social and political conditions for the production of art criticism in 1834, researchers can begin to survey the Salon reviews published in some of the major Parisian newspapers. You must first select a group of newspapers and journalists most relevant to your topic. Obviously, you can apply different standards of judgment for your selections—based, for example, on the journal's circulation or political tendencies, or the quality of the writing, or the quality of its other news coverage. The important thing is to justify your choice in the introduction of your essay, explaining why you have chosen these specific publications for your analysis. Then the detective work really begins. After having chosen some possible newspapers, check their availability, usually on microfilm. Accessibility can impose real limitations on the scope of your study, since collections of older newspapers, especially those of short duration or small circulation, are often hard to find or incomplete. This is why it is best not to set out to demonstrate a preconceived thesis through these articles: before you formulate a thesis, read quickly through the available material and try to become familiar with the language of the past.

[2]See Susan L. Siegfried, "The Politicisation of Art Criticism in the Post-Revolutionary Press," in Michael Orwicz, *Art Criticism and Its Institutions in Nineteenth-Century France* (New York: Manchester University Press, 1994), 9–28. The use of coded criticism had been especially useful at the height of state censorship during the Restoration. It again became an essential component of art criticism after 1835, when, following a period of social unrest, censorship was reestablished, making it impossible for journalists to be openly critical of the government's actions.

In the field of critical reception of the paintings exhibited at the Salon, we are extremely fortunate to benefit from the extraordinary work accomplished by Neil McWilliam, who has compiled a *Bibliography of Salon Criticism in Paris* (Cambridge University Press, 1991), listed year by year. This means that in the case of the *Women of Algiers,* one only needs to go to the year 1834 to have a complete list of each Salon review published that year. The next step is to access and skim these articles to decide how Delacroix's painting was received by the critics that spring—to try to see what patterns emerge and how the critics were divided. Was Delacroix a popular artist, and was this particular painting considered a success?

We discover, for instance, that the *Women of Algiers* was not one of the great successes of the Salon. Every newspaper, regardless of its political leanings, recognized that the three paintings that stole the show were Ingres's *Martyrdom of Saint Symphorian,* Delaroche's *Execution of Lady Jane Grey* (fig. 10.6), and Granet's *Death of Poussin,* one a religious subject and two in the tradition of historical genre.

These three paintings belonged to the classical tradition supported by the Academy. Classicism emphasized drawing over color, a tight brush stroke, and a legible narrative content. The *Gazette de France,* a journal opposed to the July Monarchy and supportive of the old aristocracy, went as far as devoting an entire article to the three paintings cited above and did not even mention any of the five paintings Delacroix exhibited that year. This made perfect sense, as the Academicians saw in Romanticism another sign of the decadence that was plaguing the country since the Revolution.

Actually, most critics spent more time discussing Delacroix's *Battle of Nancy* than they did the *Women of Algiers.* Here the pro-government agenda in publications such as *Moniteur Universel* (the official government paper) is quite clear. Delacroix had received the commission for this military painting from the government as part of King Louis-Philippe's effort to create in the palace of Versailles a museum to the glory of French history, where large paintings would commemorate the greatest achievements of France's past leaders. History painting

10.6 Paul Delaroche, *The Execution of Lady Jane Grey*, exhibited in the Salon of 1834. Oil on canvas, 250 × 300 cm. (97 × 117 in.). National Gallery, London.

was still considered the highest form of painting, mainly because of the general belief that art had to have a didactic and moral content. It was widely held that a good painting should enlighten, guide, inspire, teach a lesson, and these were things that only paintings with narrative content could do. One finds this hierarchy enforced in the Salon reviews: each critic started by reviewing history painting and proceeded down from there to genre painting (the depiction of scenes from contemporary everyday life), then on to portraits and landscape painting. Delacroix's *Women of Algiers* was relegated by most of these critics to a subcategory of genre painting, a scene from foreign life, created to charm rather than to teach.

When they did discuss *Women of Algiers,* the critics concentrated primarily on its formal execution. We generally

find the art world of the 1830s divided between those who have pledged allegiance to the tradition of Classicism, best suited for the noble subjects of history painting, and the supporters of Romanticism, who valued color over drawing and personal expression over telling the "right" story in clear pictorial terms. In the Salon reviews, the supporters of Romanticism praised the colors and the loose handling of the paint in *Women of Algiers*, finding sensuality in the paint, as if they were transferring the potentially sexual connotations of the subject onto the quality of the paint itself—as, for example, in the review appearing in *L'Artiste*, [Vol. 7 no. 6], a journal that supported the cause of Romanticism and leftist politics and was one of the rare publications to praise the painting without reservation. Opponents of Romanticism criticized Delacroix's lack of rigor and technique, the critic from *Le Constitutionnel* going so far as to call Delacroix's handling of the paint "negligent" (March 15, 1834).

Perhaps the most striking difference between the interpretations of today and the readings of 1834 is the lack of interest on the part of the critics of 1834 in the specificity of the subject matter. No one questioned the meaning of the subject. In the Salon reviews I've unearthed I find no allusion to France's recent colonization of Algeria under Louis-Philippe, no insight into the status of the women depicted, no questions about the veracity of the scene. It is all taken for granted—a scene to distract and to please, to be enjoyed, to be visually consumed. It remains for art critics in a postcolonial world to question the critical assumptions of the preceding century.

In her concluding paragraph, Chagnon-Burke remarks that none of Delacroix's contemporary reviewers questions the meaning of the subject of *Women of Algiers*. In other words, reception theory also takes into account what is *missing* from the official record. Let's take this notion a few steps further. If François-Auguste Briard's comic picture of the 1847 Salon is any indication, the French viewing public around this time was a lively mix of men and women (and children!)—some conversing, others gazing up appreciatively, one fainting in the heat

of the crush. Yet the opinions and questions of this larger viewing public are by and large absent from the archives of critical reception. Their preferences, to the extent that they differed from the professional critics', are less likely to have gone into the formation of the Western art history canon. Reading further into the absences in the historical record, we might inquire into the ways other contemporary observers might have received *Women of Algiers.* How would an Algerian Muslim of the time, for example, have assessed the accuracy of the harem scene?

The foregoing study of critical reception ends by urging modern observers to take up questions like these. The following critical approaches, again subsumed under the more general study of the social history of art, provide us with a vocabulary and methods for examining artists' representations of ethnicity, race, class, and gender.

Gender Studies, Feminist Criticism, Gay and Lesbian Studies, and Queer Theory

Gender studies, feminist criticism, and gay and lesbian studies all take as their premise that gender definitions are determined as much by ideology and convention as by physical differences. Thus visual representations of men and women are not reflections of some natural external reality but rather an encoding of social roles. From the perspective of gender theory, art historians consider how "masculine" and "feminine" characteristics are interpreted by artists and spectators in different societies and eras. Who is being looked at in a given work of art, and who is doing the looking?

In the case of *Women of Algiers,* observers might ask: By what visual signs does Delacroix portray these female figures? How do their costumes, poses, and surroundings connote gender, status, and sexuality? In what ways, for instance, is "female of higher rank" distinguished from "female of lower rank"? And what kind of audience is implied or constructed by the painting? If indeed a male spectator is posited by the painting, how is masculine subjectivity structured around images and acts of viewing?

Feminist criticism since the early 1970s has worked toward several interlocking goals. One objective, as I've

suggested above, is to examine the depiction of women and men in art and popular culture. Another ongoing project of feminist scholarship has been to recover female artists whose work has been overlooked or shuffled to the margins of art history. For example, in the course of her research on the Salon of 1834, Professor Chagnon-Burke unearthed glowing reviews of the work of Madame de Mirbel, a female portraitist (as well as a published Salon critic in her own right). One reviewer went so far as to call her group of miniatures a masterpiece, *un cadre de chefs d'oeuvre*. Today one finds scant mention of Mirbel, apart from occasional scholarly citations.

A related project of feminist criticism has been to analyze the often arbitrary and gendered processes by which canons are formed. To continue with the previous example, traditional art historians would argue that Mirbel's work does not merit study because it is "minor"—small in scale, local in reference, and of a subject matter customarily placed, along with still lifes, low down in the hierarchy of genres. (Judging from the Salon reviews Madame de Mirbel wrote, staunchly upholding the conservative ideals of her bourgeois class, Mirbel herself would probably have concurred with these critical standards.)

Feminist critics would point out that such rankings are essentially artificial and reinforced over the years by the male-dominated professions of artist and critic. As female artists were excluded from the French Academy until well into the nineteenth century, and therefore had fewer opportunities for drawing figures from life, they were less likely to attempt large-scale historical or religious subjects than portraits and still lifes. It might be argued from this evidence that the latter genres were defined, *de facto*, as minor, in the same way that "crafts" came to be distinguished as lesser forms of artistic expression than "fine arts." As further evidence of the way the canon reflects and perpetuates the prevailing ideology, feminist critics cite the general omission of women artists from survey textbooks until the 1970s—even of major figures such as Artemesia Gentileschi and Rosa Bonheur, who were known during their lifetimes for excelling at painting "big" subjects on a grand scale.

Gay and lesbian studies and, more recently, queer theory also question how the dominant culture construes notions of sexual difference. Psychoanalytic and gender theorists in the past several decades have challenged the traditional psychoanalytic assumption of a "naturally" patriarchal social structure, with its overdetermined differences between masculine and feminine roles and sexual preferences. Much of this work has focused on the acts of looking and being looked at, or the psychology of "the gaze." In an early and influential feminist article, "Visual Pleasure and Narrative Cinema" (1975), the film theorist Laura Mulvey argued that Hollywood cinema structures the visual experience as a voyeuristic pleasure that eroticizes females and presumes a "masculinized" point of view—regardless of whether the viewer is male or female. Current gender theory, however, offers more nuanced descriptions of spectatorship, rejecting the traditional binary oppositions of subject/object, male/female, heterosexual/homosexual.

Thus while *Women of Algiers* may be said to privilege a certain male viewership (insofar as the producers and patrons of such paintings have traditionally, though not always, been white males), the painting admits other subject positions or vantage points from which it can be read. What differences might there be in the nature of an artist's or viewer's perception and aesthetic pleasure if that artist or spectator is a lesbian or male homosexual or female heterosexual? In an article titled "Making Trouble for Art History: The Queer Case of Girodet" (1996), James Smalls concludes that Girodet's homoerotic painting *The Sleep of Endymion* (1791) "make[s] us aware of the numerous ways in which multiple sexual identities can be encoded in art produced prior to our own time, as well as the equally numerous ways in which homophobic and heterocentrist forces can operate to suppress them in art history" (27).

We've noted that gender criticism often works in tandem with other critical approaches to reveal the underlying social strategies of pictorial discourse. In the case of *Women of Algiers*, before we analyze Delacroix's depiction of women in the harem, we need to understand how representations of gender and sexuality are typically intertwined with representations of social class and ethnicity.

For example, as the author of our next commentary points out, Delacroix's painting faintly suggests a subtext of lesbianism that will reappear in "Orientalist" art throughout the nineteenth and twentieth centuries. (Jean-Auguste-Dominique Ingres's *Turkish Bath* of 1862–1863, shown in fig. 10.7, seems to suggest the theme more explicitly.) How does this particular construction of female sexuality become a recurrent motif in Western images of "Eastern" and "African" Others? And what are we to make of the racial hierarchy in these paintings, where darker-skinned figures are usually relegated to the background or margins? One sees the same marginalizing of African-American figures in paintings produced in the United States during this period. Postcolonial theory, another of the contemporary critical perspectives that have influenced the way we look at art, helps us make these connections.

Postcolonial Theory

Postcolonial theory examines art and literature in the context of the history of the colonial enterprise. The popularity of Orientalist art in France and England was concurrent with the growth of these nations as colonial powers in North Africa and the Near East. In France, Napoleon's Egyptian campaigns toward the end of the eighteenth century stimulated the public's interest in North African scenes. The Orientalist movement in the visual arts picked up momentum with France's colonization of North Africa in the 1830s, as painter-travelers (like Delacroix in 1832) accompanied France's emissaries to the colonies. There followed a procession of Orientalist paintings to satisfy the growing middle-class consumer market for exotic pictures of an alien culture.

Among the more popular Orientalist subjects were caravans in the desert, slave markets, Turkish baths, and odalisques (i.e., inhabitants of the harem, both servants and concubines) at leisure. Most of the artists who dabbled in these subjects had not traveled to the East but instead relied on pictures in libraries and museums. Such was the case with Ingres, one of the most prominent painters to present Orientalist themes.

10.7 Jean-Auguste-Dominique Ingres, *The Turkish Bath*, 1863. Oil on canvas on wood, diameter 109.9 cm. (43¹/4 in.). Musée du Louvre, Paris.

As empires collapsed during the 1960s and 1970s, cultural theorists began to discuss "Orientalism" as an essentially Western formulation that supported the programs of slavery, imperialism, and colonialism. In his book *Orientalism* (1978), Edward Said analyzed the representation of the Eastern Other in Western literature as "a mode for defining the presumed cultural inferiority of the Islamic Orient . . . part of the vast control mechanism of colonialism, designed to justify and perpetuate European dominance." The art historian Linda Nochlin, in an

influential review entitled "The Imaginary Orient" (1983), applied the postcolonialist critique to a discussion of Orientalism in the visual arts. In her analysis of artists' portrayals of exotic, passive figures in a fantasy land-scape, Nochlin set the stage for our consideration of the political ramifications of Delacroix's depiction of Muslim women in *Women of Algiers*.

Joan DelPlato is an art historian who has written ex-tensively on nineteenth-century harem pictures from the perspectives of postcolonial and feminist criticism. I've asked Professor DelPlato to share with us the ways in which these analytic methods have informed her re-search and writing on Delacroix's painting. Here is her commentary (again, owing to space constraints, some of the longer citations have been omitted).

Passivity and Politics in Delacroix's 1834 *Women of Algiers*

by Joan DelPlato

Delacroix's W*omen of Algiers in Their Apartment* offers us the opportunity for a case study in how scholarship opens up a well-known text, using primary sources, historical re-search, and contemporary theory. When I first looked closely at the critical literature on *Women of Algiers*, I dis-covered that the issues of colonialism and gender did not figure in the responses of the painting's viewers in 1834. Why did their perceptions differ from mine? Art is rarely direct in its treatment of politics, of course, but in what subtle ways might Delacroix's masterpiece have been political?

Through the investigative methods of cultural history, an initially "silent" painting can reveal how and what it might have communicated to its original audiences as well as to us as historically informed readers today. The painting suggests a range of historical questions about femininity, ethnicity, racial hierarchy, eroticism and colo-nialism, themes that are in fact intertwined.[1] Given the number and complexity of the issues the painting raises, I would like to limit my focus here to one theme: *Women*

of Algiers as a representation of passive women and the implications of this fact. The scene covers a life-size canvas, a scale conventionally reserved for paintings of profound themes. How is it that a nondidactic, nonheroic genre subject of women at rest—a domestic scene about an extreme and foreign femininity—was taken so seriously by one of the most talented young painters of his day?

In reading what other art historians had written about the painting, I was struck by the recurrence of a strange story: that, under an oath of secrecy and with the help of a Monsieur Poirel, Delacroix had managed to get into a real harem during his mission's three-day layover in Algiers from June 25 to June 28, 1832. I discovered that this story had developed into an elaborate mythology which has become the standard explanation for the painting: that it shows an authentic harem because Delacroix saw it with his own eyes. However, the evidence for the claim of Delacroix's firsthand experience is hearsay and highly tenuous, given the strictly observed Muslim prohibition of such a visit. Delacroix himself wrote nothing specific about the incident in his famous journal.

My own belief is that Delacroix never entered a harem.[2] Yet regardless of whether he did or not, my real interest is in the way art history has treated the question. First, uncritical acceptance of the story reinforces the cult of the artist-genius, a figure traditionally constructed as a daring risk-taker and transgressor of social convention. An important element of the stereotyped artist-genius persona is a presumptuous and masculine sexual prerogative. (Significantly, the verb often used by commentators is that Delacroix "penetrated" the harem.) Second, it is generally presumed that because Delacroix gained access to a harem, *Women of Algiers* is an authentic painting about "the Algerian character." The conventional thinking is that a representation is "truer" if the artist directly experienced the scene. This reasoning fails to account for lapses in memory or for the crucial matters of artistic invention and social construction. Whether Delacroix himself ever entered a harem, we need to consider the ways in which the artist constructs a fictional scene as well as a fictional male spectator entering it.

I: Passivity and Eroticism

The full title indicates that the painting shows women of Algiers in their apartment. Numerous elements in the portrayal of the decor and inhabitants indicate that this apartment is located within a harem—that is, the women's quarters, the heart of the upper-class Muslim home where multiple wives, concubines, unmarried female relatives, and children lived, sometimes guarded, in seclusion.

The players in *Women of Algiers* are engaged in no noteworthy activity. They are not busy attending to children or to clear-cut household duties. The two harem inmates seated on the right smoke a narghile, or water pipe. The woman on the left reclines languidly and looks out from the picture plane. The servant to the three women performs a (seemingly) minor action: she pulls aside a curtain to reveal this scene of inactivity.

While the harem itself suggests a sexual hierarchy, the arrangement of the women suggests an internal social hierarchy. The seated women's lower level of activity indicates their higher social rank; they are the "leisured" class. The standing servant occupies the lowest rank of the four; the reclining woman at left, aloof from the others, is possibly the first, highest-ranking of the wives sanctioned by Islam. The close pairing of the women seated on the right suggests an intimate friendship of peers. In scores of other harem pictures in the tradition to which this picture belongs, a pairing of women more explicitly alludes to lesbianism. This is a long-standing notion in France and England concerning the nature of sexuality in the harem, *de facto* aberrant, since several young and beautiful women await infrequent visits from one wealthy man who might satisfy several women's material needs but not necessarily their sexual ones. Delacroix's pair alludes very subtly to this conception, which is quite explicit in the literature of Orientalism—in Montesquieu's *Persian Letters* (1721), for example, and in the rather bawdy earlier accounts by travelers who claim to report the truth about the harem women's oversexed nature. In downplaying the lesbian theme, Delacroix again reinforces his women's inactivity. Delacroix's pre-

sentation of passive women allows them to function less as individuals and more as ethnographic types. Note the similarity in body and face shared by all three seated women, who together constitute "the Algerian woman."

The women's passivity is underscored by the Orientalist trappings of the harem, perhaps most prominently the narghile, which helps explain the deep *chiaroscuro* of the smoky atmosphere. The widespread habit of smoking opium in North Africa is described during the 1830s by Edward William Lane, whose *Account of the Manners and Customs of the Modern Egyptians* quickly became an authoritative source consulted by innumerable artists. Lane says opium-smoking is enjoyed by the middle and upper classes throughout Egypt and is a "pernicious and degrading custom." (At the same time, in France and England, opium-smoking took on a cult status among antibourgeois artists and intellectuals.) In the painting's narrative, opium-smoking provides a cause for the bodily passivity of the women.

The setting is cluttered with ciphers of conventional femininity, though here they are "orientalized"—elaborate jewelry, finely textured clothing, an ornate mirror, and sumptuous furnishings. These objects function in the painting as fetishes. In Freud's definition (1927), these are objects that serve to reinforce the distinction between the male (viewer) and the female (viewed), and thus to reduce masculine anxiety about gender difference.[3] More important, although these women are clothed, they are, by Muslim standards, exposed, unveiled to the sight of trespassers in the harem. This knowledge helps define the hypothetical male viewer more concretely as a transgressor and heightens the erotic component of the scene at the level of fantasy.

Thus *Women of Algiers* is erotically charged not only because of the women's passive receptivity and the array of feminine and Orientalist ciphers but also because of the exposing of a forbidden scene. This act is accomplished in the narrative of the painting by a figure that functions here as the artist's surrogate: the standing servant who pulls back a curtain to reveal the room to the spectator. In Orientalist paintings, the figure of the black

woman is typically marginalized. In Delacroix's painting, too, the servant, although bejeweled and graceful, is conceptualized as invisible; pushed off to one side, she is shown from the back, and her body proportions are smaller than those of the women she serves. In the critical literature on the painting, as well, the figure of the black woman is rendered transparent. She is simply a servant or slave, whose stance and dress provide contrast for her splendidly leisured mistresses. I would like to bring her center stage. The figure of the black woman requires a deeper, revisionist reading.

In point of fact, there was a harem hierarchy in Muslim societies of North Africa, but generally speaking it was not as strict and racially based a hierarchy as it tended to be in Western slaveholding societies. Slavery was a condition acknowledged by Islam as long as it was judiciously maintained. In the Islamic world, any non-Muslims, whether fair Georgians or dark Abyssinians, might be bought as slaves. In other words, not just the black woman, but any of the seated women depicted in the painting might have been a slave, though if the woman served as a concubine (or "odalisque"), she would be ranked higher than a domestic servant. And a slave elevated to the rank of wife would be freed. Thus in depicting the image of a black woman serving white women, Delacroix—along with many painters of Orientalist subjects—presumes a social system more familiar to his Parisian audiences, at a time when Antislavery Societies in Paris and London were arguing for the abolition of slave markets. The painting subtly reinforces the institution of slavery in a scene meant to be enjoyed by French viewers.

II: Passivity and Colonization

Women of Algiers functions on one level as sexual fantasy lightly clothed as serious ethnography. The passivity of the harem inmates in Delacroix's painting also functions at another level, pertaining to France's colonization of Algiers. Interestingly, art critics in 1834 failed to link the painting to the colonialist venture in Algiers, despite Delacroix's title. Instead many of them claimed that the painting is about pure painting, about Art.

Although Algiers was not officially declared a French colony until July of 1834, the French had occupied Algiers since 1830. In the intervening four years the French were engaged in a series of commercial and military ventures that included French massacres of rebellious insurgents. Opponents of colonization saw the venture as too expensive or morally objectionable, while proponents stressed its economic potential. At precisely the moment that Delacroix's painting hung on the walls of the Salon, Parliament was debating whether and how France would continue its policy of colonization in Algiers.

How does the painting participate in the political debate? The belief that the colonized subject, male and female alike, is passive or indolent is a recurrent justification for colonialist intervention and political dominance, as Edward Said asserts in his now-classic study of Orientalism. Akin to the long-standing stereotype of "the lazy native," the passive subject is incapable of running his own economic and political affairs and dependent on modern, industrialized overseers to attend more efficiently to his "needs" and advance his "progress." These judgments provided the moral underpinning even for well-intended efforts such as abolitionism and religious missionary work in the colonies throughout the nineteenth century. Delacroix's passive Algerian women are depicted as the "raw material," if you will, the "before," thought to be in need of colonial revision, which is the "after." That harem women are represented in Delacroix's painting as indolent suggests not only their attractive primitivism but also their moral immaturity in belonging to a polygynous institution sanctioned by Islam, an infidel religion to many viewers in predominantly Christian France.

The theorist Homi K. Bhabha notes that the Western colonizer approaches the colonized with the ambivalence that Freud described in his writing about the fetish—that is, with feelings of attraction and repulsion, love and hate.[4] His analysis is relevant to our understanding of the history of readings of Delacroix's *Women of Algiers:* the painting was attractive to French viewers in 1834, and it

also evoked moral indignation. Beautiful but idle women, sequestered in a harem, smoking opium, could hardly be considered virtuous in a bourgeois society that encouraged its women to be industrious homemakers.

I believe that Delacroix's *Women of Algiers* worked not only as a focus for psychosexual fantasy but also as pro-colonial propaganda, supporting the controversial pro-gram of French colonialism in Algiers. In this way the painting was a kind of domestic (and therefore subtler) counterpart to French military paintings of the time de-picting mounted officers ready to do battle.[5] Precisely be-cause *Women of Algiers* was thought to reside in the realm of the domestic-ethnographic genre of Art, it could func-tion as a powerful ideological tool for high politics. Be-cause the painting was considered ahistorical and apolitical, its assertion of female passivity was all the more convincing as ethnography, a piece of the "truth" about how Algerians lived. "Art" functioned to disguise politics.

Notes

1. See Mary J. Harper, "The Poetics and Politics of Delacroix's Representation of the Harem in *Women of Algiers in Their Apartment*," in *Picturing the Middle East: A Hundred Years of European Orientalism* (New York: Dahesh Museum, 1996), 52–65; and Todd B. Porterfield, *Allure of Empire: Art in the Service of French Imperialism 1798–1836* (Princeton: Princeton University Press, 1998), 127–38. See also my book *Multiple Wives, Multiple Pleasures: Representing the Harem, 1800–1875* (Teaneck and Cranbury, NJ: Associated University Presses, in press), n.p.

2. The painting is less likely a record of Muslim women of Algiers and more likely a depiction of Jewish models whom Delacroix sketched in North Africa. His preparatory sketches for the painting may have been executed at the home of the translator Abraham Ben-Chimol, a Jew living in Tangier in February 1832.

3. Sigmund Freud, "Fetishism," in *Standard Edition of the Complete Psychological Works of Sigmund Freud*, ed. and trans. James Strachey (London: Hogarth Press, 1981), 21:52–57.

4. Homi K. Bhabha, "Signs Taken for Wonder: Questions of Ambivalent Authority under a Tree Outside Dehli, May 1817," in *"Race," Writing and Difference*, ed. Henry Louis Gates, Jr. (Chicago: University of Chicago Press, 1986), 163–84.

5. The work was purchased by minister of the interior Louis-Adolphe Thiers and not King Louis-Philippe himself, whose taste was less the flamboyance of Delacroix and more the cool hyperrealism of the military painter Horace Vernet. Exactly why it was purchased is still a matter of conjecture. Thiers, who had supported Delacroix as early as 1822, may have wanted to justify

the recent awarding of a government commission to Delacroix to decorate the Throne Room of the Bourbon Palace in 1833. Or he may have sensed the potentially explosive nature of the work and purchased it in an attempt to check its circulation and thus limit its interpretations.

The recognition of contingent meanings that defy closure is the foundation of poststructuralist analysis, a set of critical methods we've already alluded to above. The following discussions of structuralism and poststructuralism touch on some of the key concepts that inform discussions of art in the late twentieth century.

Structuralism, Semiotic Theory, and Iconographic Analysis

Structuralism flourished in the social sciences and humanities until the mid-1960s. Structuralist analysis was formulated in studies of *semiotics,* or sign systems, by the nineteenth-century American philosopher Charles Pierce, and in Ferdinand de Saussure's theories of linguistics, published posthumously in 1916. Saussure described language as consisting of signs, or *signifiers*— made up of the sounds or words referring to something —and their meanings, or *signifieds.* Signifiers derive their meaning by being different from other signifiers.

In this view, language and culture are structured in the form of binary oppositions of basic elements, such as light/dark, culture/nature, male/female, West/East, and so on; in each pair, a term is defined by the way it differs from its opposite term. Anthropologists such as Claude Lévi-Strauss applied structuralist principles to their study of myths, kinship systems, and other cultural practices, to discover the underlying structures or universal laws by which those systems operate. Similarly, as we've noted in our discussion of formalism, art historians have analyzed the formal properties of an artwork in terms of contrasting pairs of basic elements—line/color, light/ dark, surface/volume, and so on—to explain how the parts work together as a whole.

Semiotic theory, which examines how signs and sign systems derive meaning, has long been used by art

historians to analyze the significance of images in art, most notably in the form of iconographic studies. Early iconographic analysis decoded the language of visual images by pointing to the literary texts or art-historical precedents to which these images refer. Erwin Panofsky's celebrated explication (1953) of Jan van Eyck's Arnolfini wedding portrait, for example, pointed to the underlying ecclesiastical significance of the objects and figures in the painting. According to Panofsky, these domestic images—mirror, candle, dog, and so on—would have been "read" by contemporary viewers as conventional Christian symbols of purity, faith, and salvation, and thus would have underscored the sacramental nature of the wedding ceremony depicted in the scene.

More recent semiotic analyses remind us that a sign within an artwork can be seen to refer to a number of different systems of meaning; an observer focuses on one system and overlooks another as a result of the conventions and beliefs of his or her era and interpretive community. For instance, in an article published in 1989 on the Arnolfini wedding portrait, Linda Seidel, citing evidence from contemporary legal documents and household books of the Florentine merchant class, reads the same group of domestic images as a visual record of an essentially financial transaction, the transfer of the bride's dowry. Seidel describes the goal of her iconographic analysis as "an expansion of the issues on which inquiry into the painting may be based and an exploration of the ways in which we talk about what we see" (59).

Returning to the example of Delacroix, we can contrast two interpretations of the iconography of *Women of Algiers:* DelPlato's, quoted above, and Jobert's, quoted earlier in this chapter (pages 226–230). Jobert essentially regards the features of Delacroix's harem as documentary facts, references to or representations of objects that exist in an external setting; Jobert's analysis focuses on the ways in which the artist has altered and rearranged the images to create aesthetic balance and harmony. DelPlato, on the other hand, reads these signifiers as encoding contemporary discourses on race, gender, and class. Seen in this light, the iconography of the painting is

a semiotic system that articulates and reinforces the social and political ideology by which colonial powers exercise control over the Other. In an article on "Semiotics and Art History" (1991), Mieke Bal and Norman Bryson describe how semiotic theory has been complicated by the post-structuralist view of the indeterminacy of meaning:

> . . . the contemporary encounter between semiotics and art history involves new and distinct areas of debate: the polysemy of meaning; the problematics of authorship, context, and reception; the implications of the study of narrative for the study of images; the issue of sexual difference in relation to verbal and visual signs; and the claims to truth of interpretation. (174).

Poststructuralism

In some ways, *poststructuralism* isn't so much a turning away from structuralism as it is a chronological descendant, for both approaches seek to demonstrate that the connections between the word or image and the thing it signifies do not occur naturally but rather are determined by society. The later approach, however, formulated amidst the political upheavals and anticolonialist movements of the late 1960s and 1970s, is marked by profound skepticism regarding the ultimate truth of any interpretation.

In poststructuralist analysis the meanings of words and images are shown to be inherently unstable and dependent on context. As we've noted in our discussions of gender and postcolonial theory, traditionally defined categories of meaning such as male/female, subject/object, West/East, begin to blur and shift under scrutiny. Rather than describing natural or universal principles, these pairs seem to be arbitrary oppositions in which Western culture habitually assigns greater value to the first term in each pair. Abandoning the agenda of finding a unified set of underlying rules for interpreting a text, poststructuralist critiques argue that fields of knowledge are constructed through ideology—that is, through the dominant discourses of a given culture. Developed during the 1960s and 1970s in the work of the French theorists Michel Foucault and Jacques Derrida, the critical methods

of *discourse analysis* and *deconstruction* seek to destabilize and dislodge these traditional patterns of perception.

To illustrate the methods and aims of the poststructuralist critique, this final section of our survey will look at how three artists—two visual artists and one writer—"deconstruct" Delacroix in their own artwork. That is to say, each work discussed below functions, in effect, as a deconstructive analysis of *Women of Algiers*. These multiple variations on a theme remind us that every act of interpretation is a re-creation of the text. Each re-creation brings to the surface some of the hidden assumptions that viewers bring to Delacroix's painting.

Pablo Picasso's *Women of Algiers,* *After Delacroix*

Picasso's series of variations (fifteen paintings plus numerous sketches and prints, executed in 1954–1955) constitutes the most famous and most extensive revisionist reading of Delacroix's *Women of Algiers*. Like a number of twentieth-century observers, Picasso sees Delacroix's work as an early and influential expression of Modernism. From this viewpoint, the painting's strange compression of space, its tilted perspective, and its self-conscious passages of explicit brushwork are seen as evidence of Delacroix's experimental shift from a naturalistic rendering of three-dimensional form to a modernist emphasis on forms and colors as abstract elements on a flat picture surface.

Picasso brings forward the subtle ambiguities of the Delacroix canvas. His variations explore competing modes of pictorial representation in the twentieth century: for example, in the lithograph shown in fig. 10.8, Picasso contrasts the more volumetric figures at the left and center of the print with the Cubist form of the reclining nude (with legs raised) on the right side of the picture.

In Picasso's variations, the realistic and ethnographic features of Delacroix's harem are abstracted or erased. As a result, the figures are more easily read as models in an artist's studio, denuded and shifted from canvas to canvas; their features are interchangeable, at times obliter-

10.8 Pablo Picasso, *Women of Algiers (After Delacroix)*, February 5, 1955. Lithograph, 23.3 × 33.7 cm. (9^1/7 × 13^1/4 in.). Musée Picasso, Paris.

ated. The dark background of Delacroix's painting, framed by a theatrical curtain, becomes in Picasso's series of pictures a doorway, a picture frame, or possibly a mirror. As Susan Grace Galassi suggests in *Picasso's Variations on the Masters*, Picasso's various transformations destabilize the visual language of Delacroix's painting: "the notion of any fixed relation between representation and reality (or sign and symbolic content) is held up to question. . . . The subject of the harem itself is fused with the studio and the brothel to become an allegory of creation" (147).

Assia Djebar's *Women of Algiers in Their Apartment*

More recently, working in nontraditional forms such as literary fragments and multimedia installations, artists of the postcolonial era have actively intervened in the history of Orientalism. The postcolonial feminist project has been to "decenter" the notion of artists and spectators as predominantly white, male, and Western—as well as the notion of artists' models as interchangeable objects of desire. One such response to Delacroix's painting is a literary text—part memoir, part art criticism, part fiction. Assia Djebar appropriates Delacroix's title for her collection of essays and stories: *Women of Algiers in Their Apartment* (1980; English translation 1992). In a piece from the

collection entitled "Forbidden Gaze, Severed Sound," the author presents her interpretation of Delacroix's painting.

Djebar's reading begins with an *ekphrasis*, a dramatic verbal description of the painting. In ekphrasis, the writer attempts to bring the visual image to life for the reader, often by imagining the emotional responses of the figures depicted in the scene. Djebar's ekphrasis of Delacroix's painting is told from the perspective of a woman in postcolonial Algeria. From this perspective, Algerian women have survived the long and bloody war for independence from France only to find themselves subjugated at home. Djebar's reading of Delacroix's painting is a critique not only of Western colonialism but of the repressive policies of the postcolonial Islamic state.

From Women of Algiers in Their Apartment

by Assia Djebar

Women of Algiers in Their Apartment: three women, two of whom are seated in front of a hookah. The third one, in the foreground, leans her elbow on some cushions. A female servant, seen three quarters from the back, raises her arm as if to move the heavy tapestry aside that masks this closed universe; she is an almost minor character, all she does is move along the edge of the iridescence of colors that bathes the other three women. The whole meaning of the painting is played out in the relationship these three have with their bodies, as well as with the place of their enclosure. Resigned prisoners in a closed place that is lit by a kind of dreamlike light coming from nowhere—a hothouse light or that of an aquarium—Delacroix's genius makes them both near and distant to us at the same time, enigmatic to the highest degree. . . .

Women always waiting. Suddenly less sultanas than prisoners. They have no relationship with us, the spectators. They neither abandon nor refuse themselves to our gaze. Foreign but terribly present in this rarified atmosphere of confinement.

Elie Faure tells us that the aging Renoir, when he used to refer to this light in *Women of Algiers*, could not prevent large tears from streaming down his cheeks.

Should we be weeping like the aged Renoir, but then for reasons other than artistic ones? Evoke, one and a half centuries later, these Bayas, Zoras, Mounis, and Khadoudjas. Since then, these women, whom Delacroix —perhaps in spite of himself—knew how to observe as no one had done before him, have not stopped telling us something that is unbearably painful and still very much with us today.

Djebar's ekphrasis gives voice to the silenced figures in the painting. The female observer and her counterparts within the painting turn the "forbidden gaze" back on the various male presences—colonial overseer, artist, husband, viewer—that are only implied in Delacroix's painting. Like other poststructuralist artists and critics, Djebar suggests that every text is just such a web of absences and presences.

Houria Niati's *No to Torture*

In her mixed-media installation entitled *No to Torture* (1982–1983), the artist Houria Niati incorporates drawings, sculpture, poetry, painting, music, and a photograph of Delacroix's *Women of Algiers*. The canvas from *No to Torture* shown in fig. 10.9 is based on Delacroix's painting, but its abstractions remind us, as well, of the way Orientalist stereotypes of North African women persisted in the paintings of modernists like Matisse and Picasso. Niati strips the Delacroix composition of its seductively decorative surfaces; the featureless faces of her nude figures are imprisoned in barred cages.

In the following excerpt from his commentary (1997) on Niati's work, the critic and artist Olu Oguibe examines the visual strategies Niati employs in her appropriation of Delacroix's theme.

10.9 Houria Niati, *No To Torture*, installation detail, 1982–83. Oil on canvas, 181.6 × 275.5 cm. (71¹/₂ × 108¹/₂ in.). Collection of the artist.

From "Beyond Visual Pleasure: A Brief Reflection on the Work of Contemporary African Women Artists"

by Olu Oguibe

In some of her paintings and installations Niati takes on nineteenth century Orientalist painting and photography in which the women of North Africa are encapsulated in a romanticized sensuality and languor that erases their subjectivity and occludes their realities. In *No to Torture*, a reinterpretation of Eugène Delacroix's *Women of Algiers*, Niati deconstructs Delacroix's false and voyeurist representation of Arab women by carefully analysing the iconography of Delacroix's paintings to produce what for want of a better term we might call an x-ray image of the original. Niati replaces the smooth finish and veneer of

Delacroix's painting with her rough and coarse brush work, and in place of the French painter's carefully manipulated chiaroscuro produces a stark contrast in polychrome. She cancels or rubs out the faces of the women in her interpretation to indicate how in the French painting the subjectivity of the characters is erased and the focus is placed on their bodies, how in Delacroix's *Women* the viewer's attention is drawn through composition and the use of light to the bodies of the women—to their bare feet and exposed bosoms, to their stares encrusted with sexual longing and invitation, to elements and features that effectively transformed them into objects of erotic fantasy. Where Delacroix located his figures in the dim and luscious architectural ambience of Arab opulence, the luxurious and dark comfort of the harem, Niati restores them to the stark particularities of reality against which they appear skeletal and stripped.

Shirin Neshat's *Rapture*

We'll conclude our discussion with a very recent example of an artist's deconstruction of Orientalism, Shirin Neshat's multimedia installation entitled *Rapture* (1999). Filmed by the artist in Morocco, *Rapture* consists of two synchronized black-and-white video sequences, each thirteen minutes long, projected on opposing walls of the exhibition space. The accompanying soundtrack, by the Iranian musician Sussan Deyhim, blends contemporary and traditional Middle Eastern and North African music. Viewers are seated on benches against the walls between the two screens. *Rapture* visually enacts the way societies use space to shape gender: men appear on one wall, veiled women on the other (figs. 10.10 and 10.11).

At intervals, the men and women in the videos seem to look across the exhibition space at one another, at once subjects and objects of the gaze. Neshat puts the viewer in the center of the space, making it impossible to take in the whole of the installation at one time. The artist thus brings to the fore the mediating role of the viewer in drawing together and interpreting the elements of a work of art.

10.10 and 10.11 Shirin Neshat, two production stills from two-screen film installation entitled *Rapture* (1999). Courtesy Barbara Gladstone Gallery, New York.

The artists discussed in this section demonstrate how observers participate in a continuing dialogue with art of the past. Our survey of critical approaches to interpretation has thus brought us back to that noisy throng of present-day viewers and historical ghosts gathered before a complex and beautiful painting in the Louvre.

The ambiguities of the painting invite their competing viewpoints. The *Women of Algiers in Their Apartment* are both Charles Blanc's "beautiful jewels in a case" and Assia Djebar's "resigned prisoners in a closed place." The painting achieves realist pictorial illusion while at the same time frankly acknowledging its own decorated surface in careful modulations of color and dashing brushwork. It is both ethnographic notation and pure paint. One of the most memorable Orientalist scenes in the history of art, it is also a disturbing anticolonialist document: a depiction of somber and isolated subjects who, for all their passivity, have successfully resisted the

10.11

viewer's mastery these past 150 years. The critical history of *Women of Algiers* shows us that the meaning and aesthetic richness of the painting live in the contested space where all these discourses converge.

WORKS CITED AND SUGGESTED READING

Books and articles on Delacroix, and specifically on the *Women of Algiers,* are listed in Chapter 9, which deals with research and documentation methods. Following is a list of selected references on critical theory and methodology in art history. Additional books on critical methodology will be found in the "Suggested Reading" sections of Chapters 3 and 4 of this book.

Bal, Mieke, and Norman Bryson. "Semiotics and Art History." *Art Bulletin* 73, no. 2 (June 1991): 174–208.

Barthes, Roland. *Image—Music—Text.* Trans. S. Heath.
 New York: Hill and Wang, 1977.
Baudelaire, Charles. *The Painter of Modern Life and Other
 Essays.* Ed. and trans. Jonathan Mayne. 2nd ed.
 London: Phaidon, 1995.
Baxendall, Michael. *Patterns of Intention: On the Historical
 Explanation of Pictures.* New Haven: Yale University
 Press, 1985.
Broude, Norma, and Mary D. Garrard, eds. *Feminism
 and Art History: Questioning the Litany.* New York:
 Harper and Row, 1982.
Chadwick, Whitney. *Women, Art, and Society.* Rev. ed.
 London: Thames and Hudson, 1996.
Clark, T. J. *The Painting of Modern Life: Paris in the Art of
 Manet and His Followers.* Princeton, N.J.: Princeton
 University Press, 1984.
Derrida, Jacques. *The Truth in Painting.* Trans.
 G. Bennington and I. McLeod. Chicago: University
 of Chicago Press, 1987.
Djebar, Assia. *Women of Algiers in Their Apartment.* Trans.
 Marjolijn de Jager. Charlottesville and London:
 University Press of Virginia, 1992.
Fernie, Eric, ed. *Art History and Its Methods: A Critical
 Anthology.* London: Phaidon, 1995.
Foucault, Michel. *The Archeology of Knowledge.* New
 York: Pantheon, 1972.
Galassi, Susan Grace. *Picasso's Variations on the Masters.*
 New York: Abrams, 1996.
Gates, Henry Louis, Jr., ed. *"Race," Writing and
 Difference.* Chicago: University of Chicago Press, 1986.
Hadjinicolaou, Nicos. *Art History and Class Struggle.*
 London: Pluto, 1973.
Jauss, Hans Robert. *Toward an Aesthetics of Reception.*
 Trans. T. Bahti. Minneapolis: University of Minnesota
 Press, 1982.
Lacan, Jacques. *Écrits: A Selection.* Trans. Alan Sheridan.
 New York: Norton, 1977.
Minor, Vernon Hyde. *Art History's History.* Englewood
 Cliffs, NJ: Prentice-Hall, 1994.
Moi, Toril, ed. *The Kristeva Reader.* New York: Columbia
 University Press, 1986.
Mulvey, Laura. "Visual Pleasure and Narrative
 Cinema." In *Feminism and Film Theory,* ed. Constance
 Penley. New York: Routledge, 1988.

Nelson, Robert S., and Richard Shiff. *Critical Terms for Art History*. Chicago: University of Chicago Press, 1996.

Nochlin, Linda. "The Imaginary Orient," *Art in America* 71 (May 1983): 118–131.

———. *Women, Art and Power, and Other Essays*. New York: Harper and Row, 1988.

Oguibe, Olu. "Beyond Visual Pleasures: A Brief Reflection on the Work of Contemporary African Women Artists." In *Gendered Visions: Five African Women Artists*, ed. Salah Hassan. Trenton: Africa World Press, 1997.

Panofsky, Erwin. *Meaning in the Visual Arts*. Garden City, N.Y.: Doubleday Anchor Books, 1955.

Pollock, Griselda. *Vision and Difference: Femininity, Feminism, and the Histories of Art*. London and New York: Routledge, 1988.

Preziosi, Donald. *Rethinking Art History: Meditations on a Coy Science*. New Haven and London: Yale University Press, 1989.

Rees, A. L., and Frances Borzello, eds. *The New Art History*. Atlantic Highlands, N.J.: Humanities Press, 1988.

Richter, David H., ed. *The Critical Tradition: Classic Texts and Contemporary Trends*, 2nd ed. New York: St. Martin's, 1998.

Saslow, James M. *Pictures and Passions: A History of Homosexuality in the Visual Arts*. New York: Viking Penguin, 1999.

Seidel, Linda. "'Jan van Eyck's Arnolfini Portrait': Business as Usual?" *Critical Inquiry* 16 (Autumn 1989) 55–86.

Smalls, James. "Making Trouble for Art History: The Queer Case of Girodet." *Art Journal*, Winter 1996, 20–27.

Wölfflin, Heinrich. *Principles of Art History: The Problem of the Development of Style in Later Art*. Trans. M. D. Hottinger. New York: Dover, 1950.

Part Three Conclusion

Research and Critical Methods

In the third and final part of this book, we've returned to a critical concept examined in Chapter 1: intertextuality—the network of visual languages, meanings, references, and discourses surrounding a work of art.

As Chapter 10 illustrates, a complex work of art provides no single, finite interpretation. Successive readings of the artwork are not simply modern readers' projections of twentieth-century information and values onto artifacts of the past. Rather, a work of art or architecture can be seen to embody more than one narrative, and sometimes conflicting narratives. We conduct research on a particular artwork not only to learn from what others have observed but to understand why a particular methodological approach supercedes another within a particular era or context.

This is not to say that more recent commentary is necessarily an improvement over what came before, or that all critical methods are applicable to every text. A historical perspective allows contemporary observers and writers to expand on, take issue with, or refine the conclusions of earlier viewers, and to find different points of emphasis. The critics and artists discussed in Chapter 10 open up a range of possibilities for interaction with works of art. In writing about art, each of us takes an active part in the ongoing conversation among artists, objects, and observers throughout history. Just as a hanging scroll bears the inscriptions and stamps of successive generations of viewers, the record of discourse on a work of visual art bears witness to, becomes part of, the communicative power of the artwork itself.

Permissions/Credits

Text Credits

Chapter 2

Linda Nochlin, "Bonnard's Bathers," © 1998 *Art in America*, Brant Publications, July 1998. Reprinted by permission.

Peter Schjeldahl, "Tub Scouts," reprinted by permission of the author and *The Village Voice*.

James Gardner, "Adventures of the Optic Nerve," © 1998 by *National Review*, Inc., 215 Lexington Avenue, New York, NY 10016. Reprinted by permission.

Charles Molesworth, Review of "Bonnard at MoMA," reprinted by permission of *Salmagundi*.

Jed Perl, "Levitation," © 1998 by *The New Republic*. Reprinted by permission.

Nicholas Watkins, excerpt from *Bonnard* by Nicholas Watkins, © 1994 Phaidon Press Limited. Reproduced with permission.

Sarah Whitfield, excerpt reproduced from *Bonnard*, exh. cat. ed. Sarah Whitfield and John Elderfield. Reprinted by permission of Harry N. Abrams.

Jonathan Jones, "So Jeffrey, Why Did You Buy All Those Marilyns" © 1998 *The Guardian*. Reprinted by permission.

Chapter 3

Original museum label for Mende helmet mask reprinted by permission of The Metropolitan Museum of Art, New York, NY.

Chapter 4

"Seattle Museum to Return Painting Stolen by Nazis," June 16, 1999, *Houston Chronicle*, reprinted by permission of Reuters America, Inc.

Susan Diesenhouse, "Looted or Legal? Objects Scrutinized at Boston Museum," © 1998 *The New York Times*. Reprinted by permission of *The New York Times*.

Fred Kaplan, "Unhidden Treasures: Russian Museum Unveils 74 Long-lost Masterpieces of Art," by permission of *The Boston Globe*.

Chapters 8 and 9

Excerpts from *Art Bulletin* Style Guidelines reproduced by permission of College Art Association.

Chapter 10

Charles Baudelaire, "The Life and Work of Eugène Delacroix," ed. and trans. Jonathan Mayne. Reproduced with permission from *The Painter of Modern Life and Other Essays by Charles Baudelaire* published by Phaidon Press Limited, 1995.

Barthélémy Jobert, *Delacroix*, ©1997 by Gallimard; ©1998 Princeton University Press. Reprinted by permission of Princeton University Press.

Assia Djebar, *Women of Algiers in Their Apartment*, Eng. ed. ©1992 the Rector and Visitors of the University of Virginia.

Olu Oguibe, "Beyond Visual Pleasure: A Brief Reflection on the Work of Contemporary African Women Artists." Originally published in Salah Hassan, ed., *Gendered Visions: Five Africana Women Artists*, Africa World Press, 1997. Reprinted with permission.

Photo Credits

7 Photo © Archivi Alinari/Art Resource, NY.
9 Photo by Katya Kallsen/© President and Fellows of Harvard College.
14 Photo © Scala/Art Resource, NY.
15 Photo © Scala/Art Resource, NY.
20 Photo © Archivi Alinari/Art Resource, NY.
29 © 2002 Artist Rights Society (ARS), New York/ADAGP, Paris. Photo: Bridgeman Art Library.
32 © 1993 Museum Associates, Los Angeles County Museum of Art. All Rights Reserved.
33 © 2002 Artist Rights Society (ARS), New York/ADAGP, Paris. Photo ©Erich Lessing/Art Resource, NY.
38 © 2002 Artist Rights Society (ARS), New York/ADAGP, Paris.
39 © 2002 Artist Rights Society (ARS), New York/ADAGP, Paris. Photo by Richard A. Stoner, 1989/The Carnegie Museum of Art.
41 Photo by Thierry Ollivier/Réunion des Musées Nationaux, France/Art Resource, NY.
43 Photo © Archivi Alinari/Art Resource, NY.
44 © 2002 Artist Rights Society (ARS), New York/ADAGP, Paris. Photo: CNAC/ MNAM/Dist Réunion des Musées Nationaux/Art Resource, NY.
45 © L & M Services B.V. Amsterdam 20010515. Photo by Philippe Migeat/CNAC/ MNAM/Dist Réunion des Musées Nationaux/Art Resource, NY.
46 Photo © Scala/Art Resource, NY.
62 Photo © Michael S. Yamashita.
67 Photo © Erich Lessing/Art Resource, NY.
71 Photo by Jean Feuillie/© Centre des Monuments Nationaux, Paris.
72 Photo © Wayne Andrews/Esto.
79 Reproduced by permission of The Metropolitan Museum of Art.
80 Photo by G. Vivien/Réunion des Musées Nationaux/Art Resource, NY.
84 Photo by Schenck and Schenck Photography.
85 Photo by Gary van Wyck, New York.
86 Photo by Nick Muellner, New York.
94 Photo © Richard Bryant/Arcaid.
95 © Barnes Foundation.
96 Photo by Don Cole/© UCLA Fowler Museum of Cultural History.
97 © David A. Mayo, Exhibition Designer, UCLA Fowler Museum of Cultural History.
98 Photo by Don Cole/© UCLA Fowler Museum of Cultural History.
100 Photo by Nick Muellner, New York.
100 © L & M Services B.V. Amsterdam 20010515. Photo by Nick Muellner, New York.
103 Courtesy Guerrilla Girls, Conscience of the Art World, NY. Photo courtesy of Parsons School of Design, Adam and Sophie Gimbel Design Library.
111 Photo by Mark Lindsey.
117 Photo © 2000 Museum of Fine Arts, Boston. All Rights Reserved.
117 Photo © 1999 Museum of Fine Arts, Boston. All Rights Reserved.
133 Photo The New York Public Library, Astor, Lenox and Tilden Foundations. Wallach Division of Art, Prints and Photographs.
137 Photo © Oroñoz-Nieto, Madrid.
151 Photo © Alinari/Art Resource, NY.
153 Photo © Louis Armstrong House and Archives, Queens College, CUNY.

154 Photo © Louis Armstrong House and Archives, Queens College, CUNY.
212 Photo © Giraudon/Art Resource, NY.
213 Photo © Erich Lessing/Art Resource, NY.
217 Photo by Cliché Frédéric Jaulmes/© Musée Fabre Montpellier.
218 Photo by Michele Bellot/Réunion des Musées Nationaux/Art Resource, NY.
219 Photo by Michele Bellot/Réunion des Musées Nationaux/Art Resource, NY.
234 Photo © Erich Lessing/Art Resource, NY.
243 Photo © Giraudon/Art Resource, NY.
255 © 2002 Estate of Pablo Picasso/Artists Rights Society, New York. Photo by Michéle Bellot/Réunion des Musées Nationaux/Art Resource, NY.
258 © Houria Niati
260 © 1999 Shirin Neshat. Photo by Larry Barns.
261 © 1999 Shirin Neshat. Photo by Larry Barns.

Color Gallery

Color Plate 1 Photo © 2001 The Metropolitan Museum of Art, NY.
Color Plate 2 © Cindy Sherman
Color Plate 3 © 2002 Artist Rights Society (ARS), New York/ADAGP, Paris. Photo © 2001 The Museum of Modern Art, NY
Color Plate 4 Photo © Erich Lessing/Art Resource, NY.
Color Plate 5 Photo © Michael S. Yamashita.
Color Plate 6 Photo © 1985 The Metropolitan Museum of Art, NY.
Color Plate 7 Photo © Susan Dirk, 1993/Seattle Art Museum.
Color Plate 8 Photo © Erich Lessing/Art Resource, NY.

Index

NOTE: Artworks are listed at the end of an entry.